"If there are no dogs in Heaven,

then when I die I want to go

where they went."

Will Rogers captured our special relationship with dogs perfectly. *Best in Show* brings us some of the finest images of "man's best friend" by distinguished artists. It is a serious show, to be sure, but it is difficult not to steal a contented smile as these images evoke our own memories of times past shared with a shaggy friend.

The Citigroup Private Bank is delighted to join the Committee of Honor in sponsoring this exhibition at the Bruce Museum. We believe that our greatest responsibility to clients is to understand their needs and to become their unabashed advocate in finding the most appropriate solutions to whatever financial challenges they face.

Our Art Advisory Service is one example of a number of specialized wealth advisory services that complement our core services of independent advice and tailored solutions. Art Advisory is a comprehensive fine art consulting service bringing art world experience and a financial perspective to the process of collecting.

We value our partnership with the Bruce Museum because it is an innovative, sensitive, serious, and constantly evolving organization, with a dedicated and passionate staff that is confident of the quality of their product—qualities that we admire and strive to share.

Sincerely,
The Citigroup Private Bank in Connecticut

citigroup
private bank

David Cattrell

Burt Hilton

Ken Russell

Juan de Choudens

Dave Rabideau

Presentation of this exhibition at the Bruce Museum is generously underwritten by

private bank

The Charles M. and Deborah G. Royce Exhibition Fund

Media Sponsorship by

MOFFLY
PUBLICATIONS INC.

GREENWICH | NEW CANAAN DARIEN & ROWAYTON | WESTPORT
MAGAZINE MAGAZINE Fairfield · Weston · Wilton MAGAZINE

and a

Committee of Honor
under the leadership of
Sue Ann and John Weinberg, Gusto, and Speedy

Best in Show

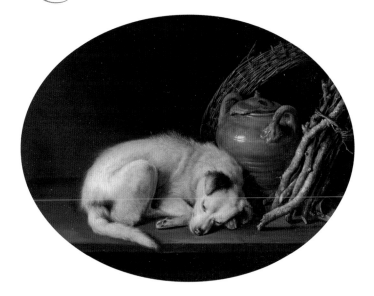

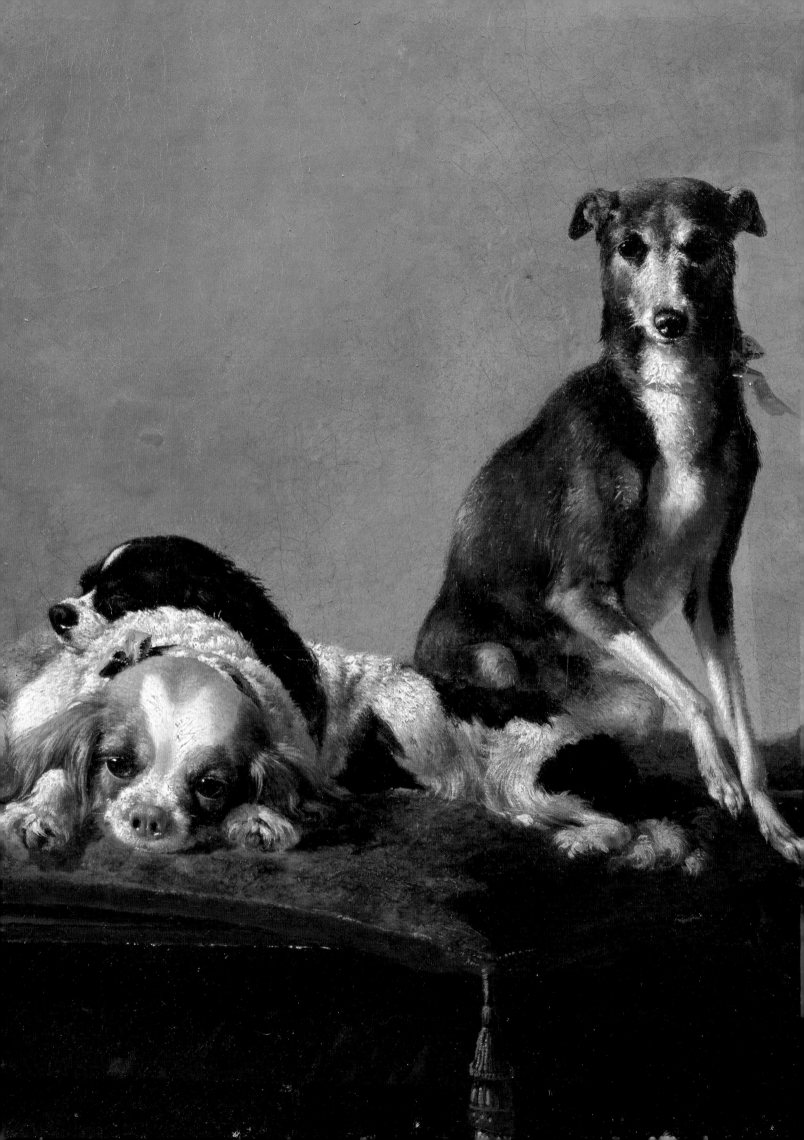

Best in Show
The Dog in Art from the Renaissance to Today

Edgar Peters Bowron, Carolyn Rose Rebbert,

Robert Rosenblum, and William Secord

Yale University Press, New Haven and London

in association with

The Museum of Fine Arts, Houston, and the Bruce Museum, Greenwich

Published in conjunction with the exhibition *Best in Show: The Dog in Art from the Renaissance to Today*, organized by Edgar Peters Bowron and Peter C. Sutton.

Bruce Museum, Greenwich, Conn. The Museum of Fine Arts, Houston
May 13–August 27, 2006 October 1, 2006–January 1, 2007

Designed and composed by Laura Lindgren

Set in Berthold Baskerville and Bickham Script

Printed and bound in Italy by Conti Tipocolor

Library of Congress Cataloging-in-Publication Data
 Best in show : the dog in art from the Renaissance to today / Edgar Peters Bowron, Carolyn Rose Rebbert, Robert Rosenblum, and William Secord.
 p. cm.
 Published in conjunction with the exhibition held in the Bruce Museum of Arts and Science, Greenwich, Conn., May 13–Aug. 27, 2006, and the Museum of Fine Arts, Houston, Oct. 1, 2006–Jan. 1, 2007.
 Includes bibliographical references and index.
 ISBN-13: 978-0-300-11588-8 (hardcover : alk. paper)
 ISBN-10: 0-300-11588-1 (hardcover : alk. paper)
 ISBN-13: 978-0-89090-143-4 (pbk. : alk. paper)
 ISBN-10: 0-89090-143-0 (pbk. : alk. paper)
 1. Dogs in art–Exhibitions. I. Bowron, Edgar Peters. II. Bruce Museum. III. Museum of Fine Arts, Houston.
 N7668.D6B48 2006
 704.9'4329772–dc22 2006009074

10 9 8 7 6 5 4 3 2 1

JACKET ILLUSTRATIONS: (front) George Stubbs, *Brown and White Norfolk or Water Spaniel* (detail), 1778 (fig. 34); (back) Giacomo Balla, *Dynamism of a Dog on a Leash*, 1912 (fig. 63)

PAGE I: Gerrit Dou, *A Sleeping Dog Beside a Terracotta Jug, a Basket, and a Pile of Kindling Wood* (detail), 1650 (fig. 28)

PAGE II: Anne Vallayer-Coster, *Les Petits Favoris* (detail), c. 1775–80 (fig. 40)

PAGE 161: Elliott Erwitt, *New York City* (detail), 1974 (fig. 72)

Contents

I had rather see the portrait of a dog that I know

than all the allegorical paintings they can show me in the world.

SAMUEL JOHNSON, 1787

Lenders to the Exhibition

Albright-Knox Art Gallery, Buffalo

The American Kennel Club, New York

The American Kennel Club Museum of the Dog, Saint Louis

BELvue Museum, Brussels

Brandywine River Museum, Chadds Ford

Charles Janoray, New York

Detroit Institute of Arts

Jack Kilgore & Co., New York

Lawrence Steigrad Fine Arts, New York

Lehmann Maupin Gallery, New York

The Metropolitan Museum of Art, New York

Michael Werner Gallery, New York and Cologne

Milwaukee Art Museum

Musée d'Art et d'Histoire, Geneva

Musée de la Chasse et de la Nature, Paris

Musée de la Vénerie, Senlis

Musée des Beaux-Arts de Tournai

Musée du Louvre, Paris

Musée Fabre, Montpellier

Musée Lorrain, Nancy

Museo Nacional del Prado, Madrid

Musée National du Château de Compiègne

Museo Nazionale del Bargello, Florence

Museum Boijmans Van Beuningen, Rotterdam

Museum of Fine Arts, Boston

The Museum of Fine Arts, Houston

National Gallery of Art, Washington, D.C.

Neuberger Museum of Art, Purchase College, State University of New York

Philadelphia Museum of Art

Richard L. Feigen & Co., New York

Saint Louis Art Museum

The Sarah Campbell Blaffer Foundation, Houston

Staatliche Kunsthalle, Karlsruhe

Tate, London

Virginia Museum of Fine Arts, Richmond

Wadsworth Atheneum Museum of Art, Hartford

The Walters Art Museum, Baltimore

White Cube, London

Yale Center for British Art, New Haven

James Birch

The Stephanie and Peter Brant Foundation

Stefan T. Edlis Collection

Tracey Emin

The Trustees of the Rt. Hon. Olive, Countess Fitzwilliam's Chattels Settlement

Mr. and Mrs. R. M. Franzblau

Lord Glenconner

Walter F. Goodman and Robert A. Flanders

Mrs. Duane Hanson

Emily Mayer

Frances G. Scaife

Anonymous private collectors

Foreword

Although exhibitions of paintings and portraits of dogs are a staple of commercial galleries, and several important exhibitions have been devoted to the topic in European museums, this exhibition is the most extensive survey ever mounted in the United States of the dog in Western art from the Renaissance to the present. The show features some of the finest images of man's best friend by distinguished and renowned painters, sculptors, and photographers, as well as exceptional works by lesser-known but equally inspired artists. Here we may admire truly great images of dogs by such pioneers of the subject as Jacopo Bassano and Titian in the Renaissance, Frans Snyders and Gerrit Dou in the Baroque period, and the brilliant eighteenth-century masters Alexandre-François Desportes, Jean-Baptiste Oudry, and George Stubbs; powerful and emotive nineteenth-century dogs by Rosa Bonheur and Constant Troyon, as well as several examples by perhaps the greatest of all dog painters, Sir Edwin Landseer; and twentieth-century and contemporary works by Jean-Léon Gérôme, Andy Warhol, Andrew Wyeth, Duane Hanson, and Jeff Koons. Though unapologetically designed to entertain and divert, the exhibition at the same time seeks to reveal both the high artistic standards the subject has sustained and how this recurrent theme functions in the history of art.

The show explores the use of dog imagery to illustrate major cultural and social concerns in Western culture. Through the nobility and drama of the hounds of the hunt in Renaissance and Baroque art; the cozy domesticity of Dutch mutts and the pampered luxury of French Rococo and Impressionist lapdogs; the studied modernity of animals of the Machine Age and the febrile angst of Expressionism's curs; the wit and irony of canine imagery in the eras of Pop, Postmodernism, and their aftermath, dogs have always taken their place beside and often in place of people. The show demonstrates how humankind not only projected anthropomorphic sentiments upon the most favored and domesticated of creatures but also repeatedly turned to the dog as an inexhaustibly mutable emblem of each new age. Since antiquity, dogs have romped through the history of art, often appearing as incidental background motifs, part of a hunting scene, religious, mythological, or allegorical composition, or beside their masters in portraits. Here, however, the dog takes center stage in an exhibition

DETAIL FROM FIG. 23

that follows the development of the theme of *canis familiaris* for almost five centuries in painting, sculpture, photography, and video.

The inspiration for this project, which was conceived by the Bruce Museum and brought to fruition by the Museum of Fine Arts, Houston, was a deceptively amusing but remarkably erudite book, *The Dog in Art from Rococo to Post-Modernism* (1988), by the distinguished art historian Robert Rosenblum. From the outset of the project, Professor Rosenblum enthusiastically embraced the idea. He joined the team that selected the works for the show and now has expanded on his own earlier writings in the graceful and witty essay published here. Edgar Peters Bowron, the Audrey Jones Beck Curator of European Art at the Museum of Fine Arts, Houston, has astutely traced the canine theme and its associations in earlier art. William Secord, a recognized expert on dog painting and the author of several best-selling books on the subject, has provided an informative essay on paintings portraying different breeds. Finally, the Bruce Museum's curator of science, Carolyn Rose Rebbert, has written an intelligent account about the science of dogs.

It is a testament to how closely humans live with dogs that this animal can tell the story of art more eloquently than any other animal. Whether indoor or outdoor pets, guardians of life's parameters or closeted domestic creatures, fierce or fawning companions, dogs through their unrivaled proximity to humans have come to embody a remarkably wide spectrum of values and emotions. And as any dog owner will attest, they also honor with unquestioned acceptance the bond with their human companions, yet possess preternatural qualities that we can scarcely fathom. If there is any truth to the old adage about people coming to resemble their dogs, it is built upon the mirrored idiosyncrasies of two inseparable but individual lives. We hope you will enjoy this parade of dogs through the centuries.

We wish to thank, above all, the lenders to the exhibition, many of whom are private collectors, for their generosity in making these works available. In Greenwich we are also deeply grateful to our sponsors, The Citigroup Private Bank, the Charles M. and Deborah G. Royce Exhibition Fund, Moffley Publications, and the Members of the Committee of Honor, who have made this delightful show possible. In Houston we are grateful for the unfailing support of the trustees of the Museum of Fine Arts, Houston.

Peter C. Sutton
Susan E. Lynch Executive Director
Bruce Museum, Greenwich, Conn.

Peter C. Marzio
Director
The Museum of Fine Arts, Houston

Acknowledgments

This catalogue and exhibition would not have been possible without the assistance of numerous friends and colleagues. Special mention should be made of Robert Rosenblum, to whom we turned again and again for advice and guidance, and who supplied a steady stream of enthusiastic suggestions for works to be considered for inclusion in the exhibition. Another of our authors, William Secord, was no less generous with his counsel and help and provided invaluable assistance in arranging loans from several private collections.

Edgar Peters Bowron would like to thank, in particular, Helga Aurisch, assistant curator of European art, and Teresa Harson at the Museum of Fine Arts, Houston, for their indispensable and indefatigable efforts in securing loans and reproductions. Numerous colleagues at the museum contributed significantly to the organization and presentation of the exhibition, notably Kathleen Crain and John Obsta, registrar's department; Jack Eby and Bill Cochrane, design; Beth Schneider and Margaret Mims, education; Marty Stein and the staff of the Freed Image Library; and the staff of the Hirsch Library, in particular Jon Evans, Margaret Ford, and Amy Sullivan. Diane Lovejoy, Heather Brand, and Christine Waller Manca merit special thanks for their preparation of the essays and catalogue for publication. Other museum colleagues who contributed their time and advice to this project include Andrea di Bagno, Alison de Lima Greene, Paul Johnson, Frances Carter Stephens, Anne Wilkes Tucker, Barry Walker, and Del Zogg. Special thanks go to Peter C. Marzio, director, and Gwendolyn H. Goffe, associate director, finance and administration.

Peter Sutton would like to thank the following in Greenwich: Nancy Hall-Duncan, Cynthia Drayton, York Baker, Ann Sethness, Anne von Stuelpnagel, Mike Horyczun, and Kathy Reichenbach.

Carolyn Rose Rebbert gratefully acknowledges the assistance of Whitney A. Martinko, Lillian Butler Davey resident intern at the Bruce Museum. She also thanks Tom Baione, Hugh Feiss, O.S.B., Alicia Gore, Lisette Henrey, Ken Nebel, and Maria Rebbert for their help and for sharing their expertise.

Among the many others to whom we have incurred debts of one kind or another, we would like particularly to acknowledge Claude d'Anthenaise, Sir Jack Baer,

Joseph Baillio, Boyd Beaumont, Justine Birbil, James Birch, Niels de Boer, Geneviève Bresc-Bautier, Philippe Brunin, Jill Capobianco, James Clifton, James P. Crowley, Kimberly Davis, Douglas Dreishpoon, James Duff, Suzanne Egeran, Judy Egerton, William Feaver, Richard L. Feigen, Gabriele Finaldi, Robert A. Flanders, Christina Forni, Jeroen Giltay, Peter Glidewell, Walter F. Goodman, Anne Guité, Jean Habert, Wesla Hanson, Michel Hilaire, The Lord Hindlip, Siegmar Holsten, Charles Janoray, William R. Johnston, Pauline Karpidas, Franklin Kelly, George S. Keyes, Jack Kilgore, Barbara Kolk, Elizabeth Mankin Kornhauser, Jacques Kuhnmunch, Susan Kuretsky, Paul Lang, Buck Laughlin, Terry Leet, Rachel Lehmann, Judith W. Mann, Molly March, Emily Mayer, Barbara McNab, Mitchell Merling, Theodore W. Millbank, Eric Moinet, Tobia Milla Moss, Jeffrey H. Munger, Patrick J. Noon, Anthony d' Offay, Richard Ormond, Bénédicte Ottinger, Marijke Peyser-Verhaar, Géry de Pierpont, Marie-Christine Prestat, Joseph J. Rishel, Nancy Rosen, Mark Rosenthal, George T. M. Shackelford, Anthony Speelman, John T. Spike, Emmanuel Starcky, Lawrence Steigrad, Beatrice Paolozzi Strozzi, Lady Juliet Tadgell, Sheilagh Tennant, Angus Trumbull, Robert Upstone, José Antonio de Urbina, Maria Grazia Vaccari, Alexander Vergara, Andrew J. Walker, Jeffrey S. Weiss, Angela Westwater, Clint T. Willour, Jörg Wünschel, and Galina Zhitomirsky.

We are grateful to Yale University Press for publishing this catalogue and extend thanks to the following staff members at the press: Patricia Fidler, publisher, art and architecture; John Long, production coordinator; and Kate Zanzucchi, senior production editor, art books, as well as to freelance production manager Ken Wong, copyeditor Janet Wilson, and designer Laura Lindgren.

Edgar Peters Bowron • Peter C. Sutton

DETAIL FROM FIG. 107

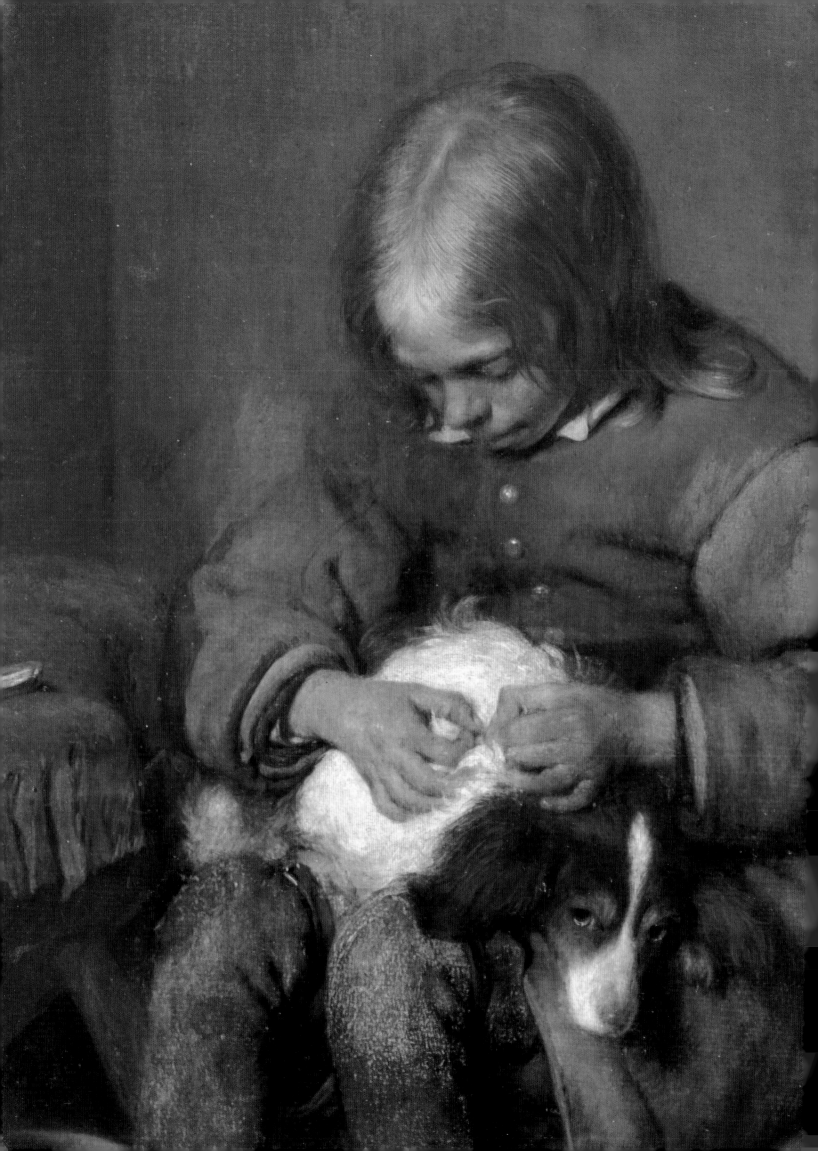

An Artist's Best Friend

Dogs in Renaissance and Baroque Painting and Sculpture

EDGAR PETERS BOWRON

Dogs are a common visual motif in Western art and have been called the "artist's best friend" for their role as companion and life model.[1] The close and accurate observation of animals is a hallmark of Renaissance and Baroque art in general, and as the most domesticated and favored of species, it is inevitable that dogs in particular would be well represented. Sketching from life was part of the Renaissance artist's normal routine, and when artists began to look at the world around them, there was the dog—a ready and willing source of inspiration.

From the beginning of the Middle Ages, the dog was generally allowed to be present in noble society as the plaything of courtiers and members of privileged religious orders, and the more it was loved, the wider the variety of roles it commanded in both sacred and profane art. Dogs were carved on tombs at the feet of their masters' effigies to watch over them after they left this world for the next. They adorned the marginalia of illuminated manuscripts and sat on brocade cushions in the center of tapestries. But they came into their own in specialized medieval treatises on the science of hunting, such as the famous *Livre de Chasse* (Book of Hunting) by Gaston Phébus, comte de Foix, an enthusiast writing at the end of the fourteenth century. Phébus himself is said to have owned sixteen hundred hunting dogs, and in his book he celebrated the respective merits of the bulldogs, greyhounds, "coursers," pointers, and mastiffs that made up the pack (fig. 1).[2]

Most noblemen in the fourteenth century kept large numbers of hunting dogs, "[f]or a hound is the noblest and most reasonable beast that God has ever created!"[3] The enthusiasm of the renowned bibliophile and patron Jean, duc de Berry, for the *mâtin*, a kind of large mastiff in the Auvergne region that was bred in his kennels at

DETAIL FROM FIG. 24

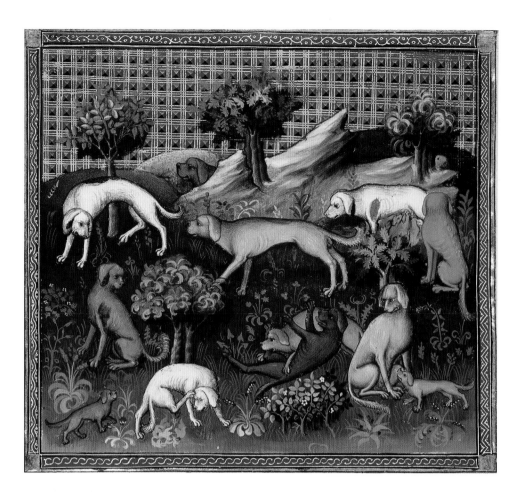

the castle of Nonette, is reflected in the prominence of these dogs in the boar-hunting scene illustrating the month of December in *Les Très Riches Heures* (fig. 2).[4] Moreover, in the famous feasting scene representing the month of January, produced for the duke by the Limbourg brothers in the same manuscript, the status of certain of the fifteen hundred dogs he is alleged to have owned in the year 1388 is undeniable—lapdogs run about on the banquet table, eating from the plates, while in the foreground a white hound is fed by a servant.[5]

Throughout the Renaissance, dogs abound in art, most often appearing as incidental background motifs, part of a hunting scene, religious, mythological, or allegorical composition, or beside their masters in portraits.[6] However, even a brief accounting of their role in the visual arts of the period involves issues that go well beyond the history of art, including court life, aristocratic tastes and fashion, pet ownership, the status of hunting among the royal and noble classes, developments in the classification of dog breeds and types, and changing views of the intelligence and mental abilities of dogs. For example, although working dogs were ubiquitous in the Renaissance—they turned cooking spits, pulled carts, herded sheep, baited wild animals, and competed in sporting events[7]—their menial status mostly precluded their appearing as such in paintings of the period.

The first great observer of animals in the Renaissance, Pisanello, produced several sensitively observed studies of dogs, evidently drawn from nature, in a sketchbook in

EDGAR PETERS BOWRON

Paris. He used these studies for the greyhounds, hound, and two small spaniel-like dogs in the foreground of *The Vision of Saint Eustace* (fig. 3).[8] Half a century later, Albrecht Dürer rendered dogs with the attention of a portraitist, in silverpoint and ink and wash, leaving us several preparatory drawings of individual animals taken directly from life that exemplify the Renaissance artist's intensifying quest for accuracy and realism.[9] The tense, nervous hunting dogs in the foreground of his largest engraving, *The Vision of Saint Eustace* (fig. 4), were realized so persuasively that they served as an important source for subsequent artists who reused them for their own compositions.[10]

Not all depictions of dogs in the Renaissance were lifelike or the result of firsthand observation, however, because many artists viewed animals as merely a vehicle for conveying a bewildering variety of complex and often contradictory symbols. Just as often as dogs were shown in Italian paintings as the companion of the young Tobias, protecting the youth as he wandered far and wide in search of the fish that would cure the blindness of his father, Tobit, they also carried the ancient burden of pariah, or

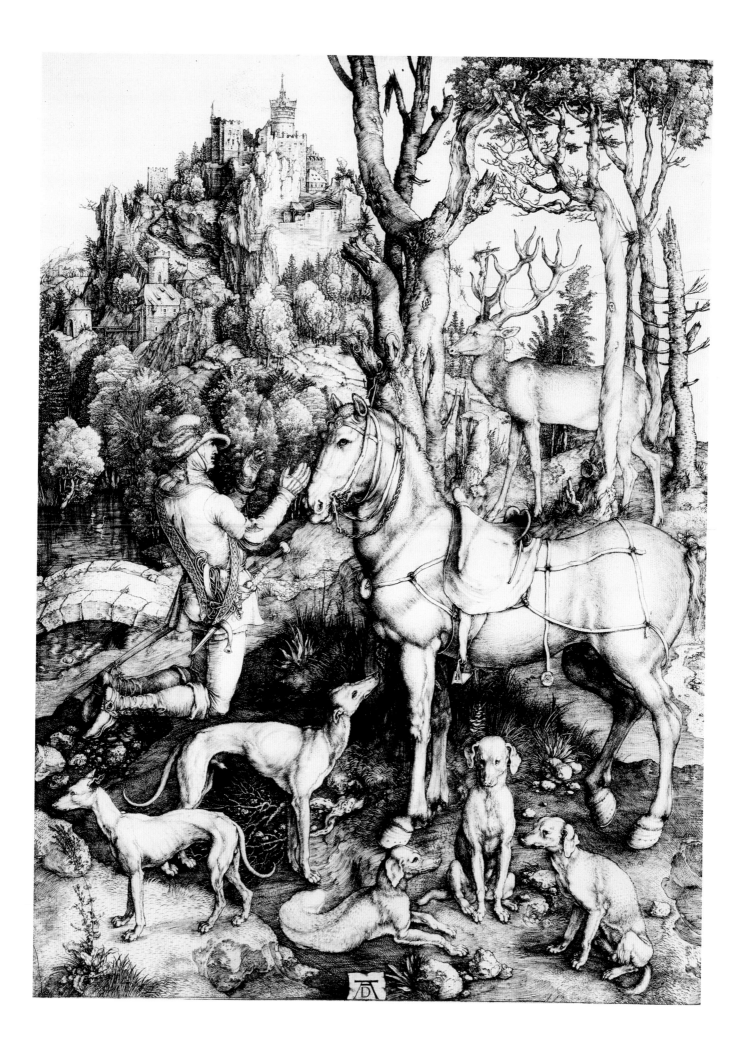

scavenger, dogs, associated in the Old Testament with evil and unclean things, and in the New Testament with Christ's persecutors. The dog was the faithful attribute of Saints Dominic, Margaret of Cortona, and Roch, as well as of the hunters Diana, Adonis, and Cephalus, but it was also a symbol of sexuality and promiscuity.[11] Yet church fathers, scholars, poets, and humanists were symbolized and accompanied by dogs. In Dürer's engraving of *Saint Jerome in His Study* (1514; Bartsch 60), the saint works on his letters or translations, while his dog sleeps quietly nearby, a vivid symbol of the contemplative life.[12]

As early as the second half of the fifteenth century, dogs began to take on an independent existence in art. Their status as objects of favor and prestige among the European ruling families and their owners' desire for conspicuous display, particularly among the Italian ducal families in Mantua, Ferrara, and Florence, resulted in a demand for portraits of individual dogs. In an undated account sent to Galeazzo Maria Sforza, Duke of Milan, by Zanetto Bugato, one of the items to be paid for was "a portrait of the dog called Bareta." Francesco Bonsignori is said to have painted for Francesco Gonzaga, 4th Marquis of Mantua, a dog whose likeness was so convincing that one of his own dogs was said to have attacked the painting.[13]

Although dog portraiture per se did not become a widespread practice until the early eighteenth century, it is clear that Renaissance patrons did not consider their dogs as frivolous or inconsequential elements of their own portraits. Dogs, even today, are natural adjuncts of portraits, appearing as fashion accessories or indications of a sitter's tastes and interests. Even in the early Renaissance they appear to have been painted from life—surely the little griffon terrier in Jan van Eyck's *Giovanni Arnolfini and His Wife* (1434; National Gallery, London) is a family pet and stares boldly at the beholder, irrespective of his role as a traditional attribute of marital fidelity.[14]

A notable example of a vivid and lifelike dog appearing alongside its owner in Italian painting is the pair of elegant greyhounds accompanying *Sigismondo Pandolfo Malatesta Kneeling before Saint Sigismondo* in Piero della Francesca's fresco (fig. 5) in the Tempio Malatestiano, Rimini. Although bred principally for hunting, greyhounds were often kept as court pets in great luxury; this pair was a gift from Pier Francesco di Lorenzo de' Medici.[15] The white greyhound, lying with outstretched paws, waiting patiently on its master, is especially well rendered. Although these noble dogs have been widely interpreted as symbolic of some virtue like fidelity, they are equally convincing examples of the high value placed upon hunting dogs in the Renaissance and were probably more greatly appreciated by contemporary observers for Piero's detailed naturalism.[16] Fifteenth-century letters survive in which Italian princes express interest in obtaining fine hunting dogs or giving them as presents. Such dogs often wore costly collars—the dog collars of the Ferrarese court were made by the court goldsmith—and the 1468 inventory of Sigismondo's possessions shows that he owned a number of elaborate dog collars studded with silver.[17]

EDGAR PETERS BOWRON

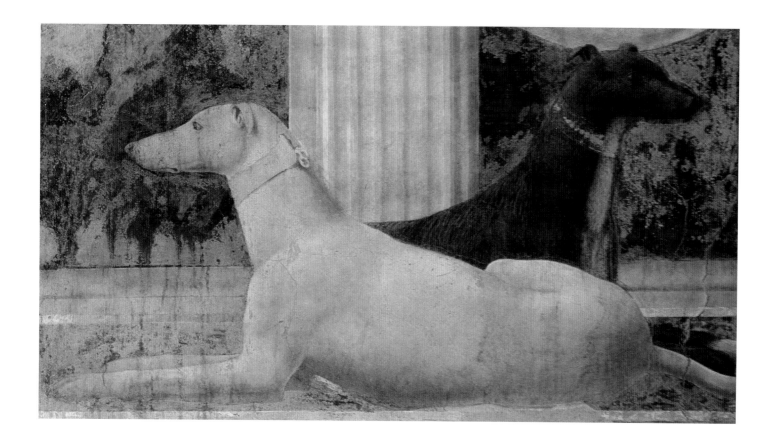

FIG. 5. Piero della Francesca (Italian, c. 1415–1492). *Sigismondo Pandolfo Malatesta Kneeling before Saint Sigismondo* (detail). 1451. Fresco remounted on canvas, 101⅜ x 139¾ in. (257 x 345 cm). Chapel of the Relics, Tempio Malatestiano, Rimini.

The affection that Ludovico II Gonzaga, Marquis of Mantua, had for his dog, Rubino, is confirmed not only through his letters and, following the animal's death, the erection of a tombstone complete with a sentimental Latin epitaph, but also by the inclusion of the creature itself–a russet-coated bloodhound-like dog–beneath his chair in Andrea Mantegna's celebrated fresco depicting Ludovico, his family, and court (1465–74; Camera degli Sposi, Palazzo Ducale, Mantua).[18] The adjacent fresco, which depicts two huge mastiffs and other hunting dogs, further attests to the passion for dogs at the Gonzaga court. Another notable representation of a dog in monumental wall painting in the Renaissance is the feathered saluki with a studded collar in the foreground of Pinturicchio's *Departure of Aeneas Silvius Piccolomini for Basel* (c. 1503–7; Cathedral Library, Siena). In this fresco the animal appears almost as conspicuous as the figure of the future Pope Pius II.

In the sixteenth century dogs adorned portraits in a variety of ways intended to reflect the character, strength, and nobility of their owners. Lucas Cranach's imposing pair of full-length portraits of Henry the Pious, Duke of Saxony, and his wife, Catherine of Mecklenburg (1514; Staatliche Kunstsammlungen, Gemäldegalerie, Dresden), illustrates the distinctions often made between dogs in royal portraiture: lapdogs represented as exclusively female companions, large hounds depicted as attributes of male virility. The size and prominence of the dog in Antonio Mor's *Cardinal Granvelle's Dwarf and Dog* (c. 1550; Musée du Louvre, Paris)–depicted with such vividness that he can only have been a living dog–suggests that the portrait of the animal interested the patron as much as that of the ornately dressed court dwarf.[19]

Increasingly during the sixteenth century dogs appear in portraits not as symbols, or objects of status or ownership, but merely because their masters considered them beloved companions. The Bolognese painter Bartolomeo Passarotti, who included dogs frequently in his late works, summarized explicitly the era's tender feelings toward dogs in *Portrait of a Man with a Dog* (c. 1585; Pinacoteca Capitolina, Rome), remarkable for the obvious display of affection between the pair.

Italian painters of the sixteenth century produced a succession of memorable canines that suggests how familiar and admired dogs had become during this period. For Kenneth Clark, the wordless sorrow of Piero di Cosimo's grieving dog in *A Satyr Mourning over a Nymph* (fig. 6), "the best-loved dog of the Renaissance," marked the beginning of a long tradition in Western art of investing animals with human characteristics.[20] Other notable depictions of dogs include the beautifully painted hounds in Parmigianino's frescoes of Diana and Actaeon (c. 1523–24; Camerino, Rocca Sanvitale, Fontanellato); Jacopo da Pontormo's dog, drawn from life with its back arched, stretching itself in the lunette fresco depicting Vertumnus and Pomona (1520–21; Gran Salone, Villa Medici, Poggio a Caiano); Dosso Dossi's white dog in the foreground of *Circe and Her Lovers in a Landscape* (c. 1511–12; National Gallery of Art, Washington, D.C.); and Federico Barocci's brown-and-white puppy appealing to the spectator at the extreme lower right of the *Madonna del Popolo* (1575–79; Galleria degli Uffizi, Florence).[21]

FIG. 6. Piero di Cosimo (Italian, 1462–1521). *A Satyr Mourning over a Nymph* (detail). c. 1510. Oil on wood, 25¾ x 72¼ in. (65.4 x 184.2 cm). National Gallery, London.

It is in the work of the Venetian painters Carpaccio, Titian, Bassano, and Veronese, however, that canine imagery flourished in a sustained fashion. One of the first Renaissance painters to employ scenes of everyday life in his work, Vittore Carpaccio gave particular prominence to dogs in two vastly different contexts: as a symbol of carnality or animal appetite at the feet of a seated courtesan (c. 1495; Museo Correr, Venice),[22] and as a symbol of the attributes of a scholar in the form of a fluffy white bichon in Saint Augustine's study (c. 1502; Scuola di San Giorgio degli Schiavoni, Venice).

With his preference for naturalistic form, Titian played an especially significant role in the promotion of the dog in the visual arts. In the portrait *Federico II Gonzaga, Duke of Mantua* (fig. 7), the gesture of the white Maltese-type dog pawing his master is especially appropriate, as the duke's love for his dogs was well known; in the spring of 1525 he owned no fewer than 111 dogs.[23] The keenly observed dogs in Titian's portraits appear as solid and real, as convincing and touching, as the human sitters—for example, *Charles V Standing with His Dog* (1533; Museo Nacional del Prado, Madrid); *Eleonora Gonzaga della Rovere, Duchess of Urbino* (c. 1537, Galleria degli Uffizi,

EDGAR PETERS BOWRON

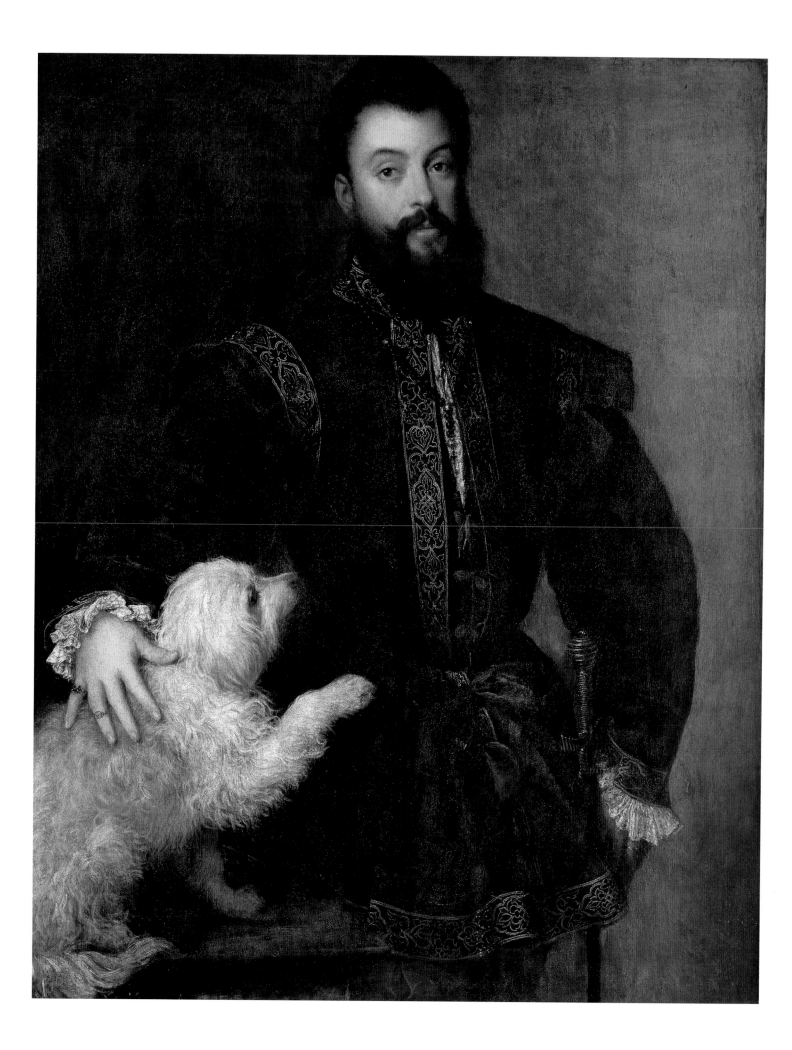

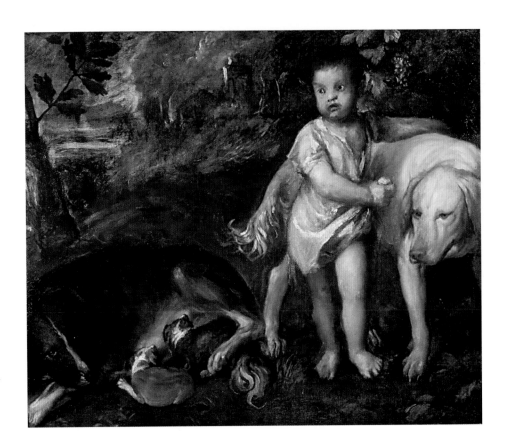

FIG. 8. Titian (Italian, c. 1488–90–1576). *Boy with Dogs*. c. 1570–76. Oil on canvas, 37¾ x 45¼ in. (96 x 115 cm). Museum Boijmans Van Beuningen, Rotterdam.

Florence); *Captain with a Cupid and a Dog* (c. 1550–52, Staatliche Kunstsammlungen, Gemäldegalerie, Kassel); and *Clarice Strozzi* (1562; Staatliche Museen, Gemäldegalerie, Berlin), in which the lifelike depiction of the small red-and-white spaniel was singled out by Pietro Aretino in a letter to the artist.

The toy dogs employed in Titian's *Venus of Urbino* (1538; Galleria degli Uffizi, Florence) and in his paintings devoted to the theme of Venus with an organist or lute player (c. 1548–49; Gemäldegalerie, Berlin), as well as in his second version of *Danaë* (1553–54; Museo del Prado, Madrid), have been interpreted as symbols of female seductiveness.[24] His hunting scenes with Venus and Adonis (1553–54; Museo del Prado, Madrid) naturally feature realistic portrayals of dogs, and they appear conspicuously in the foreground of the late *Flaying of Marsyas* (c. 1575; Archiepiscopal Palace, Kremsier). If Titian ever produced a painting with a dog as its principal subject, it has not survived; the near-exception is the enigmatic *Boy with Dogs* (fig. 8), which has been recently interpreted as an allegory of the complementary operations of nature and art: the contrast between the nursing mother's relationship to her pups and the boy's to his adult dog expresses the idea that nature brings forth, while art (or culture) trains and nurtures.[25]

Jacopo Bassano seems to have been naturally drawn to animals as his subjects, and he depicted a variety of dogs of different breeds in his historical, religious, and genre subjects over a period of forty years, beginning with the *Adoration of the Magi* (c. 1539; Burghley, Stamford, Lincolnshire), which includes a small spaniel at the Virgin's feet. He lent a naturalistic note to his compositions with motifs such as the dogs that sniff

at the sores on Lazarus's legs in the foreground of *Lazarus and the Rich Man* (c. 1554; Cleveland Museum of Art) and lick the blood of the wounded man in *The Good Samaritan* (c. 1557; National Gallery, London).[26] Around the middle of the sixteenth century Bassano produced a painting of two hunting dogs (fig. 9) that survives to mark the beginning of a tradition of commissioned "portraits," or at least likenesses, of actual dogs that reflects a new interest in and psychological understanding of animals.[27] This unusual work was commissioned in 1548 by Antonio Zentani, a patrician Venetian art collector who apparently wanted a painting of only these two dogs, suggesting to some that these animals were prized hunters from his own kennel and that their depiction was not expected to convey any symbolic or hidden meaning.

Noting Bassano's dedication to capturing the natural look of dogs, the art historian Roger Rearick emphasized his extraordinary excerption of "two perfectly straightforward canines from their familiar context" and the dedication of a painting to them and them alone.[28] More recently, however, it has been suggested, on the basis of the patron's spiritual inclinations, that the dogs tethered to a stump, in fact, convey "a severe, almost cheerless message" and represent a complex allegory of the combat between earthly and spiritual life.[29] Irrespective of the symbolic connotations or

FIG. 9. Jacopo Bassano (Italian, c. 1510–1592). *Two Hunting Dogs.* c. 1548–50. Oil on canvas, 24 x 31½ in. (61 x 80 cm). Musée du Louvre, Département des Peintures, Paris.

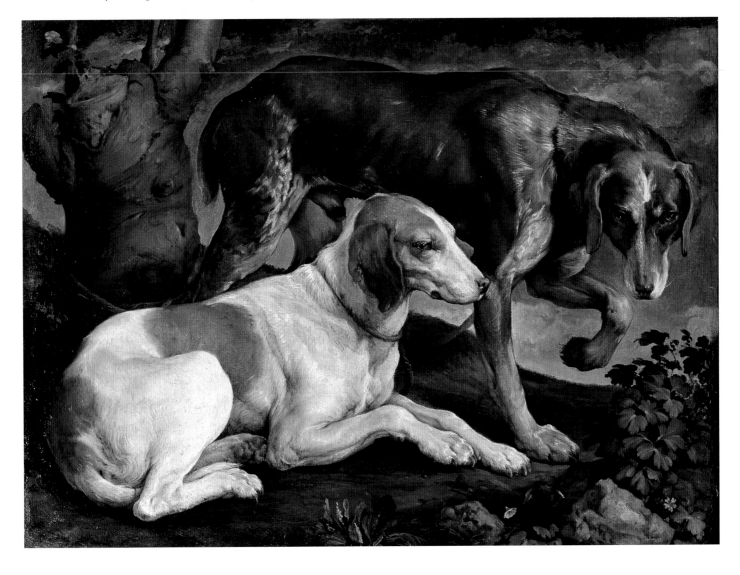

moralizing intentions of Bassano's composition, the animals are beautifully realized and remarkable for their truthful representation. The pose of the dog on the left appears to have caught the attention of Tintoretto, who inserted it nearly exactly into his painting *Christ Washing the Disciples' Feet* for the church of San Marcuola, Venice (c. 1548–49; Museo del Prado, Madrid). By the beginning of the seventeenth century, *Two Hunting Dogs* was thought to be a work by Veronese, and thereafter it passed as a painting by Titian through a number of celebrated collections, including those of Cardinal Silvio Valenti Gonzaga, William Beckford, and the Duke of Bedford; it was not until the middle of the twentieth century that its proper authorship was restored.[30] The naturalistic tenor of Bassano's art was given further expression in a similar painting of two dogs by themselves that he made shortly thereafter, *Two Hunting Dogs* (c. 1555; Galleria degli Uffizi, Florence), and, two decades later, in *A Greyhound* (c. 1571; private collection, Turin).[31]

Paolo Veronese, who has been called the "greatest dog-lover in Italian art," included dozens of dogs, from greyhounds to spaniels, in his religious scenes, mythological and allegorical works, and portraits.[32] Dogs abound in particular in his large paintings of biblical feasts executed for the refectories of monasteries in Venice and Verona. The *Feast in the House of Simon the Pharisee* (c. 1560; Galleria Sabauda, Turin), painted for the refectory of Saints Nazaro and Celso in Verona, Veronese's earliest extant supper scene, contains two dogs under the table that have elicited the admiration of observers from Giorgio Vasari ("so beautiful that they appear real and alive") to John Ruskin ("The essence of dog is there, the entire, magnificent, generic animal type, muscular and living").[33] In two versions of the *Supper at Emmaus* (c. 1560; Musée du Louvre, Paris, and Staatliche Kunstsammlungen, Gemäldegalerie Alte Meister, Dresden), he seems to have taken special pleasure in showing children and dogs playing together. And in the vast *Marriage at Cana* (fig. 10) for the refectory of San Giorgio Maggiore, Venice, the most ambitious of Veronese's banquet scenes, a pair of magnificent white hounds immediately draws the spectator's attention to the center of the composition.

In the interior of the Villa Barbaro at Maser, where Veronese executed a rich and iconographically complex decorative fresco program about 1561, one of the rooms is traditionally called the Stanza del Cane, after a beautifully rendered little dog occupying a ledge high above the visitor. Veronese's dogs are painted with such loving attention that they must reflect his own feeling toward animals—a feeling that perhaps is mirrored in the motif of Diana nuzzling one of her greyhounds in the clouds of the Sala di Olimpo.[34] The abundance and variety of dogs in Veronese's art make it difficult to attribute specific symbolism to them—they are too numerous and appear in too many diverse settings. Veronese is said to have produced formal "portraits" of individual dogs, including his own,[35] but his only extant painting in which dogs vie with the human figure for prominence is *Cupid with Two Dogs* (c. 1580–83; Alte Pinakothek, Munich). This painting shows a winged Cupid wearing a golden quiver

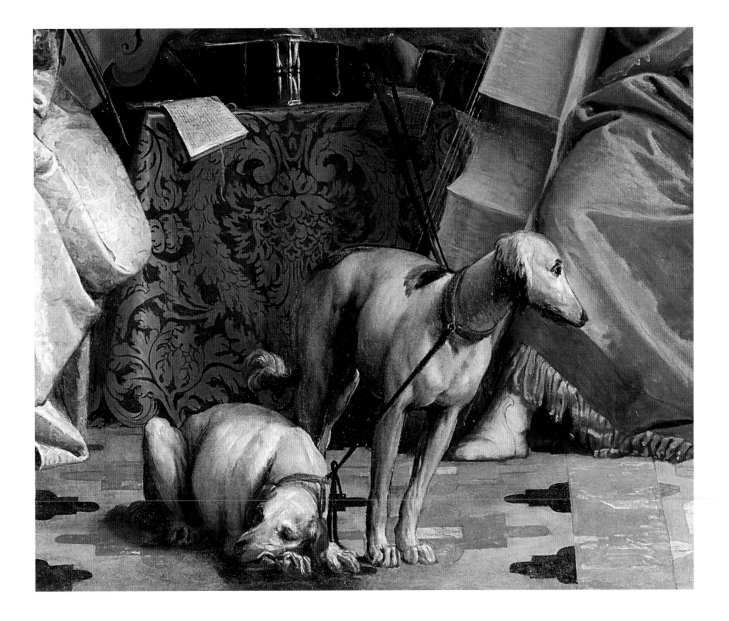

FIG. 10. Paolo Veronese (Italian, 1528–1588). *Marriage at Cana* (detail). 1562–63. Oil on canvas, 266½ x 391⅜ in. (677 x 994 cm). Musée du Louvre, Paris.

and holding two black-and-white hunting dogs on a chain, a composition that has been interpreted variously as an allegory of the contrariness of love, faithfulness in love, and the restraint of the animal appetite for love.[36]

Dogs are the subject of a few Renaissance sculptures, the finest of which is Benvenuto Cellini's bronze relief of a saluki (fig. 11) commissioned by Cosimo I de' Medici, Grand Duke of Tuscany, and completed by August 25, 1545.[37] Originally the hunting companions of nomadic Bedouin tribesmen, salukis were popular among the Italian aristocracy in the fifteenth and sixteenth centuries for coursing game. For several reasons, this subtle bronze relief (in which Cellini seems to have emulated ancient animal gems, the source of the "classic" dog-portrait pose that shows the animal standing in profile with all four paws on the ground) occupies a critical role in the development of canine imagery in the Renaissance: a dog is featured by itself as the subject of a work of art; the popularity of salukis, or *levrieri turchi* as they were called, at the Medici court is revealed; and the sculpture is the result of a specific request from a distinguished patron for a depiction of a favored dog. Cellini's modeling of the animal

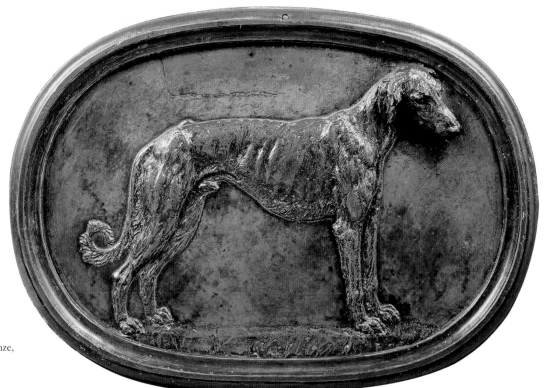

reveals a careful study of canine anatomy that for historians of the breed confirms the consistency with which the saluki has been bred to type over the centuries.[38]

The demand from Italian patrician families for likenesses of their dogs increased in the seventeenth century, especially in Florence, where the Medici proudly included them in their portraits. Their court painter, Justus Sustermans, not only represented such vivid examples as the large Dalmatian-type standing beside an eight-year-old boy in *Francesco de Medici* (1622; Galleria degli Uffizi, Florence), one of his celebrated portraits of the family, but he also painted the dogs by themselves in what could be considered formal portraits, for instance, a pair of King Charles–type spaniels in the Uffizi.[39] In a group of hounds (private collection, Paris) portrayed by Sustermans with a remarkable sense of realism, two salukis wear collars bearing the coat of arms of the Medici grand dukes, underscoring the importance of the dog-loving Florentine court in the development of such painting as an independent category of art.[40]

The passion for dogs on the part of the grand-ducal family is further revealed by an amusing document in the Archivio di Stato, Florence, showing that a Medici agent, Annibale III Ranuzzi, Count of Porretta, was charged in 1668 with buying works of art in Bologna; he was specifically requested to purchase several little *cani Bolognese* for Cosimo de' Medici if they could be obtained at an advantageous price.[41] The so-called Bolognese was a toy breed of Mediterranean ancestry related to the Maltese, bichon frise, and Havanese, of the kind known as a "comforter," or lady's lapdog.[42] The type sought by the Medici was raised in Bologna by breeders who deliberately stunted their growth by rubbing them with *spirito di vino* at birth. The future grand duke was quite specific in his instructions to the agent regarding the size (tiny, almost to the point

EDGAR PETERS BOWRON

of deformation), color (preferably black and white), and age (older than a year and a half, younger than four) of the dogs he desired, which he intended to give as presents to the *"bellissime Dame di Bruxelles."*

Underscoring the importance of the lapdog at the Medici court is a painting traditionally attributed to Tiberio di Tito (fig. 12), which shows a Medici dwarf, perhaps a kennel-man or breeder, surrounded by a number of pampered and coiffed toy spaniels adorned with bows, jeweled collars, earrings, and rosettes before the amphitheater in the Boboli Gardens.[43] The care of these small companion dogs was entrusted to dwarfs who combed and adorned them. Here the dwarf holds the lead of a much larger dog that seems resigned to the presence of the pugs and spaniels around him. Small dogs of these types are present in numerous official Medici portraits, for example, appearing beside their owners in Sustermans's portraits *Maria Maddalena d'Austria*, c. 1620; *Leopoldo de'Medici*, 1622; *Vittoria della Rovere*, 1624; and *Eleonora Gonzaga*, c. 1621 (all in the Galleria degli Uffizi, Florence). Since the later Middle Ages, the essential requirement of such pets was that they be quite small: "The smaller they be," wrote Abraham Fleming in 1576, "the more pleasure they provoke, as more meet playfellows for mincing mistresses to bear in their bosoms, to keep company withal in their chambers, to succor with sleep in bed, and nourish with meat at board, to lay in their laps and lick their lips as they ride in wagons."[44]

Depictions of dogs in seventeenth-century Italy were often intended to convey emblematic or symbolic associations; for example, four greyhounds belonging to

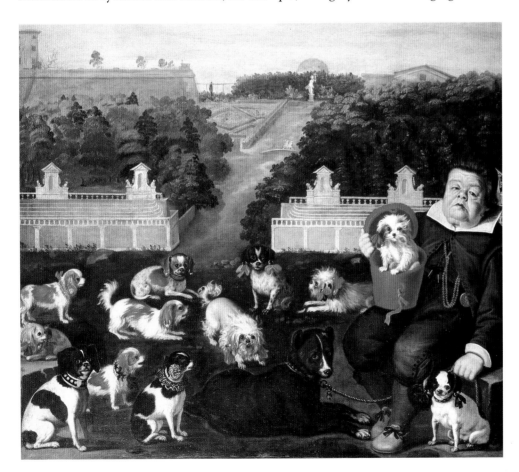

FIG. 12. Tiberio di Tito (Italian, 1573–1627). *A Dwarf with Medici Dogs in Boboli Gardens.* 1620–25. Oil on canvas, 52 x 60⅝ in. (132 x 154 cm). Private collection, England.

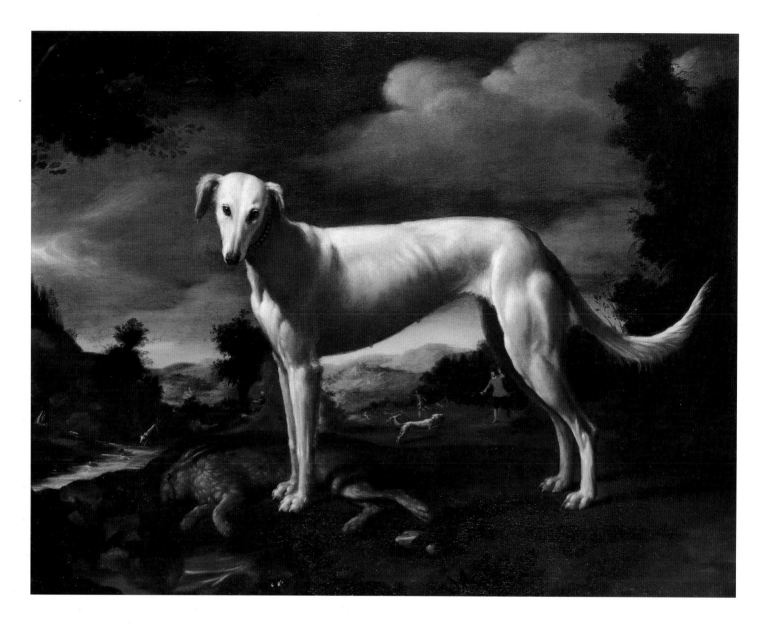

the Chigi family, set in frescoed landscapes at Palazzo Chigi in Ariccia by Michele Pace del Campidoglio in 1665, represent the family's feudal domains.[45] But sufficient examples survive to confirm that straightforward portraits of dogs were also in demand. A brilliant example is a portrait recently attributed to the Florentine painter Baccio del Bianco (fig. 13) of a greyhound bitch standing over a dead rabbit in the classic foursquare portrait pose, parallel to the picture plane, head turned toward the viewer—no doubt a faithful likeness of a beloved hunting dog. The pureness of line and the animal's white coat vividly establish her presence against the dark landscape.[46]

Although better known as a painter of still lifes of fruit, flowers, mushrooms, and fish, Simone del Tintore occasionally turned his powers of naturalistic representation to the depiction of living and dead animals. A sharply observed record of four greyhounds, yoked in pairs and just setting off for, or returning from, the chase (fig. 14), is remarkable for the physical solidity of the animals, bold effects of light and shade, and rich textural effects.[47] The simple scene is invested with real dramatic

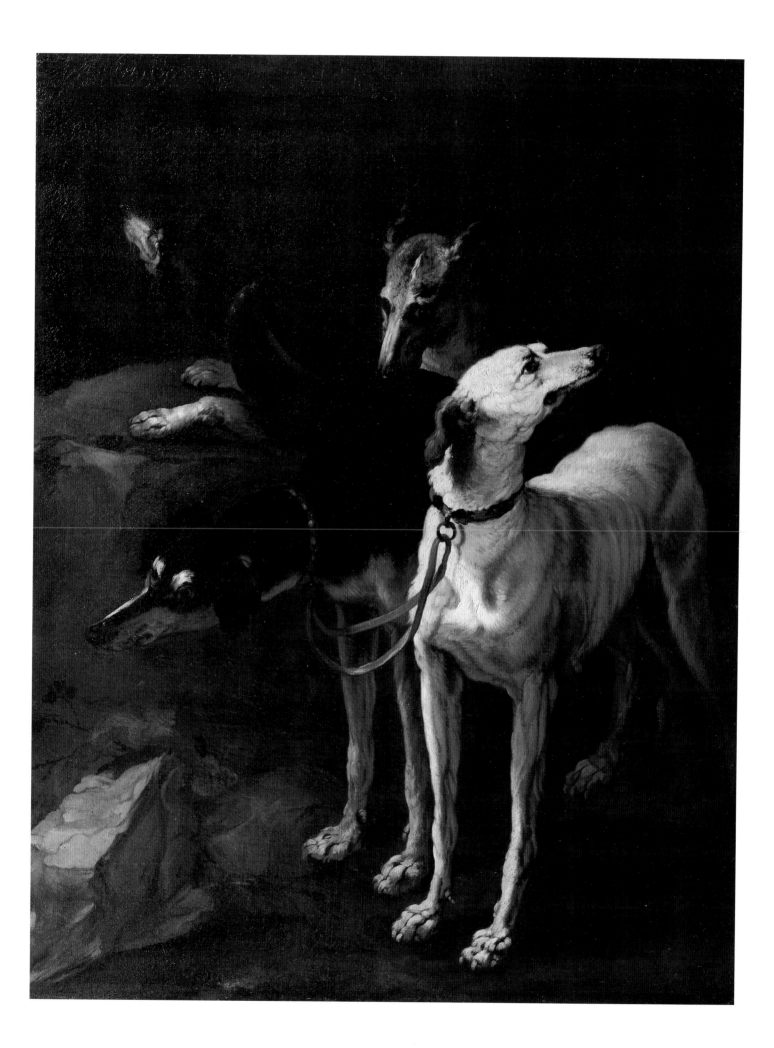

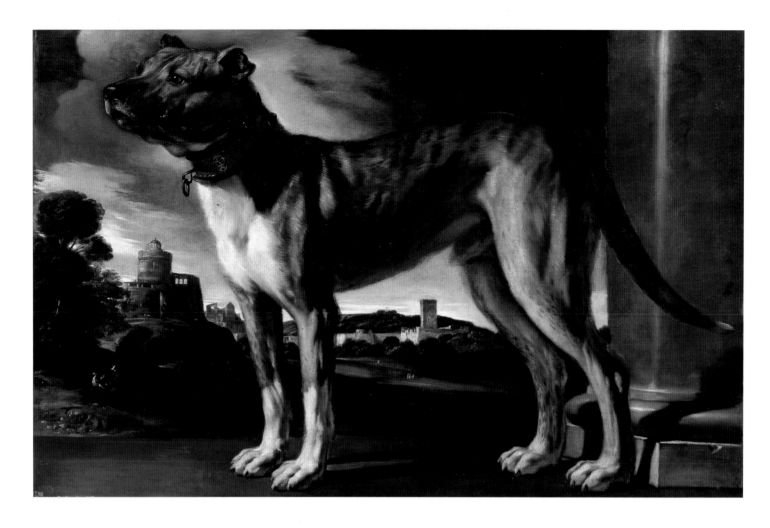

FIG. 15. Giovanni Francesco Barbieri, called Guercino (Italian, 1591–1666). *A Dog Belonging to the Aldovrandi Family.* c. 1625. Oil on canvas, 44 x 68¼ in. (111.8 x 173.4 cm). The Norton Simon Foundation, Pasadena.

power and clarity, and the white greyhound in particular stands out, illuminated in a brilliant light as if from a spotlight above. The dogs are presented with great sympathy and almost certainly painted from life. Tintore employed the group as a *modello* for a *Rest after the Hunt* (1688; private collection), a realistic genre scene with a pile of dead game in which the four dogs appear verbatim at the right of the composition.[48] The white greyhound appears again in the painting *Diogenes with His Dog* (Stanley Moss & Company, Riverdale, New York) from approximately the same period.

Perhaps the best-known portrait of a dog from the seventeenth century is Guercino's great mastiff (fig. 15), a prized possession of the artist's friend and patron, Count Filippo Aldovrandi, whose coat of arms is painted on the dog's collar.[49] The distant landscape view behind the dog may represent the Aldovrandi Castle in Bologna, where the painting was presumably hung high in a large room or salon so that the animal would appear to tower over the viewer, his presence emphasized by the low horizon, his massive head silhouetted against the clouds.

Not surprisingly, the Aldovrandi dog was believed until the mid-twentieth century to be a work by Titian, so long was the shadow cast by the great Venetian on painters in Italy, Spain, and the Netherlands in the seventeenth century. Velásquez made careful note of the older painter's precedent of featuring dogs prominently beside their

masters, and he was remarkably alert to the character and expression of the hunting dogs that seem to have been an obligatory element of his Spanish sitters' assertions of power. Those that accompany the sitters in *Cardinal Infante Don Ferdinando*, c. 1632–33; *King Philip IV*, c. 1632–35; and *Prince Balthasar Carlos*, 1635–36 (all in the Museo del Prado, Madrid) are painted with remarkable veracity and skill. The little white spaniel seen in *Infante Felipe Próspero* (1659; Kunsthistorisches Museum, Gemäldegalerie, Vienna) epitomizes the close, warm-hearted relationship that can exist between an animal and a child, and was celebrated for its lifelike qualities by Antonio Palomino in his book about the life of the artist.[50] The much-discussed Spanish mastiff that reclines before the dwarfs in *Las Meninas* (1656–57; Museo Nacional del Prado, Madrid), which Kenneth Clark considered the greatest dog in art, says everything about the esteem in which dogs were held at the Spanish court at the time.[51]

The Flemish painter Anthony van Dyck also produced a memorable series of dogs in his portraits, elevating the status of the animals to a prominence often equal to that of their owners. Even the matter-of-fact inclusion of a dog as a standard symbol of marital fidelity in a portrait of a woman (c. 1620; Lord Romsey, Broadlands, Hampshire), from the painter's first Antwerp period, reveals his aptitude for animal painting, conveying the mischievous character of the creature peering around its mistress's voluminous skirt. Dogs appear more frequently in the portraits of the artist's second Antwerp period, notably in *Philippe Le Roy* (1631; Wallace Collection, London), in which the large affectionate hound deliberately invokes the example of Titian; the painting provides an amusing contrast to the suspicious lapdog at the feet of Le Roy's wife, Marie de Raet, in the pendant full-length portrait, echoing a stratagem employed a century earlier by Lucas Cranach.

But it was in England that van Dyck's outstanding ability as a painter of dogs is most strikingly demonstrated, especially in his portraits of the three eldest children of Charles I. In one of these works (1635; The Royal Collection, London) the two King Charles spaniels, painted with remarkable fluency, have been praised recently as "arguably the finest dogs in the history of British painting."[52] Van Dyck's most memorable depiction of a dog, however, is the magnificent greyhound in the full-length painting of the king's ardent supporter and relation, *James Stuart, 4th Duke of Lennox and 1st Duke of Richmond* (fig. 16), who gazes adoringly at his master. Although the dog has been thought to serve as both an attribute of nobility and the sitter's support for the monarch, his prominence in the composition, as well as the display of obvious affection between hound and master, was probably due to the insistence of the duke, whose life was supposedly saved by the dog during a boar hunt on the Continent.[53]

The dog prospered in art throughout northern Europe in the seventeenth century as the taste for naturalism and accurate and detailed observation became more prevalent. Jan Breugel the Elder, whose oeuvre comprises a remarkable repertory

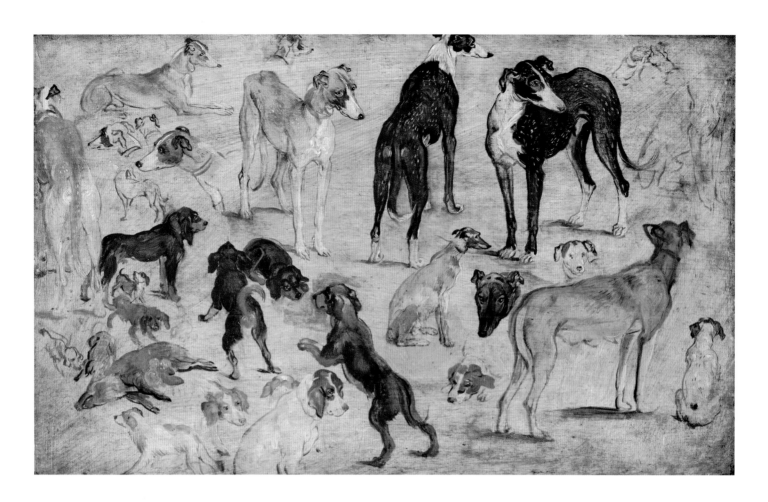

of still lifes, landscapes, and allegorical and mythological scenes, was a versatile and gifted painter of dogs. He represented a variety of hunting dogs, notably in mythological scenes such as his collaboration around 1620 with Peter Paul Rubens, *Diana's Departure for the Hunt* and *Sleeping Nymphs with Satyrs* (1621; Musée de la Chasse et de la Nature, Paris).[54] Each of these cabinet-size paintings includes more than two dozen different dogs, shown in characteristic poses, standing, lying, and sleeping. The range of types and Breugel's sensitive characterization of each have been explained by his familiarity with the hunting dogs of his patron, Albert, Archduke of Austria, ruler of the Netherlands, at the court in Antwerp. A small oil sketch of about 1616 in Vienna (fig. 17) is typical of the kind of notations Breugel made from observing actual dogs, a few of which he used directly for the pack of hounds in the mythological paintings for Archduchess Isabella in Paris, suggesting that he probably depended on several such studies in the course of working out the details of a particular composition.[55]

Frans Snyders, the Flemish painter of animals, hunting scenes, and still lifes, developed a new genre of dog painting that focused on the animal alone, without the presence of humans. Images of dogs fighting over a bone had appeared in the marginalia of medieval manuscripts, but Snyders, the finest animal painter of his day, was the first to treat the subject as an independent theme. As one observer of Snyders's work, Susan Koslow, has noted, the artist frequently employed an innovative close-up

EDGAR PETERS BOWRON

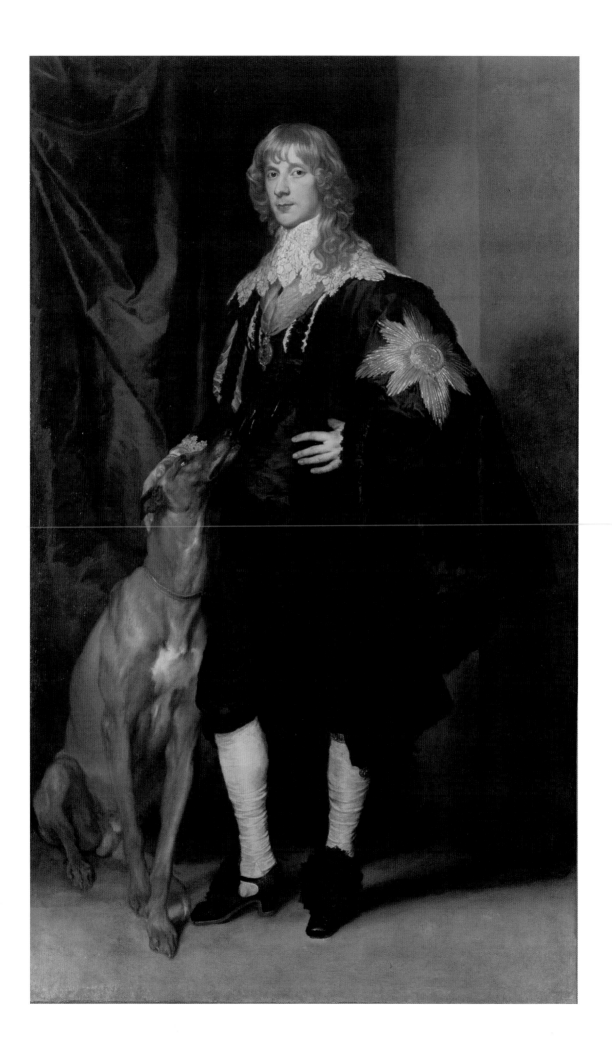

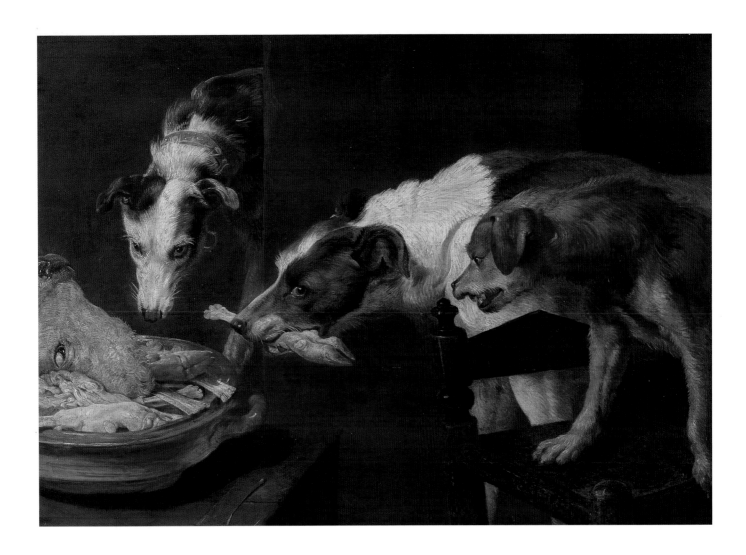

FIG. 18. Frans Snyders (Flemish, 1579–1657). *Three Dogs in a Kitchen with Bones.* Early 1630s. Oil on wood, 29½ x 42⅛ in. (75 x 107 cm). Musée d'Art Ancien, Musées Royaux des Beaux Arts de Belgique, Brussels.

view in his compositions (fig. 18), often going so far as to show only an animal's head, chest, and paws, and in some instances the head alone.[56] The esteem bestowed on Snyders's dog paintings at the time is confirmed by *Two Dogs and a Cat in a Kitchen* (fig. 19), painted in the 1630s for the legendary Spanish collector, Diego Mexía, Marqués de Leganés, when he resided in Brussels. In 1636 Leganés gave the picture to Philip IV of Spain, who had it installed in his private supper room, the antechamber to his bedroom in the summer apartments in the Alcazar palace, together with three additional pictures by Snyders that Leganés presented to the king at the same time.

The Prado painting shows a powerful stray mongrel that has gained entry to a larder and seized a joint of meat, overturning a basket of fruit and shattering a Chinese porcelain plate. Dominating the composition, the snarling dog aggressively defends his prize against a spaniel—presumably a resident of the household because it wears a collar—that has crept forward on its belly to seize a chain of sausages. Koslow defines Snyders's intention as the depiction of "barbarous conduct unrestrained by reason, manners, or education, propelled by a naked desire that mindlessly destroys the inventions and products of civilized life."[57] Although it is not known with certainty how seventeenth-century viewers regarded such paintings, it is thought that they may have called to mind amusing, anecdotal, or moralizing proverbial sayings.

EDGAR PETERS BOWRON

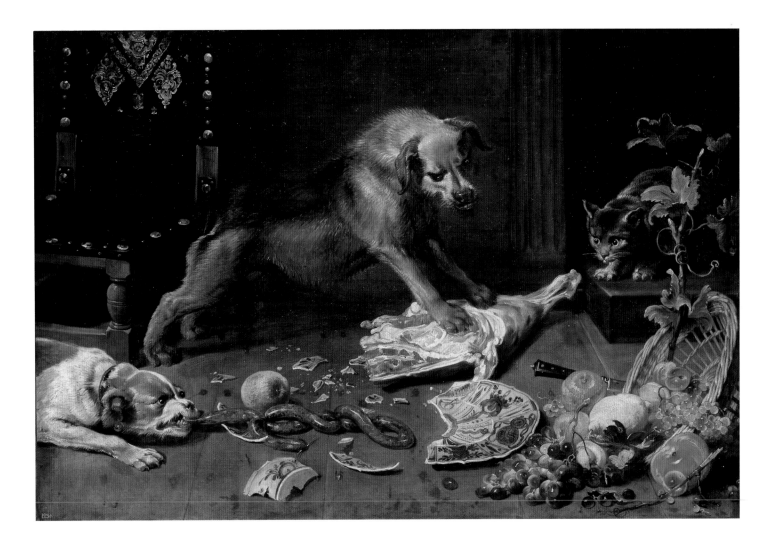

FIG. 19. Frans Snyders (Flemish, 1579–1657). *Two Dogs and a Cat in a Kitchen.* c. 1630–35. Oil on canvas, 39 x 57¼ in. (99 x 145 cm). Museo Nacional del Prado, Madrid.

Koslow cites proverbs on the themes of greed and opportunism ("As greedy as a dog"; "A dog will endure no companions in the kitchen"; "While a dog gnaws a bone, he hates his fellow") and the ruinous results of carelessness and lack of vigilance as possible emblematic sources for Snyders's dog pictures.[58]

Snyders's role in the history of dog painting is tremendous. He anticipated the nineteenth-century habit of investing animals with human characteristics in paintings such as *The Fable of the Dog and Its Reflection* (fig. 20).[59] Among the artist's representations of Aesop's animal fables, in the form of easel paintings that were installed in the Buen Retiro, the king's pleasure palace in suburban Madrid, is the story of a dog with a piece of meat in his mouth crossing a bridge over a stream. When the dog sees his reflection in the water and takes it for that of another dog with a piece of meat double his own in size, he immediately lets go of his meat and attacks the other dog to get his larger piece. When he opens his mouth, the meat falls into the stream. Snyders thus uses the dog to illustrate the moral "Beware lest you lose the substance by grasping at the shadow."

It is perhaps the theme of the hunt that offered Snyders the greatest opportunity for expressing his gifts as an animal painter. Peter Paul Rubens, a gifted painter of animals, whose dog in *Raising of the Cross* (1610–11; Cathedral, Antwerp) was admired

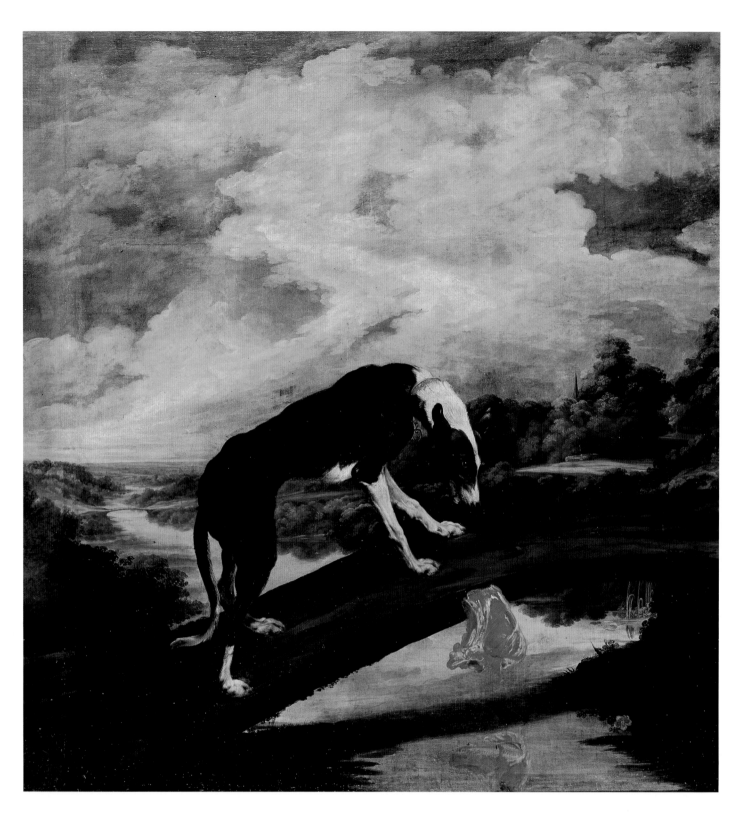

FIG. 20. Frans Snyders (Flemish,
1579–1657). *The Fable of the Dog and Its
Reflection.* c. 1636–38. Oil on canvas,
81½ x 82¼ in. (207 x 209 cm). Museo
Nacional del Prado, Madrid.

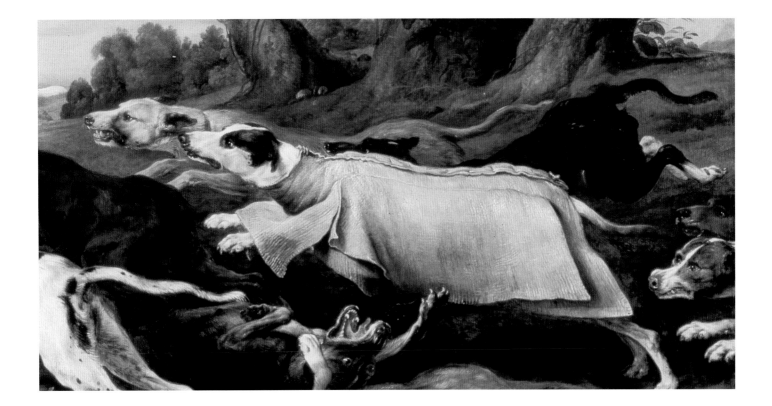

FIG. 21. Frans Snyders (Flemish, 1579–1657). *Boar Hunt* (detail). 1625–30. Oil on canvas, 86⅞ x 198⅞ in. (220.6 x 505 cm). Museum of Fine Arts, Boston.

by Sir Joshua Reynolds during his visit to the Netherlands in 1781, is generally considered responsible for reviving the popularity of hunting scenes.[60] Snyders exploited the genre as a means of expressing the feelings and passions of animals, especially the aggression of ravening hounds attacking their prey. He painted a number of large-scale hunting scenes with dogs bringing down prey, without human intervention, none more remarkable than an enormous friezelike composition in Boston (fig. 21) depicting more than a dozen dogs that is a virtual catalogue of hunting practices of the day.[61] Snyders's hunts epitomize the animal savagery that his aristocratic patrons seem to have found essential in such themes and allowed him to express the qualities of vigorous movement and emotional intensity associated with Baroque art. Arnold Houbraken, the Dutch painter and writer on art, might well have had the Boston *Boar Hunt* in mind when he praised Snyders's ability to "paint animals at their highest pitch and passion": "We seem to hear the hunting hounds whistling by, as we watch them run down the quarry. When they seize it with their sharp teeth, fire gleams from their eyes; the pain of a wounded dog is represented so naturally by an arched back, straining muscles and a distended muzzle that we pity it."[62]

The most gifted Netherlandish painters of dogs influenced by Snyders included his brother-in-law, Paul de Vos (fig. 22), and Jan Fyt, both of whom represented dogs in scenes of fighting animals, fables, still lifes, and the hunt. Fyt's drawings include studies of dogs and hunting scenes, and in 1642 he produced a popular set of large etchings of dogs in landscape settings dedicated to a Spanish patron, Don Carlo Guasco, Marqués de Solerio, a counselor to Philip IV. Fyt's ability to individualize the types, forms, attitudes, and expressions of animals, combined with his painterly

insistence on texture and detail, explains why he was one of the most prosperous artists in Antwerp and why his work was in demand from the important collectors and patrons of the period. Dogs play an essential part in Fyt's game pictures, and he often showed them resting beside elaborate still lifes of dead game, as in *Hounds Guarding the Kill* (1659; Liechtenstein Collection, Vienna). Fyt's realistic and accurate depictions of hunting dogs were important precedents for his pupil Pieter Boel, for French eighteenth-century specialists such as Alexandre-François Desportes (fig. 23) and Jean-Baptiste Oudry, and for dog painting generally in France, Germany, and the Netherlands in the nineteenth century.

Dogs prevail in seventeenth-century Dutch painting and are commonplace in scenes of the rustic houses of the poor, fashionable middle-class domestic interiors, taverns, brothels, and churches. Toy spaniels are frequently represented in Dutch genre scenes because, particularly after midcentury, the dogs had become integral members of many Dutch families, no longer the prized pets of the very wealthy but the companions of even the lower classes and the poor. The naturalism of seventeenth-century Dutch painting demanded the presence of dogs in a variety of interior and exterior settings, and the contemporary viewer would have expected to

FIG. 22. Paul de Vos (Flemish, 1596–1678). *Partridges Discovered by Three Spaniels.* c. 1650. Oil on canvas, 667/8 x 921/8 in. (170 x 234 cm). Koninklijk Museum voor Schone Kunsten, Antwerp.

EDGAR PETERS BOWRON

see animals as a matter-of-fact element of the scene, probably giving little thought to their allegorical or symbolic content. The appearance of nearly identical dogs in the compositions of Gabriel Metsu, Gerard ter Borch, Jan Steen, and Pieter de Hooch suggests that these animals were regular inhabitants of the painters' studios and probably family pets.[63]

But if dogs were a natural element in depictions of everyday contemporary Dutch life, they were also used by artists to complement the meaning of their paintings. As in the Renaissance, dogs continued to play a significant role in bringing to life narratives from sacred or secular literature and, in painting, bore the burden of conveying a bewildering variety of emblematic and proverbial associations. Emblem books were in great vogue in seventeenth-century Holland, and dogs often transmitted deeper meanings than their matter-of-fact activities of eating, sleeping, copulating, and defecating may suggest at first glance.

A case in point is Gerard ter Borch's *A Boy Caring for His Dog* (fig. 24), in which a young boy attentively searches for fleas on his brown-and-white spaniel, which lies contentedly in his lap, his eyes raised plaintively toward the beholder. But even in this sympathetic and seemingly straightforward scene of everyday life, the subject has a moralizing message concealed beneath the surface. As Arthur Wheelock has suggested, the boy cares for his dog in much the same way that a mother cares for her child, and this care is probably intended to reinforce the importance of cleanliness, careful grooming, and nurturing—virtues often stressed in Dutch family life.[64] Thus

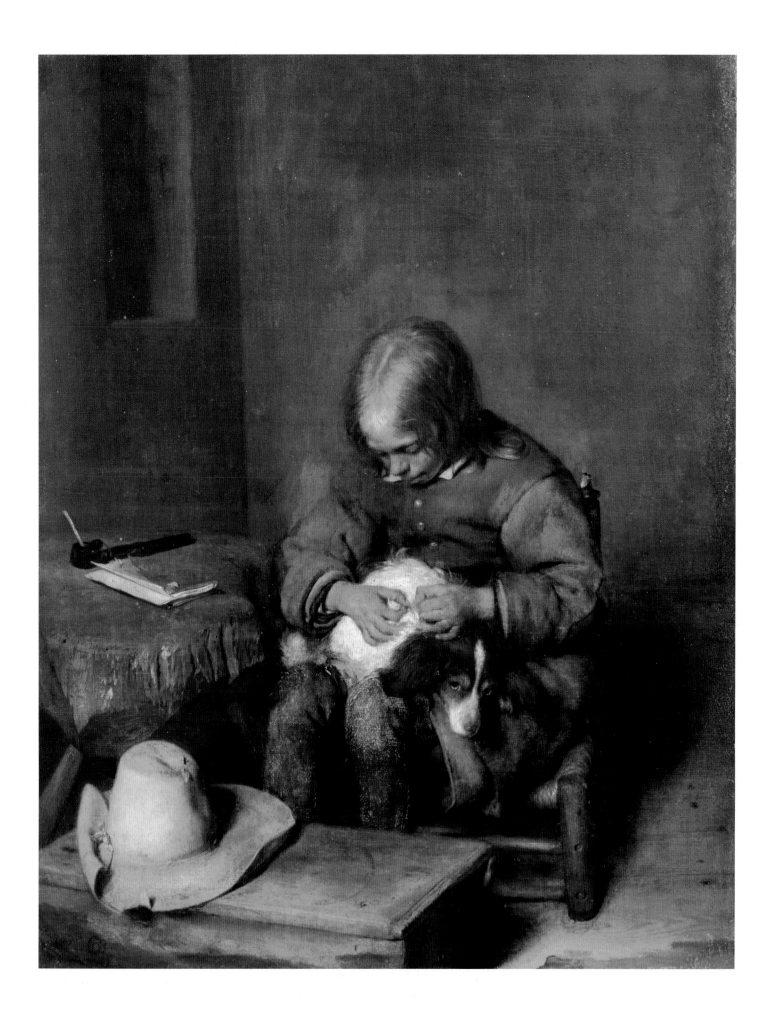

the dog in Dutch art has been described as a "multivalent beast" for its role in intimating various pictorial meanings.[65]

Dogs in Dutch paintings are frequently depicted for reasons that may escape the notice of the modern viewer. Karel van Mander, in his 1604 handbook on allegorical personification (*Uytbeeldinghe der Figueren*), spelled out a common and age-old interpretation: "By the dog one indicates fidelity; for the dog is most faithful and never forgets a kindness shown him."[66] But dogs were also seen as lascivious creatures and fulfilled an erotic function in literature and the visual arts. The dog lying faithfully next to its mistress, with a heart pendant dangling from its collar, immediately signals associations with love, as, for example, in Jan Steen's *The Doctor's Visit* (c. 1661–62; Wellington Museum, Apsley House, London). Dogs also symbolized women's lovers and were among the pets traditionally kept by courtesans.[67] In this sense they could indicate lust or animal passion, although never more explictly than in Frans van Meiris's *Inn Scene* (1658; Mauritshuis, The Hague), in which the coupling dogs underscore the erotic overtones of the painting. The dancing dog, a relatively common pictorial motif, as seen, for example, in *The Little Dog* by Frans van Meiris (c. 1660; State Hermitage Museum, Saint Petersburg), may also have been intended to convey a moral message and hold amorous implications, standing in it for its mistress's absent lover.[68] On the other hand, dogs were cited as models of obedience and functioned as metaphors for teachability, and so the dancing dog, like the dog sitting up on command in Ludolf de Jongh's *Boy Training His Dog* (1661; Virginia Museum of Fine Arts, Richmond), is thought to represent the desire and ability to learn and served as a metaphor for effective child-rearing.[69]

Dogs often appear in scenes of Dutch church interiors (although warders in real churches were presumably required to send them away), thus adding a note of both plausibility and ordinary earthiness to the picture. Even a dog engaged in the prosaic activity of having a bowel movement–Rembrandt's unassuming dog squatting in the foreground of the *Good Samaritan* etching (1633; Bartsch 90), for example, or Emanuel de Witte's *Interior of the Oude Kerk, Delft* (1651; Wallace Collection, London)–conveyed more than a note of amusing, if vulgar, realism. Rembrandt, who delighted in representing dogs in a variety of contexts and seems to have genuinely enjoyed the canine world, may have intended his "disreputable" dog to serve as metaphor for the impure, physical human self in need of spiritual redemption.[70]

Thus the problem of interpreting the meaning of individual dogs that appear in Dutch and Flemish seventeenth-century art is not easily solved. Dogs are commonplace animals that were a part of everyday life in the Netherlands for several centuries, but their appearance in the emblem books of the sixteenth century and later has created vexing problems of interpretation. Jan Baptist Weenix's scene (fig. 25) of a powerful hound guarding his meal–the heart and lung of an ox–from a cat in the upper right corner is a case in point. Weenix was a fine animal painter who made careful studies from life in preparation for his painted compositions.[71] Although

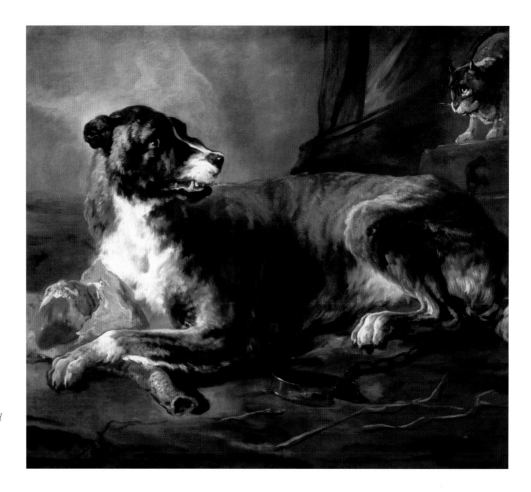

undated, the painting is signed with the Italian version of his given name, *Gio[vanni] Batt[ist]a Weenix*, the form he preferred to use in signing his work after he returned from Italy in 1647. The work must have been done a few years later and shows the broad, fluid handling of his game pieces painted after the middle of the century, such as *Still Life with a Dead Swan* (c. 1651; Detroit Institute of Arts). The precise subject of the painting is unclear, although it presumably refers to the sort of proverbial and emblematic literature that informed Snyders's paintings, perhaps illustrating the saying "These things agree not together . . . dogs and cats in a kitchen."[72]

Formal portraits of dogs were commissioned in seventeenth-century Holland and Flanders, although they remain as scarce today as those from earlier centuries. Abraham Bloemaert is recorded as having painted in the 1620s a portrait of Babler, the favorite of the Winter Queen Elizabeth Stuart, sister of Charles I, a woman inordinately fond of dogs who was described by a contemporary as preferring "the sight of her monkeys and dogs to that of her children."[73] Justus Lipsius, the celebrated Antwerp scholar of classical literature, history, and antiquities, whose affection for his three dogs, Mopsus, Mopsulus, and Saphyrus, was well known to his contemporaries, had his dogs painted, some of them several times, and added to these portraits his own laudatory Latin epigrams.[74] Autonomous scenes of dogs were more common in prints than in paintings, but enough examples survive to suggest the existence of an independent category of painting intended to highlight the specific features and innate

EDGAR PETERS BOWRON

character of individual (mostly hunting) dogs.[75] These include a greyhound and a *"spioen"* attributed to Weenix (c. 1650; Rijksmuseum, Amsterdam), and a pair of dogs in a landscape (1670s; Kennel Club, London) attributed to David de Coninck.

It is not at all surprising that the greatest Dutch painter of animals, Paulus Potter, best known for his scenes of cattle and sheep in sunlit meadows, produced several vivid and realistic characterizations of dogs. Potter's first paintings of dogs were hunting scenes–*Boar Hunt* (1648; Town Hall, Enkhuizen) and *Bear Hunt* (1649; Rijksmuseum, Amsterdam)–inspired by the works of Flemish artists like Snyders and Fyt. But in 1649 he painted a fascinating group of eight "titivated little dogs" in an interior (fig. 26) that can only have been a specific commission.[76] The precise subject of this unusually large painting by Potter, in effect a canine conversation piece, remains unclear. What, for example, did the artist intend by showing the little dogs in the presence of an oversized chair?

Toward the end of his short life, Potter produced one of the true masterpieces of dog painting, the powerful, life-size *A Watchdog Chained to His Kennel* (fig. 27), hailed

FIG. 26. Paulus Potter (Dutch, 1625–1654). *Dogs in an Interior*. 1649. Oil on canvas, 46¾ x 59 in. (118.7 x 149.8 cm). Noortman Master Paintings.

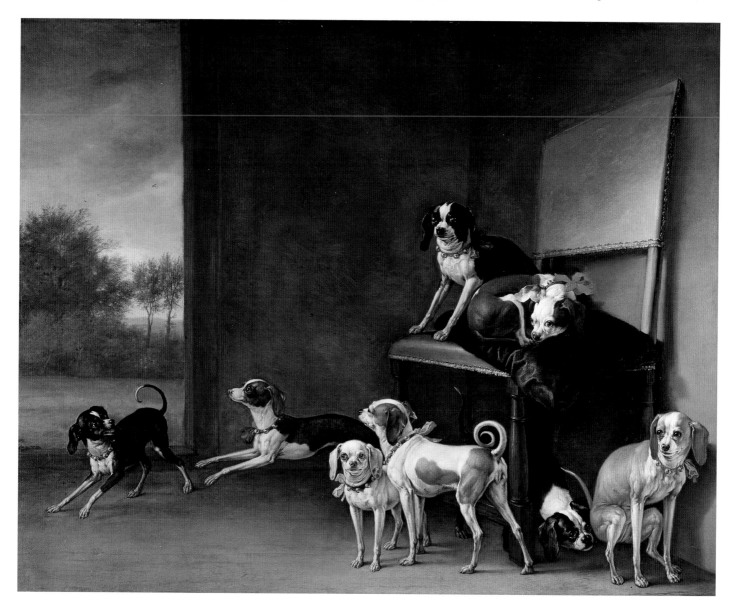

by an early owner, the eighteenth-century Dutch collector Johan van der Marck, as "absolutely magnificent, painted forcefully and as if alive; lacking nothing in the anatomy." The dog, traditionally described as a wolfhound, resembles a cross between a European greyhound and a sheepdog. The effort Potter made to portray the animal as faithfully as possible, depicting its moth-eaten coat with powerful brushstrokes and sharply setting off the short, bristly hairs around its muzzle and nose against the cloudy sky, has been observed.[77] Whatever emblematic or didactic meaning this great dog may possess, he vividly conveys the ancient role of the guard dog celebrated centuries earlier by Virgil: "Never, with them on guard, need you fear in your stalls a midnight thief, nor onslaught of wolves, nor restless Spaniards behind your back."

If Potter painted the most heroic dog in seventeenth-century Dutch painting, Gerrit Dou depicted the most winsome (fig. 28). The little wire-haired dog sleeping on a table beside a large earthenware pot exemplifies Dou's gifts for careful observation and meticulous rendering. He was a virtuoso in describing surfaces—some of his pictures were painted with the aid of a magnifying glass—and he painstakingly described every aspect of the animal, from the texture of its coat and the red on the inside corners of its eyes to its wet nose and the leathery texture of its paws. The

FIG. 27. Paulus Potter (Dutch, 1625–1654). *A Watchdog Chained to His Kennel.* c. 1650–52. Oil on canvas, 38 x 52 in. (96.5 x 132.1 cm). The State Hermitage Museum, Saint Petersburg.

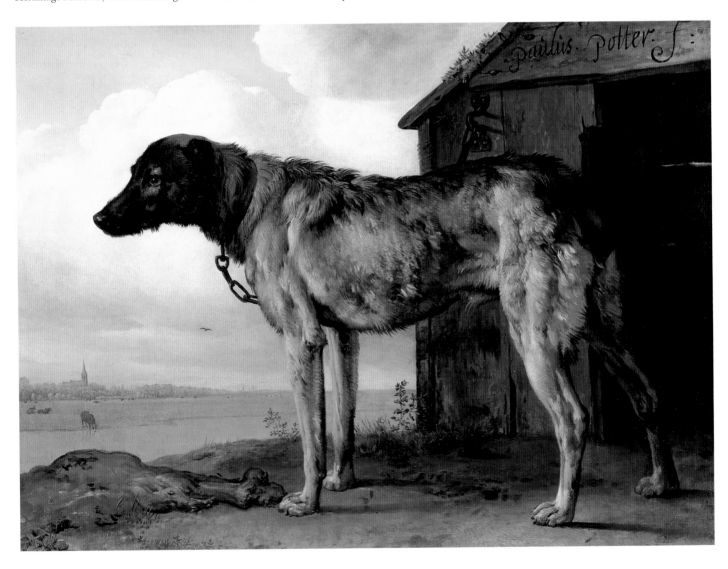

EDGAR PETERS BOWRON

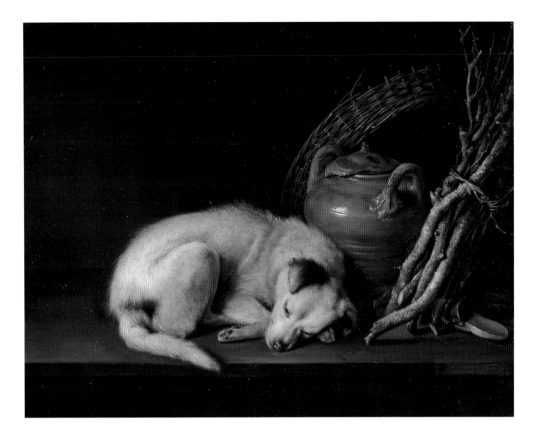

superb quality of the panel was recognized as early as 1834, when the great chronicler of Dutch painting John Smith said that "it is impossible for painting to be carried to higher perfection than that displayed in this exquisite little picture."[78]

The same dog and terra-cotta jug appear in the right-hand corner of Dou's *The Spinner's Prayer* (c. 1645–50; Alte Pinakothek, Munich), a typical example of the artist's finely rendered scenes of the Dutch bourgeoisie. His decision to focus in this small composition entirely on the animal itself was probably inspired by the example of Rembrandt, who shortly before had produced a drawing and an etching, *Sleeping Watchdog* (1637–40; Museum of Fine Arts, Boston) and *Sleeping Puppy* (1639–40; Bartsch 158).[79] Many of Dou's paintings, like those of his Dutch contemporaries, are laden with veiled symbolism, derived from traditional moralizing or didactic themes, which allow them to be read on more than one level. It is moot, however, whether one should search very hard for the symbolic expression of this little fellow, who sleeps with one eye slightly open, as if dreaming, in spite of the strong tradition for such instructional themes in the painter's native city of Leiden.

Another prominent Dutch animal painter, Abraham Hondius, produced powerful compositions featuring dogs, mostly in the context of the hunt but several of the animals by themselves. One of his most unusual paintings, a work that appears to be unique in subject, is the *Amsterdam Dog Market* (fig. 29). The work was praised in the eighteenth century by the English writer and antiquarian George Vertue, who saw it at auction in 1726 and described it as "being much noted. & esteemed as his Master peice [sic]. the dogs of all sorts and kinds, extreamly Natural."[80] The painter's

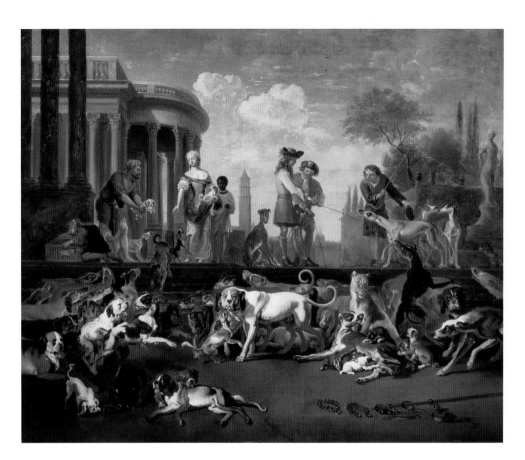

FIG. 29. Abraham Hondius (Dutch, c. 1631–1691). *Amsterdam Dog Market.* c. 1671–72. Oil on wood, 38½ x 48½ in. (97.8 x 123.2 cm). Walter F. Goodman and Robert A. Flanders.

biographer, Jacob Weyerman, described the composition in greater detail: "We remember having seen his Amsterdam Dogmarket in which are featured more than thirty different types of dogs, beautifully drawn and charmingly painted; this scene features among other things, a white bitch with her six pups and in her eyes one can see the care and the love for her litter."[81]

The painting depicts several elegant and well-dressed figures inspecting the various dogs, which include spaniels, mastiffs, greyhounds, and several other canine types. One of the most unusual features of the work, recently described as "a veritable encyclopedia of the breeds which were available at the time," is the array of highly specialized collars laid out in the right foreground, ranging from simple metal bands intended for everyday use to "murderously spiked ones" for outfitting fighting or hunting dogs.[82] The exchange of dogs had been a practice among the European nobility for centuries, but the trade in dogs is not thought to have become an international institution until the seventeenth century, with the rise of a newly wealthy merchant class in Holland. It has been suggested that Amsterdam, for all practical purposes the banker, auctioneer, and purveyor of collectibles for Europe, also developed a commercial trade in dogs.[83]

However, the idealized classical architectural setting in Hondius's composition is imaginary and almost certainly does not record an actual marketplace, leaving one to question whether an allegorical or proverbial intention lies behind the painting. Whether actual dog markets existed, where patricians such as those depicted by Hondius could select and purchase the animals, is not at all certain. Purebred dogs

EDGAR PETERS BOWRON

were very scarce in the seventeenth century and available only for a narrow elite, probably bred by a loose network of kennel masters and breeders for noble and aristocratic patrons.

Yet over the course of the following century and a half, the inexorable rise in pet keeping and the intensifying attachment of members of the middle classes to their dogs resulted in the proliferation of marketplaces for the sale of dogs. It is estimated that by the mid-ninetenth century there were approximately twenty thousand London street traders who dealt in live animals, and at least a dozen who specialized in the brass collars, priced from sixpence to three shillings apiece, sported by most respectable Victorian dogs.[84] Pet owners also commissioned portraits of their canine companions, a growing practice that would lead to the increasing role of the dog in art in the century to come.

Notes

1. Eisler 1991, p. 163. There is ample evidence that Renaissance artists felt differently about dogs than about other animals. Several times in his autobiography the sculptor Benvenuto Cellini mentions Barucco, his "shaggy dog, very big and handsome," given to him by Alessandro de' Medici, Duke of Florence. He extolled the dog's virtues as a retriever and watchdog and provided a compelling account of how the animal captured a thief and recovered jewels stolen from his shop (Cellini 1995, pp. 97–98, 100–101). Sofonisba Anguissola chose to include the family dog in a portrait of her father, sister, and brother, *Amilcare, Minerva, and Asdrubale Anguissola* (c. 1557–58; Nivaagaards Malerisamling, Niva, Denmark). Agostino Carracci represented his dog with great sympathy in an engraving (1582–85; Metropolitan Museum of Art, New York), very few copies of which exist because the family was never willing to sell the copper plate, even for a high price (DeGrazia Bohlin 1979, no. 95, repr.; Malvasia 2000, p. 252). And in Baroque Rome, Caravaggio is recorded as having gone about the city accompanied by a black poodle (*un cane barbone negro*) named Cornacchia (the Italian word for raven, or bird of ill omen), which so impressed the Venetian painter Carlo Saraceni that, partially in jest, he obtained a black dog for himself and gave him the same name (Baglione 1642, p. 147; I am indebted to John Varriano for this reference).
2. Phébus 1998, p. 35.
3. Ibid., p. 31.
4. Meiss 1974, vol. 2, fig. 439.
5. Meiss 1967, vol. 1, pp. 31–32, cites Jean de Berry's fondness for small dogs, one of which bore the affectionate name of Lion. In many portraits, beginning with the *Petites Heures*, the duke is accompanied by one or two little white dogs; vol. 2, figs. 34, 114. MacDonogh 1999, p. 42, identifies the little dogs on the banqueting table as reflecting the practice at the Burgundian court of using *chiens-goûteurs* to taste food for poison.
6. For a further discussion of the ideas and images associated with dogs in the Renaissance, see Höltgen 1998, pp. 1–36.
7. Ritvo 1987, p. 85.
8. Syson and Gordon 2001, figs. 4.35, 4.59–4.61.
9. Eisler 1991, pp. 163–83, figs. 7.7, 7.38, 7.39.
10. See Brown 1981, pp. 46–49, for Parmigianino's and Dosso Dossi's use of the dogs in Dürer's print.
11. Jongh 2000, p. 36, cites the depiction of purgatory in *Les Très Riches Heures*, where a dog's head is close to the pudendum of a naked female sinner.
12. Reuterswärd 1991, p. 213, writes that about 1500 the representation of a dog in the humanist's study could suggest intuition, sagacity, and fidelity, as well as faith; see also Eisler 1991, p. 174.
13. Campbell 1990, p. 159.
14. See Hall 1994, pp. 114–16, for a critique of the traditional symbolic meaning of the dog as faith.
15. MacDonogh 1999, p. 72.
16. Lavin 2002, pp. 72–73, interprets the dogs as standing for their master's religious faith. Lightbown 1992, p. 94, emphasizes their naturalistic plausibility within the composition.

17. Lightbown 1992, p. 94.

18. Signorini 1978, pp. 317–20. The author points out that not only Rubino but a great many dogs at Mantua received tombs and epitaphs: there were Bellina, Oriana, and Isabella d'Este's Aura. The tomb for Viola, which Giulio Romano was asked to design in 1526, is perhaps the elaborate one with a poodle, still in existence at the Palazzo del Té (Reuterswärd 1991, p. 214). For funeral monuments to dogs generally, see Penny 1976, pp. 298–303.

19. Campbell 1990, p. 105. Mor's portrait stands at the beginning of the tradition of portraying dwarfs and small children beside large and powerful dogs, a convention of Spanish and English court portraiture in the seventeenth century.

20. Clark 1977, p. 49.

21. Costamagna 2005, p. 284, fig. 12.

22. Posner 1973, pp. 78–79.

23. Signorini 1978, p. 318, and Signorini 1988, p. 21.

24. Cohen 1998, p. 195.

25. Garrard 2004, pp. 251–52; see also Pedrocco 2001, p. 303.

26. For a discussion of Bassano's use of canine imagery, see Ballarin 1995, pp. 378–408, pls. 223–59.

27. Habert 1991, pp. 212–20; Habert and Legrand 1998, pp. 19, 68–69, no. 3 (with earlier references).

28. Rearick 1993, pp. 84–85, nn. 123–25; see also Ballarin 1995, pp. 225–26, 228–29.

29. Aikema 1996, pp. 44–46, 184 nn. 163–64; Brock 1998, pp. 76–77.

30. Habert 1991, pp. 218–19; for the provenance of the painting, see p. 212.

31. Ibid., repr. p. 219.

32. Clark 1977, p. 181.

33. Vasari 1568, vol. 2, p. 415; Ruskin 1873, vol. 2, p. 203. For dogs in Veronese's art, see Bialostocki 1990, pp. 220–30.

34. Waters and Waters 1984, p. 8, identifies the two dogs as salukis and calls attention to the artist's affection for the breed, which appears in more than thirty of his paintings between 1559 and 1585.

35. Coutts 1980, p. 142; Bialostocki 1990, p. 225.

36. Rolf Kultzen, in Alte Pinakothek 1986, p. 560; Filippo Pedrocco in Paris and Venice 2004–5, p. 164.

37. Spallanzani 1983, pp. 363–64. Pope-Hennessy 1985, pp. 225–26, notes the extreme subtlety of the relief system, which is in the technique of a goldsmith. Cosimo I preempted the relief for the rich collections at the Guardaroba in the Palazzo Vecchio, where in 1553 it was described as the "*Canino di metallo basso rilievo in uno ovato di mezzo braccio, di mano di Benvenuto* (Little dog, metal bas-relief in an oval of a half-*braccio*, by the hand of Benvenuto)." Dogs were also the subject of freestanding sculptures in the Renaissance and its aftermath; see, for example, Mezentseva 1978, pp. 5–8, and Berger and Krahn 1994, pp. 274–76.

38. Waters and Waters 1984, p. 94.

39. Florence 1983, p. 65, no. 40.

40. Kultzen 1977, pp. 39–40, fig. 38; see also De Luca and Winspeare 2003, figs. 3, 4, 15, for other portraits of Medici dogs attributed to Sustermans.

41. Carapelli 1986, pp. 101–7.

42. MacDonogh 1999, pp. 77–78.

43. Paulussen 1980, pp. 109, 123 n. 79, fig. 19; see De Luca and Winspeare 2003, figs. 9, 14, for other dog portraits attributed to Tiberio di Tito.

44. Abraham Fleming, *Of English Dogges*, 1576, the English translation of the royal physician and dog expert Johannes Caius's *De Canibus Britannicus*, published in Latin in 1570; quoted in Thomas 1984, pp. 107–8.

45. Faldi 1966, pp. 144–45, figs. 60 a, b; 61 a, b. An independent portrait of a Dalmatian-type dog by Campidoglio (oil on canvas, 136 x 99 cm), formerly with Galerie Canesso, Paris, and now in a French private collection was kindly brought to my attention by Tobia Milla Moss.

46. Damian 2004, pp. 8–11.

47. Moro 2000, p. 134.

48. Patrizia Giusti Maccari, in Bocchi and Bocchi 1998, pp. 488–97, fig. 621.

49. Pulini 2001, p. 172, no. 50, with earlier references.

50. López-Rey 1996, vol. 2, p. 320, citing Antonio Palomino (1655–1726), *Life of Velásquez*, published in 1724: "On the chair is a little dog which seems alive, and it is a portrait of one that Velásquez valued a great deal. It would seem that he had the same experience as Publio, an excellent painter, who portrayed his dear little dog, Isa, to make it immortal, as Martial wittily said, and as Velásquez too could have said."

51. Clark 1977, p. 50; see Glen 1993, pp. 30–36, for a recent discussion of Velásquez's dogs.

52. Oliver Millar, in Barnes, De Poorter, Millar, and Vey 2004, p. 479.

53. See ibid., pp. 584–86. Marjorie E. Wieseman, in Sutton 1994, pp. 337–38, no. 41, published the artist's extraordinarily fine black-chalk studies of the dog in the British Museum. See also Arthur Wheelock's observations on Van Dyck's transformation of Titian's precedent of juxtaposing a nobleman with a dog, in Wheelock, Barnes, and Held 1990, p. 260.

54. D'Anthenaise, de Fougerolle, MacDonogh, and Prestate 2000, pp. 133, 141, repr. col., pp. 41, 101.

55. Alexander Wied, in Ertz and Nitze-Ertz 1997, p. 304.

56. Koslow 1995, p. 272, from whom this discussion of Snyders's paintings of dogs is taken.

57. Ibid., p. 273.

58. Ibid., p. 277.

59. For Snyders's fable pictures, see ibid., 1995, pp. 259–69. Animal fables, a revival of a classical genre made famous by ancient poets such as Aesop and Phaedrus, were extremely popular in the Netherlands in the sixteenth and seventeenth centuries.

60. Reynolds 1996, p. 42: "[H]e has even added a dog, which he has introduced in an animated attitude, with his mouth open, as if panting; admirably well painted."

61. For Snyders's hunting pictures, see Koslow 1995, pp. 219–57. For the Boston *Boar Hunt*, see Sutton 1994, pp. 567–69.

62. Arnold Houbraken, *De Groote Schouburgh der Nederlandtsche Konstschilders en Schilderessen*, 2d ed. (The Hague, 1753), vol. 1, p. 84; quoted in Koslow 1995, p. 219.

63. See Kloek 2005, figs. 46–48, 63, and 86, for Steen's use of a brown-and-white spaniel, and Sutton 1998, nos. 37, 38, for the black-and-tan hound that appears in de Hooch's paintings of the 1660s and 1670s, respectively.

64. Wheelock 2004, p. 118.

65. Franits 2004, p. 159.

66. Otto Naumann, in Sutton 1984, p. 260 n. 10.

67. Posner 1973, pp. 78–80.

68. Naumann 1981, vol. 1, pp. 104–7, for the erotic symbolism of the copulating and dancing dogs in van Meiris's genre paintings.

69. See Bedaux 1990, p. 113; Franits 1993, pp. 148–55, on dogs as pedagogical metaphors.

70. Kuretsky 1995, pp. 150–53.

71. See Broos 1990, p. 475, repr., for a study in Rotterdam of dogs in various positions.

72. Koslow 1995, p. 276.

73. Roethlisberger 1993, vol. 1, pp. 113, 114.

74. Papy 1999, p. 167

75. For the print series largely devoted to dogs, see Walsh, Buijsen, and Broos 1994, p. 142 n. 6.

76. London 1999, lot 21, p. 43.

77. Walsh, Buijsen, and Broos 1994, p. 141.

78. New York 2005, p. 34. My discussion of the painting derives from the entry in the sale catalogue, which was prepared with the assistance of Dr. Ronni Baer.

79. Ackley 2003, pp. 122–23, repr.

80. Gerson 1951, pp. 246–48. Dr. Marijke Peyser-Verhaar, the leading authority on the work of Hondius, has recently suggested (communication of October 2, 2005) that on the basis of style and handling the painting must date before the artist's departure from the Netherlands in 1671–72, not from the artist's final years in London, and that a number of passages in the composition are painted in the tradition of Dutch *Fijnschilders*, typical of Hondius's earlier manner.

81. Weyerman 1729–69, vol. 3, p. 158, transcribed and translated by Dr. Marijke Peyser-Verhaar (communication of October 5, 2005), to whom I am extremely grateful for her kind assistance.

82. Secord 1992, p. 37. For an indication of the care with which Hondius prepared his composition, see the study of the mastiff in the center of the composition in Secord 2001, p. 21, pl. 10, who observes that Hondius was one of the first artists to depict mastiffs with massive heads. For a discussion of historical dog collars, see D'Anthenaise, de Fougerolle, MacDonogh, and Prestate 2000, pp. 68–74.

83. McConathy 1982, n.p.

84. Ritvo 1987, p. 86. For pet keeping in the nineteenth century generally and references to the earlier ownership of dogs, see Ritvo 1987 and Kete 1994.

From the Royal Hunt to the Taxidermist

A Dog's History of Modern Art

ROBERT ROSENBLUM

Who but dogs would happily share not only their eyes but their entire lives to help the sightless members of our own species? And who but our own species could have invented a legend about how the archetypal canine, Lupa, a she-wolf, harbored such domesticated instincts that she was willing to offer her own milk to save the lives of Romulus and Remus, abandoned infant twins who would then go on to found a great civilization? Prompted by the untimely passing of his six-month-old bulldog, Pelléas, Maurice Maeterlinck, the Belgian author who so often explored the mysterious lives of the animal kingdom, from bees to birds, wrote a rhapsodic essay, "On the Death of a Puppy" (*Sur la mort d'un petit chien*, 1904), about the ineffable bond between dogs and us. "Is it we," he asks, "who sought out the poodle, the mastiff, and the greyhound among the wolves and jackals or is it they who came spontaneously to us?" And he concludes that "we are alone, absolutely alone on this chance planet; and amid all the forms of life that surround us, not one, except for the dog, has made an alliance with us." Nor have we humans ever stopped thanking dogs for this alliance.

Often commemorated, their attachment to us has been a universal theme. We can find it as long ago as Homer's account of Odysseus' dog, Argos, who waited and waited for his master to return after an absence of twenty years and then, at last recognizing him, turned over and died, his unswerving patience finally rewarded. Such tales of canine courage and loyalty have never stopped echoing through time and space. There is, for example, the story of "Greyfriars' Bobby," the Skye terrier who, from 1858 to 1872, lay on the grave of his master, John Gray, in Edinburgh's Greyfriars' churchyard—an act of fidelity that prompted not only many portraits of this archetypal Fido but even a children's book by Eleanor Atkinson that, in turn, was

made into a Walt Disney movie (1961). And in Asia in the twentieth century, there is Tokyo's bronze statue of Hachiko, placed outside the Shibuya subway station in honor of this loyal Akita who waited there every afternoon for his master, Professor Eisaburo Ueno, to return from the university in order to join him for their daily walk home. Although the professor died suddenly on May 21, 1925, never to emerge from the subway again, Hachiko kept waiting for him, day after day, year after year, while being cared for and cherished by the locals. His statue, now a major tourist attraction, was erected in 1934. Hachiko attended the unveiling and died the following year.

Such tales and images of devotion speak volumes about the ineffable bonds between humans and canines that all people of feeling continue to recognize today. (Those who do not should read no further.) We can surely imagine that both ancient Romans and sixteenth-century Venetians loved their dogs as much as we do ours and were endlessly grateful to them not only for providing their special kinds of canine comfort behind the closed doors of domestic life but also for contributing their professional skills to the anonymous daily business of herding sheep, exterminating rodents, hunting animals for food, or, in the case of the aristocracy, such as the Medicis or the Bourbons, learning to participate in the kind of ritual sport venerated in the ancient myths of Actaeon or Atalanta. Dogs joining their human companions in fierce pursuit of edible stags and pheasants or criminal foxes and wolves provided a major role for their appearance in art, whether in Gothic illuminated manuscripts or Renaissance panels. But despite the consistent roles dogs have played in our lives, the restless changes in Western thought and emotions also meant that, at different times in history, artists and their patrons would emphasize different aspects of those dogs with whom they lived and hunted. It was in the eighteenth century that we began to register sea changes in the depiction of dogs. This should hardly come as a surprise, because it is also in the eighteenth century that we begin to sense unfamiliar emotions in the depiction of people—tearful sentiment, hedonistic excesses, uncommon heroism, primitive regressions. And because dogs have always served as Rorschach tests for their owners and their admirers, appearing to be joyous or melancholy, innocent or naughty, rich or poor, lonely or sociable, they continued to

FIG. 30. Alexandre-François Desportes (French, 1661–1740). *Tane, A Hunting Dog of Louis XIV*. 1702. Oil on canvas, 64⅜ x 53⅜ in. (163.5 x 135.5 cm). Musée de la Chasse et de la Nature, Paris (Dépôt du Musée du Louvre, 1967).

ROBERT ROSENBLUM

accommodate, as no other animal could, the most flexible scenarios invented for them by their human friends.

Looking for signs of change, we might turn to three paintings by Alexandre-François Desportes. His specialization in paintings of the hunt and his eighty-two-year-long life span made it possible for the artist to be patronized by both Louis XIV and Louis XV, whose royal hounds he would commemorate for posterity. In one of these paintings, *Still Life with Dog and Game* of 1710 (see fig. 23), we see a later variation on a theme already explored in both indoor and outdoor scenes by Frans Snyders and Jan Fyt: a close-up view of a dog who may be either obedient or mischievous when confronted with his owner's comestible possessions, sometimes wreaking havoc in the kitchen by chomping down the meat destined for dinner or elsewhere nobly guarding in a remote landscape the fruits of the hunt as a trophy of his professional prowess and dedication. When we give a dog a name, the boundary between the generic and the individual, the human and the canine, is forever crossed, and this point is confirmed again and again in the official portraits of the Bourbon monarchs' hunting dogs. In 1702 Desportes was commissioned by Louis XIV to paint four large portraits of the king's favorite hounds, to be placed in the antechamber of his quarters at the Château of Marly, and lest there be any doubt about their specific identity, their names were inscribed in gold beneath them, just as the names of aristocratic human sitters, whether a Windsor or a Hapsburg, would often add an official stamp of authority to their painted effigies. In *Tane, A Hunting Dog of Louis XIV* (fig. 30), as in the other three portraits in the series, we catch the royal dog at work, its left paw nervously extended, stealthily sniffing the almost camouflaged pair of partridges that will soon become trophies. Such a delicate, cultivated pose, like that of a dance performed at Versailles, is matched by the surrounding landscape, a framed vista of the Ile de France that, with its ever more luminous mixture of sunlight and clouds, water and earth, transports us to a fairy-tale world where Diana and her huntresses would not be strangers.

Desportes's knowledge of the hunt was hands-on. Not only did he make many preparatory studies of dogs in their elegant postures as highly trained predators, but he even painted his self-portrait as a huntsman, displaying publicly the category in which he excelled. His artistic reign far outlived that of his first royal patron, Louis XIV, and in the last decade of his life he was still enjoying the same kind of commissions from the king's great-grandson, Louis XV. His double portrait *Pompée and Florissant, Hounds of Louis XV* (see fig. 88), clearly identified by their names inscribed in gold, is part of a series made in 1739 for the young king's quarters at the Château de Compiègne. This time the dogs, rather than being captured at the cliff-hanging moment of seizing their feathered prey, have become the main players in an elegant theatrical tableau that also includes lush botanical and ornithological specimens. Standing and seated, in profile and in three-quarter view, Pompée and Florissant provide a pair of elegantly interlocked silhouettes, whose legs and tails rhyme with the grace and precision of

ballet dancers. In the foreground below, these artificial rhythms are enforced by the two white bubble plants (*bouillons blancs*), one of whose blooms sways in tandem with the dogs' tails. Above, perched almost as a taxidermic display in a tree, are three gorgeous birds—a great spotted woodpecker, a pheasant, and an oriole—that display their plumage with seeming indifference to the potential predators just below them. Blood, fang, and claw seem so remote from this royal peaceable kingdom that we might almost forget that these creatures have their roots in nature.

But it was, in fact, the powerful tug of nature that began to fascinate eighteenth-century artists who, while still keenly aware of the way in which animals in general and dogs in particular could fit into the rational patterns designed by their human superiors, nevertheless began to take more and more notice of how these domesticated creatures could stir up memories of a mysterious world of instincts and passions that were perhaps even shared by their human owners. Even within the mannered confines of painters who, like Desportes, specialized in depicting those dogs who could live up to the highest courtly standards, glimpses of this buried world of nature can be seen. There is, for example, the case of Jean-Baptiste Oudry, who succeeded and rivaled Desportes as the painter best equipped to record the disciplined minds and bodies of Louis XV's royal hounds or to paint the portrait of Pehr, the beloved dachshund of the Swedish ambassador to Paris, Count Carl Gustaf Tessin, who had his dog commemorated together with his symbolic trophies—a rifle and, hanging above him from a nail, the fruits of the chase, a pheasant and a hare (fig. 31). But Oudry offered many surprises as well, such as his unforgettable life-size illusion of a dog staking out his claim within the domestic realm of furniture (fig. 32). In a marvel of trompe l'oeil painting, Oudry would have us enjoy the ultimate elegance of a house-trained dog who can now take his place inside the most refined interior. Within the proscenium of this canine theater, the veined marble frame of a Rococo fireplace, the dog poses alongside its exquisite porcelain bowl of water, which adds a third textural delight to the contrast of fur and glistening stone. A stunning two-dimensional deception, Oudry's imaginary dog and decor had many tangible three-dimensional counterparts in the upper tiers of eighteenth-century domestic life in the very real indoor doghouses provided for those pampered pets who might want, for the moment, to take refuge from human laps and cushioned sofas and to enjoy a bit of privacy in a Louis XV- or Louis XVI-style pavilion.

This triumph of Rococo artifice in no way prepares us for Oudry's most path-breaking contribution to uniting the human and canine races, a seemingly ordinary scene of an anonymous bitch hound (what the French refer to as a *lice*) nursing her puppies in a barnyard stable (see fig. 89). Exhibited at the Paris Salon of 1753, two years before the artist's death, it elicited a wide spectrum of enthusiasm that ranged from an observation about the mother's paw raised protectively over one hungry pup to a more far-reaching comparison with the archetypal Christian image of maternity,

ROBERT ROSENBLUM

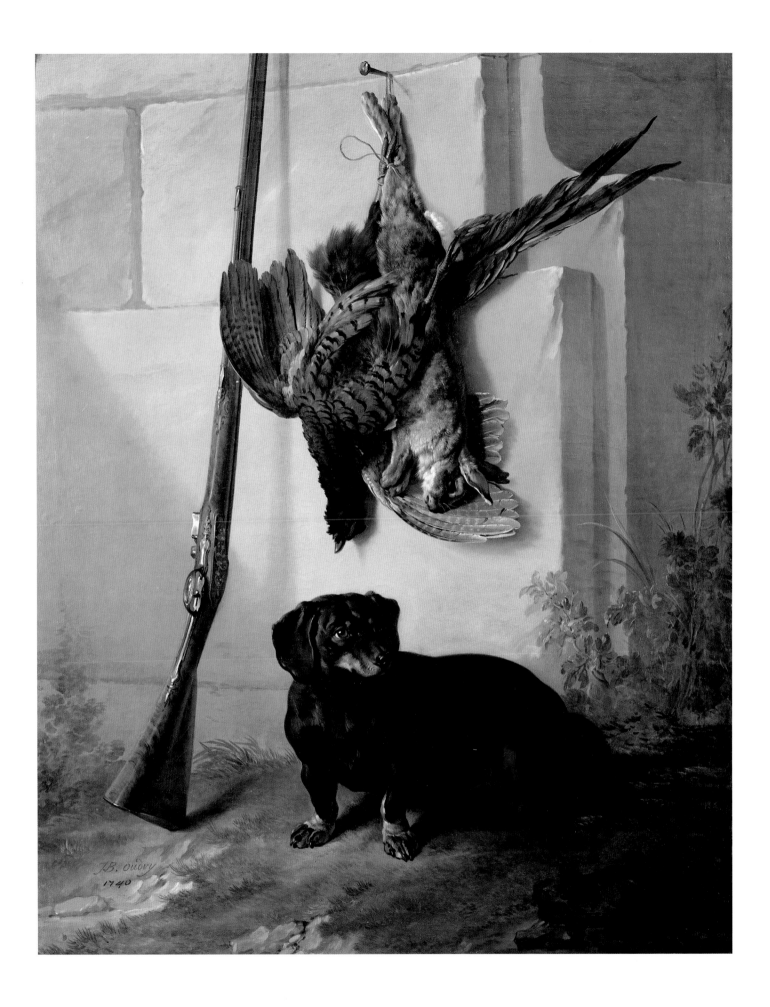

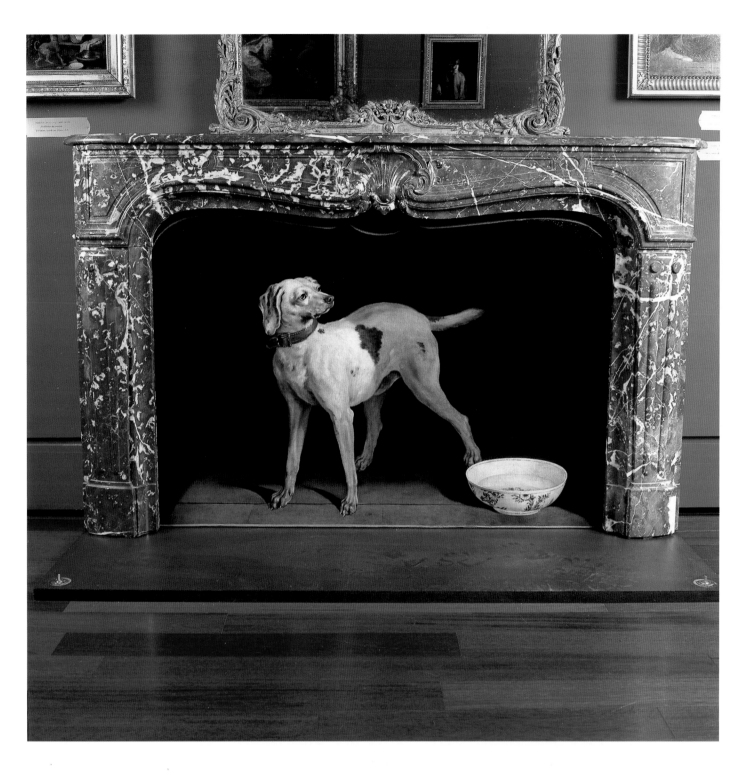

FIG. 32. Jean-Baptiste Oudry (French, 1686–1755). *Dog with Bowl*. c. 1751. Oil on canvas, 45¼ x 51⅝ in. (115 x 131 cm). Musée de la Vénerie, Senlis.

namely, the Holy Family and, more specifically, Rembrandt's version of this theme, now in the Louvre. Oudry's painting, in fact, could immediately be viewed as a perfect icon of selfless motherhood, staged in a setting as humble as Joseph's carpentry shop and bathed in a sunlit glow of almost supernatural sanctity. The painting clearly touched new nerves of feeling in which canine and human emotions could overlap, so much so that Oudry made a second version of it, which was reexhibited as an engraving after the artist's death, eliciting yet another anthology of touching comments about this paragon of maternal love and care. Oudry's subject could not have come at a better time, coinciding as it did with the mid-century's welling urge to shed artifice and to

ROBERT ROSENBLUM

regress to more natural, simple forms of life and experience. Most particularly, the painting could speak to the new and revolutionary advocacy of breast-feeding, so vigorously propagated by Jean-Jacques Rousseau that by the late eighteenth century even the most well-heeled mothers had rejected the long tradition of nipping maternity in the bud by immediately sending their newborns off to wet nurses, choosing instead to return to animal instinct and, like Oudry's canine mother, to nourish their own brood. In fact, portraitists from Sir Joshua Reynolds to Jacques-Louis David would mirror this new embrace of organic nature by depicting even the fanciest duchesses and countesses discreetly making their breasts available to the infants cuddled in their arms.

Throughout the eighteenth century, dogs mirrored a seesawing balance between the demands of reason and artifice and the urge to explore a subhuman world that belonged not only to their own feral origins in savage communities of wolves but to their masters themselves, who, more and more, would respond to the pull of natural forces, whether those of uncultivated landscapes, where winds might howl and storms rage, or surging emotions that would break the constraints of civilized decorum. In the work of George Stubbs, which explores with scientific precision the anatomy and feelings not only of domesticated British dogs and horses but also of such exotic creatures as the rhinoceros, zebra, tiger, cheetah, and monkey, this polarity is clear. Even while recording the most thoroughbred of racing horses, Stubbs, like Oudry, would turn his attention to a scene of mares nursing their foals in an open field. His paintings of dogs show them also in shifting roles, from players in a regimented human scheme to creatures thoroughly rooted in nature. Stubbs's *Five Staghounds in a Landscape* of c. 1760 (see fig. 86) represents one of these extremes. Five hunting dogs are lined up in a frieze that, as in many of Desportes's elegant displays, turns their silhouettes into a pattern of curved tails and straight backs. Moreover, their alternating genders–male, female on the left facing male, female, male on the right– are as regimented as a courtly quintet of dancers. And the Poussinesque landscape that provides their setting is also perfectly tamed, evoking an orderly scale in which, even without a human presence, the dogs seem to exist on a lower tier, subservient to their masters. But this taut control, a reflection of the countless disciplines imposed on the horses and hounds who were taught to coexist with the human residents of country estates, would often give way to a different vision of an animal world in which dogs, like horses, could become individuals, each with a unique personality, and could be seen not within the confines of kennels and stables but against wilder landscapes that recall their natural origins.

A superb trio of dog portraits, from 1776, 1778, and c. 1780, takes us to this new territory. With his professional credentials as a master of zoological illustration, Stubbs, of course, insists on defining the particularities of every breed–foxhound, staghound, Norfolk spaniel, King Charles spaniel–each a suitable image for an encyclopedia of dogs. But Stubbs gives us much more. In the case of a Norfolk water dog, often

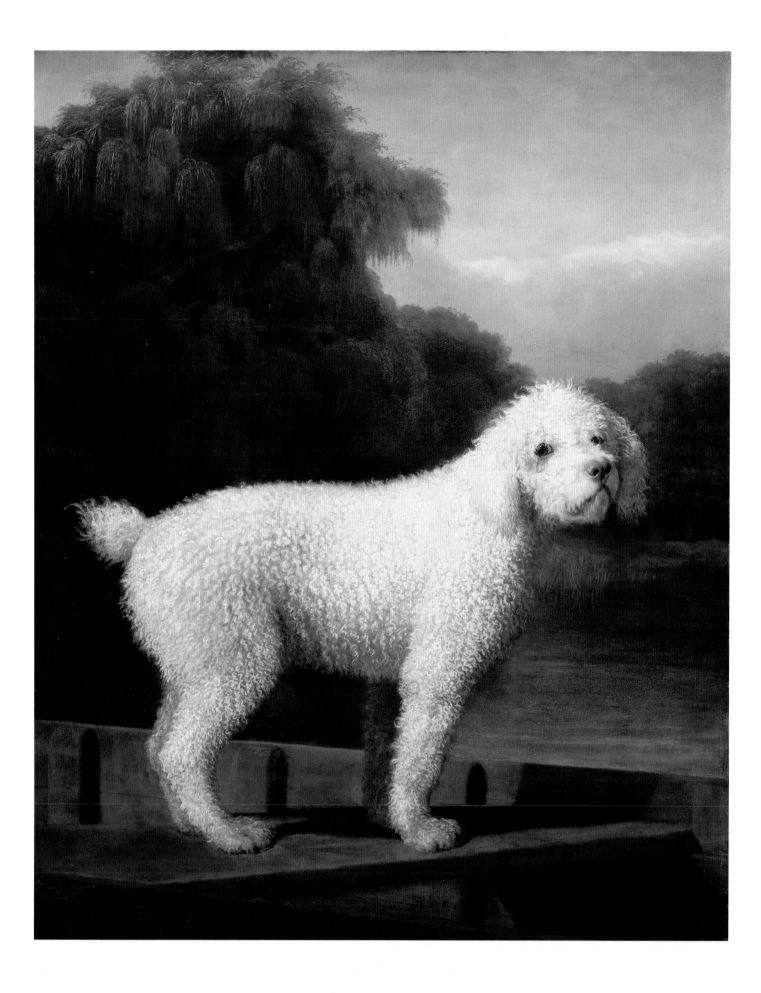

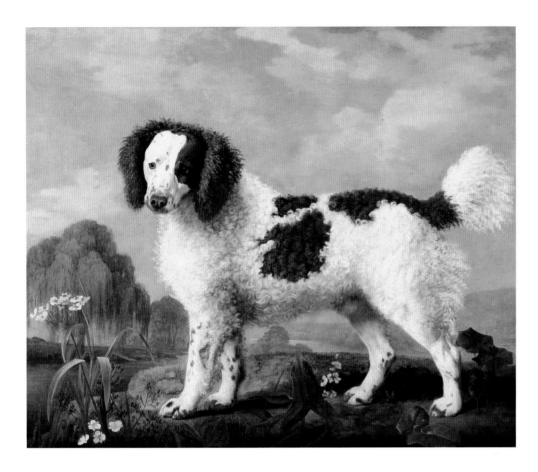

FIG. 34. George Stubbs (English, 1724–1806). *Brown and White Norfolk or Water Spaniel.* 1778. Oil on canvas, 31¾ x 38¼ in. (80.7 x 97.2 cm). Yale Center for British Art; Paul Mellon Collection.

identified as a poodle, with whom it shares a common ancestry, the dog, far from being a human accessory, demands full-scale attention, not only because he occupies more than half the picture space but because he turns his head toward us with an expression that demands immediate empathy (fig. 33). Poised precariously on a punt and glimpsed midstream with no human in sight, he seems a bit anxious, as if eager to return to solid ground. This anxiety, of course, may be a projection from the mind of the beholder, but the overriding point is that Stubbs establishes a one-to-one relationship with another sentient creature, not a human being but a dog. The Norfolk water spaniel (fig. 34) also insists that the boundary between humans and dogs be crossed. No longer at his master's feet, he dominates the landscape and cloud-filled sky behind him.

To be sure, in many seventeenth-century paintings, such as Paulus Potter's *Watchdog Chained to His Kennel* (see fig. 27), a dog may expand to almost the size of a horse, but its role is still that of a guardian, protecting its master's property. Here the spaniel appears unfettered by human constraint, as if he had reconquered his own natural terrain, liberated within and towering above an uninhabited landscape. Even more surprising, in terms of these canine regressions, is Stubbs's King Charles spaniel (fig. 35). This breed had, in fact, become a symbol of pampered luxury, especially conspicuous in royal and domestic portraits, and, as in the case of a painting of 1778 by Jean-Baptiste Huet, was often depicted alone as a precious pet that could barely survive without the comfort of velour curtains and cushions (fig. 36). But Stubbs returns this dog to an almost menacing landscape, more appropriate, one feels, to the

OPPOSITE

FIG. 33. George Stubbs (English, 1724–1806). *Norfolk Water Dog in a Punt.* c. 1780. Oil on canvas, 50 x 40 in. (127 x 101.5 cm). National Gallery of Art, Washington, D.C., Paul Mellon Collection.

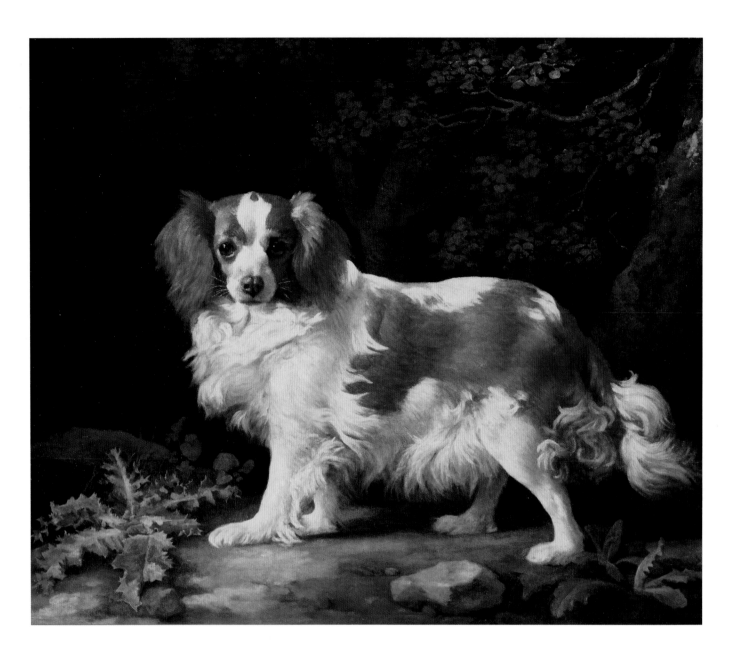

artist's images of lions and tigers in their cavernous lairs than to ladies' boudoirs. Remote from man-made law and order, this small dog appears larger than life, suddenly confronting us in the dark underbrush with a luminous flash of white and brown fur, as if, in a remote forest, we had come upon a wild animal. Seen now at eye level rather than as a toy at our feet, the dog fully returns our gaze with its piercing, inquiring eyes, demonstrating in canine terms that, as Immanuel Kant would put it, the eyes are windows on the soul. In revealing this profound emotional tie between man and beast, Stubbs opened endless vistas for later artists to explore the mysterious natural origins that blur the boundaries between species. Half a century later, the artist Théodore Géricault, above all, would understand Stubbs's precocious manifesto of animal liberation.

In recognizing that dogs' primal roots hark back to a precivilized world, Stubbs was hardly alone in his generation of British painters. Although far more famous for painting people than animals, Thomas Gainsborough, Stubbs's junior by three

ROBERT ROSENBLUM

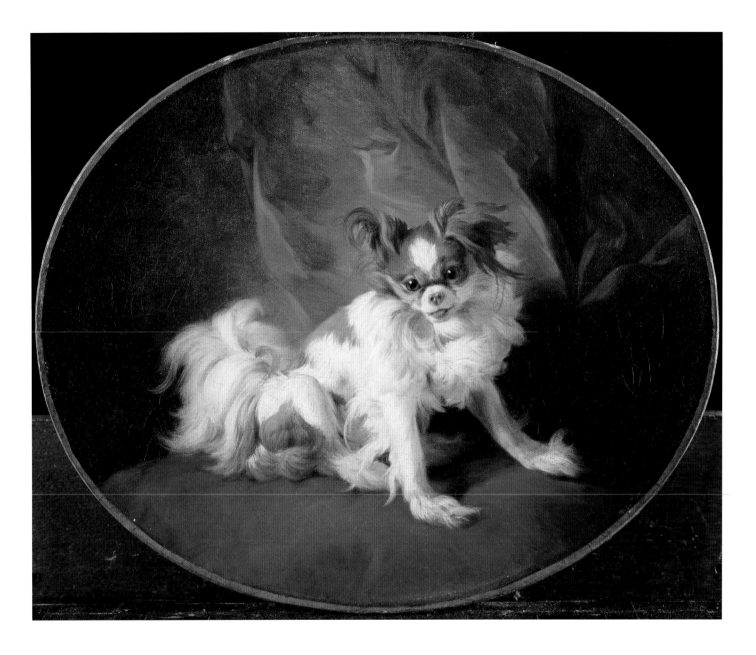

FIG. 36. Jean-Baptiste Huet (French, 1745–1811). *A King Charles Spaniel.* 1778. Oil on canvas, 18 x 22 in. (45.8 x 55.8 cm). Private collection, courtesy Wildenstein & Co., New York.

years, would often follow the same instinctive path in his occasional dog portraits, evident in his small but surprisingly intense portrait, c. 1780–85, of a pug that belonged to a fellow painter, Jonathan Spilsbury (fig. 37). Pugs, like King Charles spaniels and other lapdogs, were synonymous in the eighteenth century with beloved miniature toys, totally adapted to the intimate comforts of upper-class domestic life and cherished by the likes of Mme de Pompadour, Queen Charlotte, and Marie-Antoinette. It is particularly surprising, then, to find one that is not treated as an adored accessory or, as in the case of William Hogarth's self-portrait with his pug, Trump, an intelligent pet on equal footing with his human counterpart. This one, in fact, seems to have escaped from his nearby country house and master, taking refuge in the woods. Flaunting his signature virtuoso brushwork, Gainsborough almost camouflages this surprisingly independent pug by fusing its furry beige coat with the dappled, scruffy landscape, making us feel like hunters who have just spotted their prey hiding in the underbrush.

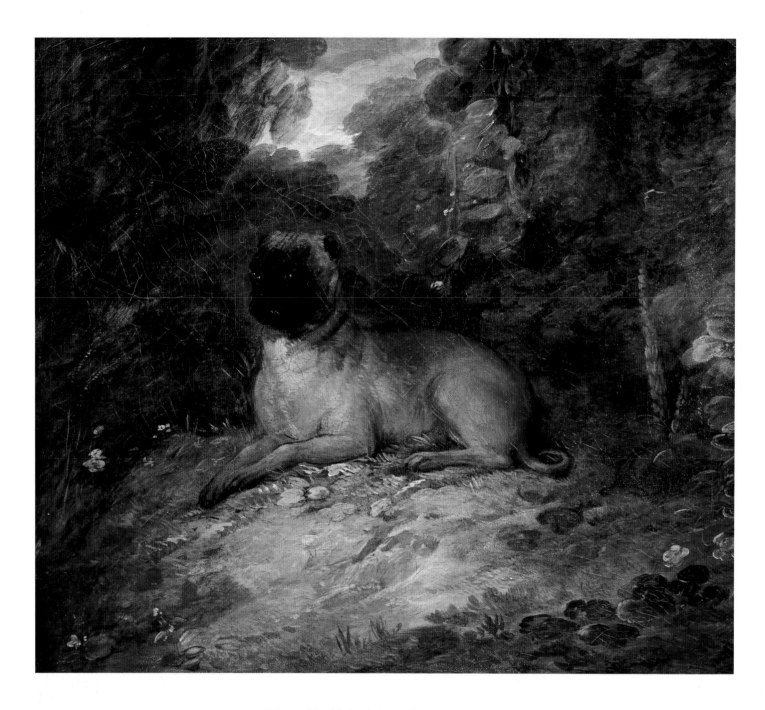

FIG. 37. Thomas Gainsborough (English, 1727–1788). *Portrait of a Pug Belonging to Jonathan Spilsbury, in a Landscape.* c. 1780–85. Oil on canvas, 11½ x 13½ in. (29.2 x 34.3 cm). Richard L. Feigen & Co., New York.

OPPOSITE

FIG. 38. Johann Gottlieb Kirchner (German, 1706–after 1738). *Bolognese.* c. 1733. Meissen, hard-paste porcelain, 16¹³/₁₆ x 14½ in. (42.7 x 36.8 cm). The Metropolitan Museum of Art, New York; gift of R. Thornton Wilson, in memory of Florence Ellsworth Wilson, 1954.

Most of Stubbs's eighteenth-century contemporaries, however, kept their dogs in human bell jars, as domestic partners beloved and cosseted enough to have the finest artists commemorate their cherished presence within palaces and châteaus. Earlier in the century, inspired by the expanding import business of porcelains from China and Japan, European sculptors, centered in Meissen, on the outskirts of Dresden, turned their skills to the making of, among other porcelain confections, menageries that could fill such extravagant residences as August the Strong's Japanese Palace in Dresden. One of the earliest of these translators of Far Eastern into Western ceramics was Johann Gottlieb Kirchner, whose imagination, inflamed by the often grotesque stylizations of fantasy animals in Asian art, had little interest in the real thing, inventing his own elephant or rhinoceros without the help of a living model or a zoological illustration. Even when it came to such a commonplace as a dog, he

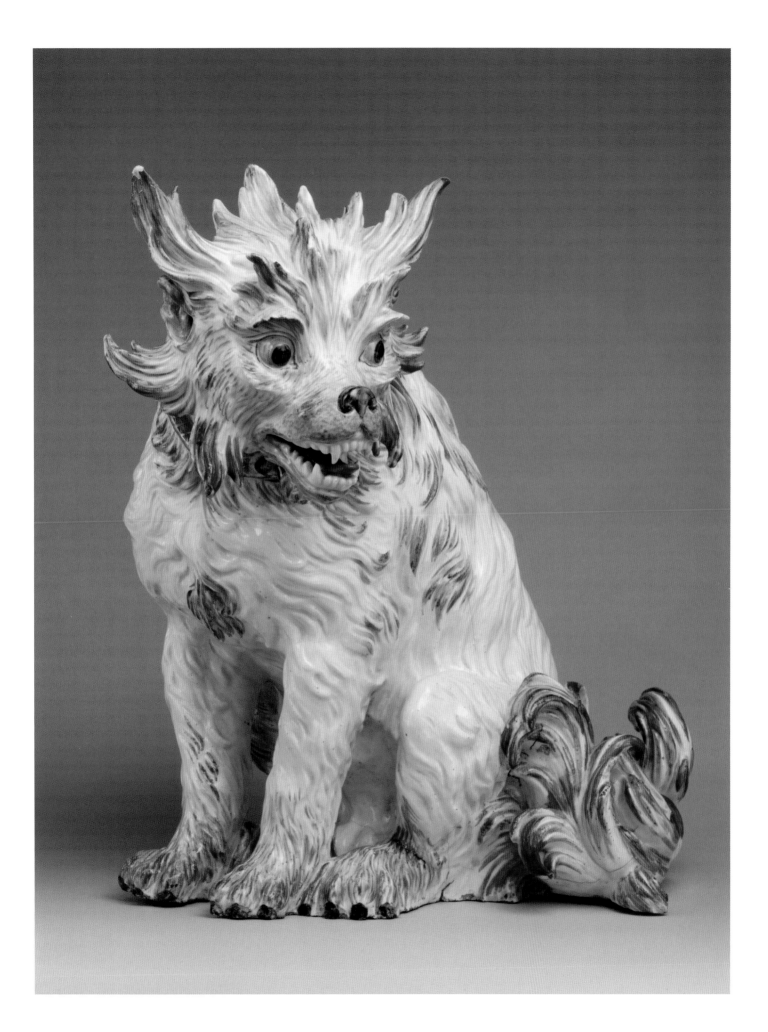

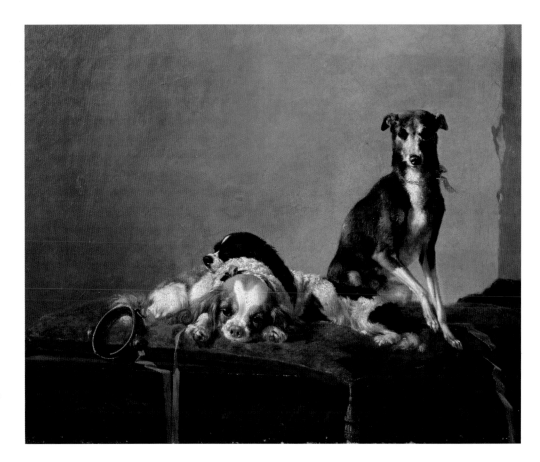

FIG. 40. Anne Vallayer-Coster (French, 1744–1818). *Les Petits Favoris.* c. 1775–80. Oil on canvas, 16¹¹/₁₆ x 20⁹/₁₆ in. (42.4 x 52.2 cm). Private collection; courtesy Richard L. Feigen & Co., New York.

could also produce bizarre creatures, frighteningly apparent in his scary porcelain of a Bolognese dog of c. 1733 (fig. 38), whose white fur seems to have been set on fire, from tail to mane, by the devil himself and whose threatening fangs and bloodshot eyes totally belie the character of this breed, a cuddly white relative of one of the century's favorite lapdogs, the bichon frise, and one equally happy and harmless with fancily dressed ladies and mischievous children.

But such a hellish vision of a high-bred miniature breed was an eccentric exception in eighteenth-century artists' vast repertory of adored and adorable house pets, recorded in their Sunday best in every Western nation, even by artists who seemed to live in airborne worlds. So it was, for example, that in the 1760s the much-traveled Venetian painter Giovanni Battista Tiepolo could take time from the elaborate allegorical frescoes he was painting at the Royal Palace for King Carlos III in Madrid in order to record the beloved spaniel of the Infanta Maria Josefa (fig. 39). Perched with regal dignity on a gilded cushion and further ennobled by a swag of drapery, this furry sitter might almost be mistaken for a junior member of the Bourbon dynasty.

Especially in France, dog portraits aspired to the luxurious excess that was familiar to the residents of Versailles, and it would be easy to assemble an anthology of candidates for a pampered-pooch contest, whose reign would soon be overthrown by the mongrels of the Revolution. One prime contestant would be *Les Petits Favoris*, from the late 1770s, by Anne Vallayer-Coster (fig. 40). Like another female artist, Elisabeth Vigée-Lebrun, Vallayer-Coster enjoyed the patronage of Marie-Antoinette,

OPPOSITE

FIG. 39. Giovanni Battista Tiepolo (Italian, 1696–1770). *Portrait of the Spaniel of the Infanta Maria Josefa de Bourbón,* c. 1763. Oil on canvas, 17⁷/₈ x 12¹/₈ in. (45.5 x 31 cm). Private collection; courtesy Galería Caylus, Madrid.

ROBERT ROSENBLUM

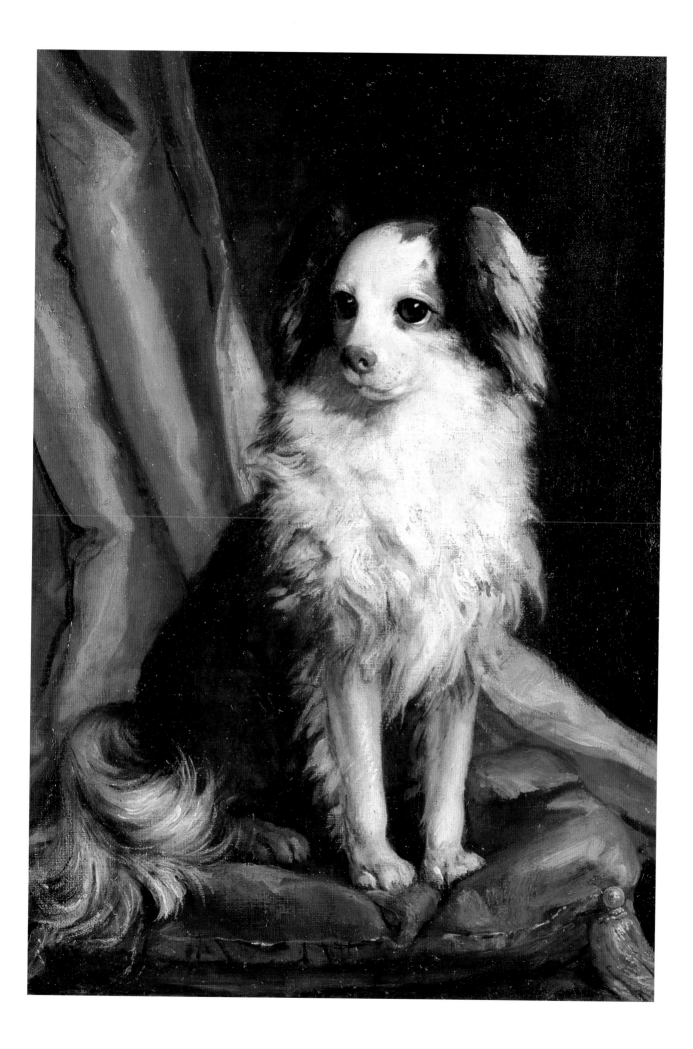

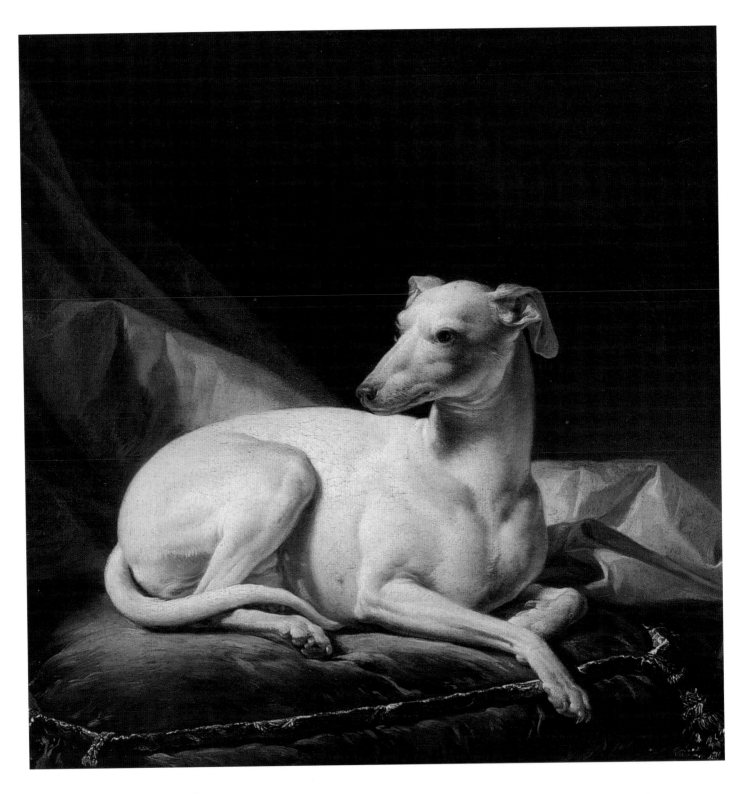

FIG. 41. François-André Vincent (French, 1746–1816). *Portrait of Diane, Greyhound of Bergeret de Grandcourt.* 24³⁄₈ x 29³⁄₈ in. (62 x 74.5 cm). Musée des Beaux-Arts et d'Archéologie, Besançon.

making her mark primarily as a still-life painter who chose the rarest and most precious objects for her table arrangements, whether porphyry bases, coral branches, or mineralogical specimens. It is hardly a surprise, then, that when she painted a canine still life, so to speak, it would reach similarly aristocratic excesses. Against the deceptively austere contrast of a blank, luminous wall, three adorable and exquisite dogs are displayed like an offering of jewels from a lady's boudoir. Two sleepy King Charles spaniel puppies relax beside another breed of lapdog, an Italian greyhound, whose attenuated grace is poised against the spaniels' informal pairing

ROBERT ROSENBLUM

as an improvised pillow of well-groomed fur. Already beribboned and accompanied by a jewel-encrusted dog collar, this trio is given the extra comfort of a tasseled velvet cushion, a prop familiar to this category of Rococo pets, which at times look even more spoiled than their owners. A velvet cushion can also be found in a painting of 1774 by François-André Vincent, a portrait of another greyhound, Diane (fig. 41), named after the huntress who, for those steeped in classical mythology, might be considered the patron saint of all hounds, much as Neptune would later be a name common to the Newfoundland breed, famous for its prowess in saving shipwreck victims from drowning. (As for classical names, two of Queen Victoria's favorite dogs were named Hector and Nero, and Prince Albert's beloved greyhound was named Eos.) Propped up on the cushion, against a swag of drapery, Diane seems to belong to a genealogical table as exalted as her name. Her master, Pierre-Jacques-Onésyme Bergeret de Grandcourt, a wealthy financier, commissioned Vincent to do not only his dog's portrait but his own, and both paintings were shown to the Parisian public at the Salon of 1777, where the artist also displayed more high-minded subjects, such as *Socrates Teaching Alcibaides*.

Bergeret de Grandcourt's affection for his pets could at times reach ludicrous extremes, which in retrospect symbolize the peaks of blue-blooded excess that led to the violence of 1789 and the beginning of the French Revolution. Upon the death of another one of his beloved dogs, Ninette, a bichon frise, he commissioned the most virtuoso of Rococo sculptors, Clodion, to design several mausoleums for her remains, and even the death of his pet canary, Fifi, prompted him to have the sculptor design a funerary monument. As for Ninette's tomb projects, the more elaborate one, from the early 1780s, shows the adored lapdog lying, predictably, on the kind of cushion that must have comforted her throughout her life (fig. 42). Supporting the tomb, two more lapdogs demand our attention by sitting up and begging, and therefore provide a witty spoof of the Greek caryatids that support the weight of a cornice. In a further display of classical erudition, these dogs hold in their hind paws the smoking torches familiar to the genies on funerary sculpture, leaving puffs of smoke, like an expiring life, spilling over the base of the monument. A lighthearted exercise in the tearful sentimentality that the French defined as *larmoyant*, this tomb can make one both laugh and cry.

A comparably extravagant, mock-serious conceit can be found in an unforgettable commemoration of a canine musician, a spaniel who happens to be a professional

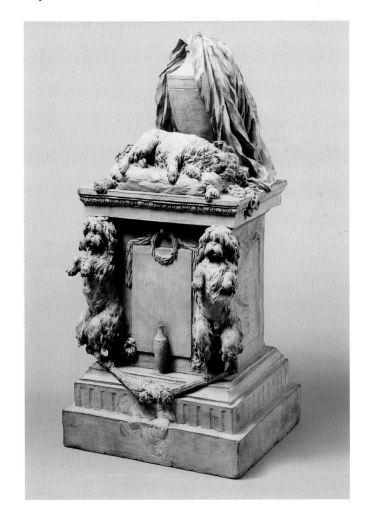

FIG. 42. Clodion (French, 1738–1814). *Model for a Mausoleum for Ninette.* c. 1780–85. Terra-cotta, 14 15/16 x 7 1/16 x 6 1/4 in. (38 x 18 x 16 cm). Musée Lorrain, Nancy.

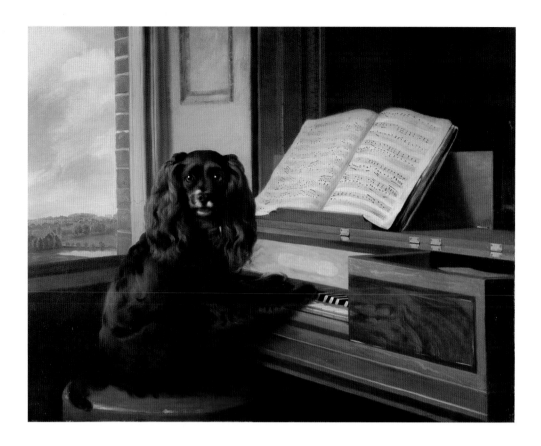

pianist. *Portrait of an Extraordinary Musical Dog* by Philip Reinagle, a canvas shown to Londoners at the Royal Academy exhibition of 1805, offers a glimpse of a keyboard virtuoso practicing, it would seem, in the privacy of a room in a country house (fig. 43). Seated on a piano stool before a window that frames an expansive landscape and sky, the spaniel stares us down with the intense eyes of another Beethoven, a Romantic genius immersed in his music-making. We know that Reinagle, who painted many dog portraits, was particularly interested in the training of spaniels, although hardly to this extreme; it has also been persuasively suggested that this ultimate fantasy of canines capable of the most complex human activity is a satire on musical life in late-eighteenth-century London. The score is apparently a florid variation on the tune of "God Save the King," of a sort that might have delighted a concert audience; but more to the point, the furry pianist is intended as a joke on the succession of human child prodigies who awed the public, beginning with Mozart's performances in 1764–65 and continuing with another infant pianist, William Crotch, who in 1777, at the age of two, could play "God Save the King," and two years later performed for the king and queen. Dogs playing human roles would become stock-in-trade for legions of popular painters and illustrators in the following centuries, when communities of dogs might be seen playing poker or running for the U.S. Congress, but few if any reached the peaks of this lonely pianist captured in an intimate moment of creative passion.

As fascinating as dogs' ability to mimic human behavior might be, constantly ascending an evolutionary ladder, their origins as wild animals, regressing back down

the ladder, continued to haunt artists' imaginations. Stubbs's legacy may be seen, for example, in the work of many French painters in the heyday of Romanticism, about 1815 to 1830, when animals so often became metaphors for the irrational instincts that might ultimately control the course of human behavior, whether in the ardors of love or the savagery of battle. A noble, if modest, reflection of this return to nature can be seen in the *Portrait of "Bel Pirro,"* by François-Xavier Fabre (fig. 44). On the occasion of the seventy-first birthday of his long-term mistress, the Countess of Albany, whose cosmopolitan company was known throughout Europe, his gift was this painting of her beloved dog, inscribed "Portrait du Beau Pyrrhus, offert à Mme la Comtesse Louise d'Albany, en reconnaissance de son grand amour pour lui, Florence 25 août 1823" (Portrait of the Handsome Pyrrhus, offered to the Countess Louise of Albany in recognition of her great love for him, Florence 25 August 1823). This avowal of intimate affection was further confirmed by the fact that the artist put his own signature, F.X.FABRE, on Pyrrhus's collar. Sporting a classical name, like so

FIG. 44. François-Xavier Fabre (French, 1766–1837). *Portrait of "Bel Pirro."* 1823. Oil on canvas, 25⅝ x 38⅝ in. (65 x 98 cm). Musée Fabre, Montpellier.

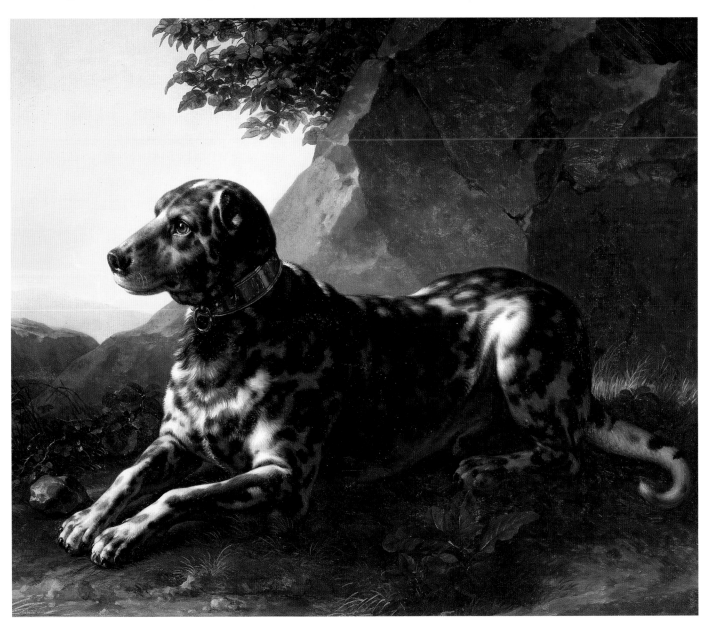

FIG. 45. Jean-Jacques Bachelier (French, 1724–1806). *Head of a Dog.* 1758. Oil on canvas, 20½ x 18⅛ in. (52 x 46 cm). Private collection.

many other dogs born in those centuries when tales of antique heroes and heroines were still vivid, Pyrrhus (whose portrait, incidentally, Fabre had also included in the landscape of one of his mythological paintings, *Oedipus at Mount Cithaeron*) seems as remote from human society as those dogs by Stubbs who have retreated into a forest far beyond the confines of their masters' property. Here, at human eye level and therefore demanding a full-scale confrontation, the countess's dog is alone and tensely alert in a rocky landscape, and the setting evokes his rugged natural origins rather than the cultivated intellectual pleasures of his mistress's famous salons.

For those French painters and sculptors who, in a post-Napoleonic world, would explore the passions of animals as a mirror of the frightening and uncharted depths within us all—the subrational territory that Sigmund Freud would later call the id—Stubbs could open one vista after another. In a period of high Anglophilia for a new generation of rebellious Romantics who turned to William Shakespeare or Lord Byron for the wildest releases of the imagination, Stubbs's paintings of both savage and domesticated animals could trigger new insights into turbulent emotional territories. Both the short-lived Théodore Géricault and his younger friend and fervent follower, Eugène Delacroix, would be ignited by the feral sparks widely disseminated in prints after Stubbs's work and, in their eagerness to absorb his lessons, made copies, both strict and free, of his inventions. Even in such a seemingly modest but shockingly intense painting of a bulldog by Géricault, probably dating from c. 1816, we sense this lineage (see fig. 119). Surprisingly, the dog is not seen seated or standing on all fours, but is cropped into a bust-length format, which forces us to confront it as if it were another human being. Occasionally dog portraits in the mid-eighteenth century, such as those by Jean-Jacques Bachelier (fig. 45), would depict only the upright head of a canine sitter, but this was done in a jocular way, as if noting with a smile the similarity between the wig of some aristocratic fop and the curly mane of a poodle. For Géricault's bulldog, who might have been nothing more ominous than the friendly pet of a neighbor, night has fallen, as its dark head bursts abruptly into the cramped space, seen as if in a flash of lightning. Its askew gaze darts toward us as if in fear, and this dog insists on eye-to-eye contact, a close-up confrontation that obliges us to share, for an instant, whatever passions are animating this sentient creature. In

ROBERT ROSENBLUM

a grimly ironic way, such a dog portrait provided Géricault with a trial run for his later portraits of the deranged patients of a pioneer of psychiatric studies, Dr. Etienne-Jeanne Georget. These distressed sitters also demand that we meet their glance in an emotional ambience of surprise and anxiety, as if the painter were trying to capture the fleeting mysteries of an irrational being who suddenly registered our presence, but on an unfamiliar level of distrust and confusion. In this small painting of a nameless dog who seems to have appeared by accident, Géricault seizes the rock-bottom fact that underneath their layers of civilized decorum, dogs, no less than people, conceal mysterious, irrational cores.

Although Géricault's attraction to the darker side of both animal and human psyches corresponded to the welling Romantic fascination with emotions of unbridled passion, few of his contemporaries could rival his genius in plumbing these depths. One of them was the much older James Ward, an animal painter whose feverish fantasies encompassed original scenarios and settings even for a commissioned posthumous portrait of the architect Sir John Soane's beloved dog Fanny, who is depicted meditating on top of a ruined column in a classical archaeological site of the type that had inspired his master. Ward's *Persian Greyhounds* (fig. 46), exhibited at the Royal Academy in 1807, transports us to an Orientalist dream in which familiar British foxhounds are replaced by a pack of salukis, an exotic breed of Bedouin hunting dogs favored by the Italian aristocracy, as documented in Benvenuto Cellini's bronze relief (see fig. 11). But here these luxuriant creatures, as taut and attenuated as European greyhounds and fabled for their Olympic speed, are seen against a wild and

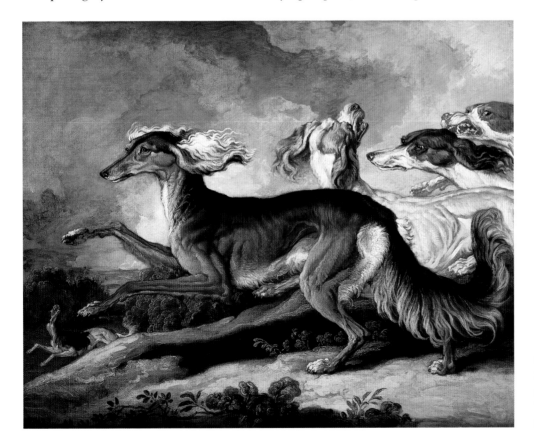

FIG. 46. James Ward (English, 1769–1859). *Persian Greyhounds.* 1807. Oil on canvas, 40 x 50 in. (101.5 x 127 cm). The American Kennel Club Museum of the Dog, Saint Louis.

desolate landscape, where stormy winds animate the delicately curling plumes of hair that mark their ears and tails. The pack, led by a saluki whose full serpentine grace is displayed in a life-size profile view, seems to rush past us like the vision of a djinni from the *Arabian Nights*. Ward, a central figure in the more extravagant reaches of the Romantic imagination, had no qualms about distorting the heads and bodies of his dogs and horses in order to enrich their expressive drama, a precocious preview of Delacroix's own Romantic bestiary.

Unlike Ward's dreamlike animals, most early-nineteenth-century depictions of dogs and wilder beasts emphasized bodies far more than souls, continuing in the footsteps of Stubbs's more scientifically objective accounts of animal anatomy. A case in point is the work of Ward's contemporary, the Geneva-born Jacques-Laurent Agasse, who, after studying veterinary science in Paris, in 1800 settled in England, where, like Stubbs, he painted both domesticated and wild beasts, ranging from racehorses and thoroughbred dogs to such zoological rarities, to European eyes, as a Nubian giraffe and the now extinct quagga. (He also tried his hand at antiquity, depicting the primordial legend of canine-human bonding, the she-wolf Lupa suckling Romulus and Remus (fig. 47). In *Rolla and Portia* of 1805 (fig. 48), he records a pair of greyhounds belonging to Lord Rivers, who bred these racing dogs on his Hampshire estate and gave them all names beginning, first, with the letter P, when he was the Hon. George Pitt, and then, with the letter R, when he became the second Lord Rivers. Within the protective outdoor enclosure of their kennels at Stratfield Saye, these greyhounds might be surrogates

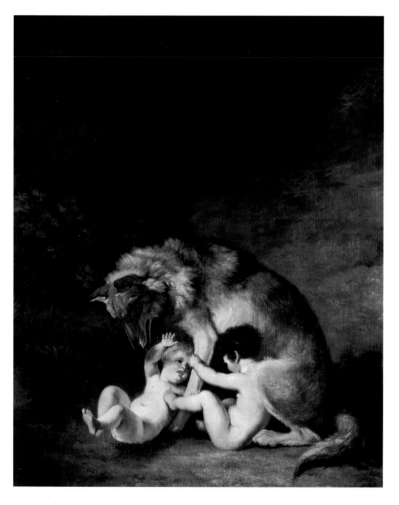

for Lord Rivers himself, who, a close friend of the Prince of Wales, was considered the very model of a dandy. Posing informally with the ease and long-limbed elegance familiar to portraits of the British nobility, this couple creates, with their attenuated silhouettes and seeming indifference, an aloofly aristocratic duet that is both welcoming and off-putting.

Such innate grace and dignity, conspicuous in greyhounds, could also be found in the work of the sculptor Antoine-Louis Barye, a member of that French Romantic generation, including Géricault and Delacroix, who could stalk the Paris zoo for insights into the savage terror of wild beasts, as well as record the more familiar company of domesticated horses and dogs. In the case of *Tom, Algerian Greyhound*, one

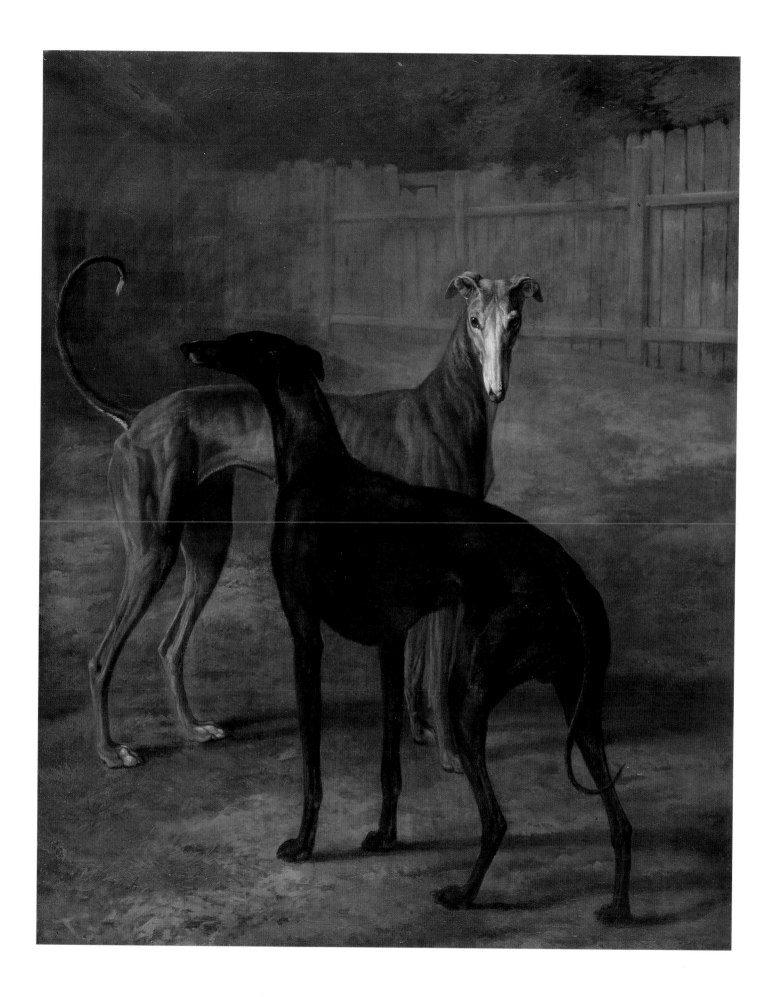

of his late bronzes from c. 1868 (fig. 49), Barye, like Agasse, captures the particular majesty of the breed, in this case transforming his own pet greyhound, Tom (given, like so many French dogs, an English name), into something akin to an ancient deity. With sphinxlike majesty, Barye's dog seems to stretch out for eternal admiration and worship, a creature of perfect symmetry with two identical side views, yet revealing, beneath his taut skin and richly colored patina, a veterinarian's knowledge of canine bone and muscle structure. Within the growing abundance of dog sculpture for a nineteenth-century public that cherished real dogs as well as bronze and marble ones in their living rooms, such canine beatification was not uncommon.

Another case in point from Barye's own generation of sculptors is the generically titled *Hound* (fig. 50) by the far lesser-known Grégoire Giraud, who exhibited this small marble at the Paris Salon of 1827, where the battle between Classicists and Romantics, led by Jean-Auguste-Dominique Ingres and by Delacroix, reached a fever pitch. Like Barye's greyhound, Giraud's dog is elevated on a geometrically pure base, here an oval, that helps transform it from fact to symbol. But Giraud's homage to this noble animal is far more than subliminal, because he has also illustrated on the plinth, in highly refined relief sculptures, the abstract qualities that define the dog's superior character: fidelity, courage, vigilance, and agility. These miniature narratives range from a dog fearlessly attacking a stag or a bull to a dog heroically risking its life to kill a snake that threatens a sleeping baby (a folkloric tale also illustrated by French painters of Giraud's generation). So it is that, despite its modest size and informal, if alert, posture, this dog is meant to embody all those qualities that give its species a unique sanctity, worthy of the kind of devotion that might be offered to a Christian saint.

FIG. 49. Antoine-Louis Barye (French, 1795–1875). *Tom, Algerian Greyhound.* Modeled 1868, cast c. 1889. Bronze, 17⅞ x 34½ in. (45.4 x 87 cm). The Walters Art Museum, Baltimore.

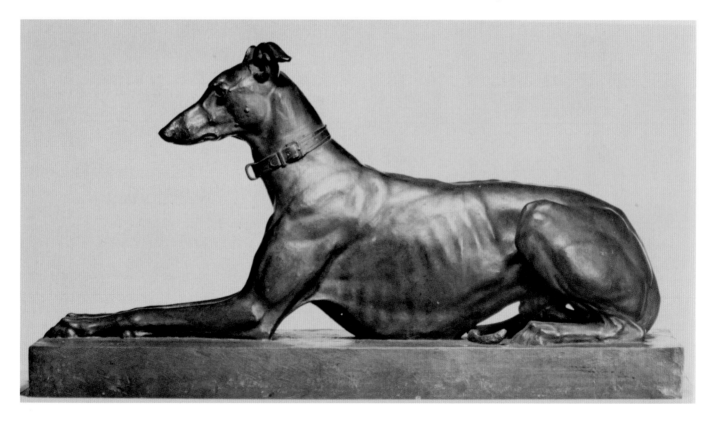

ROBERT ROSENBLUM

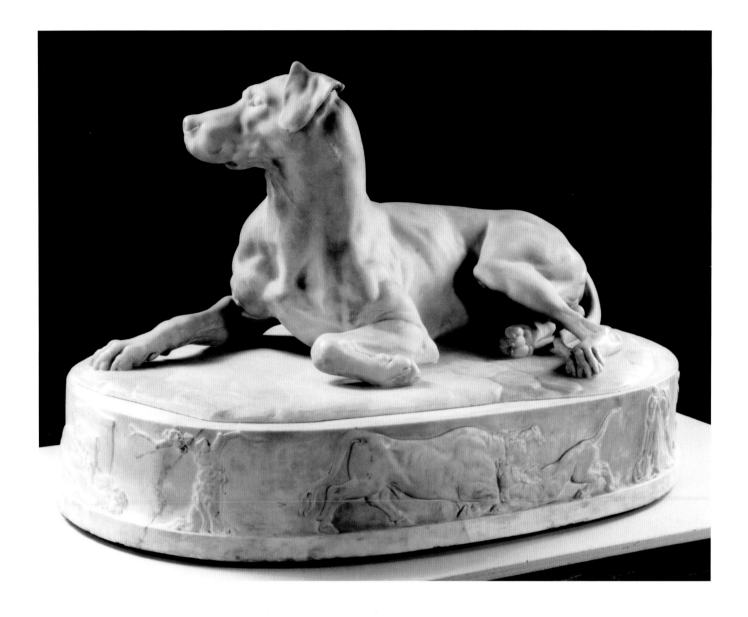

FIG. 50. Grégoire Giraud (French, 1783–1836). *Hound*. 1827. Marble, 20⅞ x 32¼ x 19⅝ in. (53 x 82 x 50 cm). Musée du Louvre, Département de Sculptures, Paris (Inv. N 15568).

Two years later, in 1829, the young Sir Edwin Landseer, the most famous dog and animal painter of nineteenth-century Britain, offered a very different variation on the same theme, namely, the extraordinary fidelity and courage that, unlike other animals, dogs can summon up to protect their human masters. But far from being a marble rebus of idealized abstractions, Landseer's painting, *Attachment* (fig. 51), offers a reportorial, seemingly eyewitness account of a hair-raising and heart-wrenching story. In April 1805 a young artist, Charles Gough, set off on a courageous outdoor adventure in the Lake District, planning to climb Helvellyn Mountain with only his dog as a companion. He was never seen alive again. Three months later a local heard a dog barking and found her watching over the corpse of the mountain climber, who had apparently fallen from a cliff, had died of head injuries, and was then desperately succored by his canine companion. Moreover, the story adds that, in the same tragic period, the faithful dog had given birth to a puppy, who did not survive the ordeal.

This tale of a dog's heroic watchfulness and devotion immediately triggered imaginative ruminations on the savage powers as well as the healing forces of wild

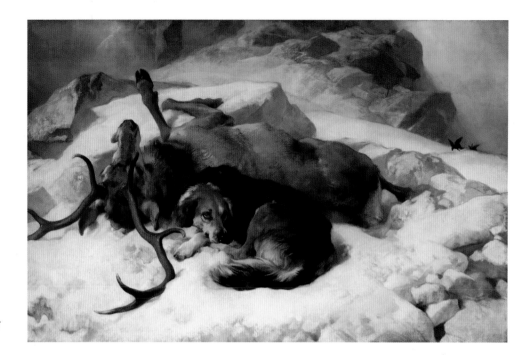

FIG. 52. Sir Edwin Landseer (English, 1802–1873). *Dog and Dead Deer* (also called *Chevy*). c. 1868. Oil on canvas, 54 x 82 in. (137.2 x 208.3 cm). The Detroit Institute of Arts; Founders Society Purchase, Alvan Macauley, Jr., Fund.

nature; and immediately afterward, two great Romantic authors wrote poems about the event (William Wordsworth's *Fidelity* and Sir Walter Scott's *Helvellyn*). Like the later nineteenth-century story of Edinburgh's "Greyfriars' Bobby," the Skye terrier who watched over his master's grave for fourteen years, this tale had a rich afterlife in word and image. Exhibited at the Royal Academy in 1830, with a quote from the poem by the dog-loving Scott, who, in 1824, had welcomed the artist to his fabled home in the Highlands, Landseer's painted interpretation of this literally cliff-hanging tragedy pulls out all the stops. We are perched on the edge of a vertiginous precipice, separated from the abyss by a boulder that has trapped the white-faced victim's arm and shroudlike cloak. And in the middle of this sublime and terrifying landscape, the lone terrier, for weeks into months, has never stopped watching over her master, both grieving him and perhaps still hoping that with her pawing vigilance she may resuscitate him. In one small canvas Landseer distills the widest spectrum of human drama, from the malevolent potential of untamed nature to the harmonious but heartbreaking emotional bond between man and beast that here reaches the almost operatic climax of star-crossed lovers. It was a theme of life and death, of canine self-sacrifice that Landseer had already explored in 1820 in a painting of two St. Bernards, equipped with brandy and a blanket, reanimating another mountain climber. He continued to vary this theme, depicted in less horrendous but still baleful circumstances, in perhaps his most famous painting, *The Old Shepherd's Chief Mourner*, of 1837. In this work, judged by John Ruskin to be a great modern painting, a lone collie rests its head on a shepherd's coffin. The same vein was tapped much later, in 1868, in *Dog and Dead Deer* (also called *Chevy*), in which we see the most loyal of hunting dogs freezing on a snow-capped mountain but still guarding the spoils of the chase, a dead deer, for his master (fig. 52). The painting's subtitle added a quote, in

OPPOSITE

FIG. 51. Sir Edwin Landseer (English, 1802–1873). *Attachment*. 1829. Oil on canvas, 39 x 31¼ in. (99.1 x 79.5 cm). Saint Louis Art Museum; gift of Mrs. Eugene A. Perry in memory of her mother, Mrs. Claude Kirkpatrick, by exchange.

ROBERT ROSENBLUM

Scottish dialect, that presumably recorded the gillie's confidence in Chevy's steadfast courage: "Weel, sir, if the deer got the ball sure's death Chevy will no leave him." Witnessing such passionate emotions, we realize that Landseer's contemporaries were becoming more and more attuned to the fact that animals were capable of feelings, of experiencing joy and suffering, akin to ours. This growing revelation was symbolized, in 1824, in the prime of Romantic rebellion, by the founding of the Royal Society for the Prevention of Cruelty to Animals.

Landseer's range in the depiction of animals in general and dogs in particular was vast, covering everything from the violence and bloodshed of traditional hunting scenes to portraits of the pets cherished by his most famous patrons, Queen Victoria and Prince Albert. His versatility was quickly demonstrated in his first decade of success, the 1820s. In 1828, one year before *Attachment*, he painted a portrait of Jocko, a fox terrier who belonged to Owen Williams, a wealthy member of Parliament (fig. 53). Jocko, like a curious infant, seems dumbfounded by his first encounter with a hedgehog, which responds to his tentative pawing by curling up and playing dead. Typically, Landseer examines here a charming moment in the education of an animal, assuming the role of an adoring parent who smiles at the innocent puzzlement of a child's first encounter with something strange and unexpected. More and more, Landseer, like his contemporaries, could push human society aside in order to focus on social exchanges in the dog community, a point made clear in a painting of 1839, *Deerhound and Recumbent Hound* (see fig. 91). Here we have clearly moved to dog level and are privy to what seems an informal exchange of intimacy and affection between

two hunting dogs in their man-made shelter, the equivalent of glimpsing the private lives of off-duty servants.

Across the Channel, artists also focused on these canine communities, offering, as it were, genre scenes that paralleled the Realist urge to depict anonymous people doing their daily, ordinary things, in sickness or in health. It is sickness that provides the theme of a remarkable glimpse of the downside of canine life by Alexandre Decamps, *Hospital for the Mangy ("The Convalescent Dogs")* (fig. 54). *"L'Opital des galeus,"* crudely inscribed on a cross beam at the upper right, in a swath of coarse paint that mirrors the humble setting, is a semiliterate version, appropriate to this makeshift, rural hospital, of *"L'Hôpital des galeux,"* that is, "hospital for the mangy." And as further reminders that we are in a lowly world, the artist has inscribed his own name and date, 1830, on the end of the wooden trough and, as wall decoration, has hung a horse's skull—a joke on the sacrificial ox skull (the bucranium) used to decorate the friezes of classical buildings. But we quickly turn from these asides to the poignant, if minor, drama, a pair of bassets who, suffering from mange, a highly contagious skin parasite, have been quarantined, their isolation and melancholy touchingly

FIG. 54. Alexandre-Gabriel Decamps (French, 1803–1860). *Hospital for the Mangy ("The Convalescent Dogs")*. 1830. Oil on canvas, 15 x 18⅛ in. (38 x 46 cm). Charles Janoray, New York.

emphasized by their friends, who, just like people, look at the patients from the other side of a barrier. Appearing at the same Paris Salon as Eugène Delacroix's grandiose *Liberty Leading the People*, Decamps's small canvas provided a modest diversion much relished by critics, not only for its tender canine translation of the commonplace of illness but also for its virtuoso variations on the bassets' warm, brown tonalities, an earthy palette that evoked comparison with Rembrandt. It is no surprise to learn that soon after, in 1834, the painting, retitled *The Convalescent Dogs*, was seen at the Royal Academy's annual exhibition in London, where an audience that had just become familiar with Landseer's canine dramas must have been particularly receptive to this import from Paris. The French, in fact, had many specialists who permitted audiences to share both the occasional excitement and the domestic tranquillity of dogs' lives, in both country and city. A particularly original example is *French Hounds* of c. 1860, an unexpected close-up of four hunting dogs (see fig. 98) by Albert de Balleroy, a specialist in animal painting who, like his close friend Édouard Manet (next to whom he stands in Manet's *Music in the Tuileries Gardens*), often exhibited at the Salons of the Second Empire. Here we are put in a startlingly face-to-face confrontation with a quartet of hunting dogs who loom up before us under a night sky, their legs and bodies cropped as they invade our space. Their white fur glistening in the moonlight and their collars chained together, they appear as apparitional, nocturnal creatures on the scent of their prey.

Balleroy's efforts to capture the intensity of the lives of hunting dogs as part of a more savage, mysterious landscape were echoed by many mid-century artists, especially in France. One example is *Hounds in a Wooded Landscape* of c. 1850–55 by Alfred Dedreux (see fig. 96), in which a darkening sky adds drama to a pair of hunting dogs, one at rest, while the other, a white greyhound, one of the artist's favorite models, is caught in a flash of white, suddenly tense and alert, sniffing the air. The same scent of prey permeates the air in *Hound Pointing*, a painting of 1860 by Dedreux's contemporary, Constant Troyon (fig. 55). Just footsteps behind this pointer, who, momentarily poised in a ditch with one paw over the edge, turns his head toward an unseen animal, we empathize with the excitement that marks the life of a hunting dog, further dramatized here by the threatening storm clouds gathering on the horizon.

These hounds could also be depicted in less heroic guise at home in their kennels rather than as courageous adventurers pitted against an often malevolent nature. A particularly endearing example is the portrait *"Barbaro" after the Hunt* by Rosa Bonheur (see fig. 97), whose fame as an animal painter and sculptor was as international as Landseer's, a celebrity status that prompted the Legion of Honor to make her its first female officer. Settled at the edge of the forest of Fontainebleau, Bonheur immersed herself not only in a world of domestic animals, from sheep to rabbits, but even had a menagerie that included lions and monkeys, all providing models for her art. Like many of her mid-century contemporaries, she specialized in one-to-one efforts to

FIG. 55. Constant Troyon (French, 1810–1865). *Hound Pointing*. 1860. Oil on canvas, 64½ x 51⅜ in. (163.8 x 130.5 cm). Museum of Fine Arts, Boston; gift of Mrs. Louise A. Frothingham.

ROBERT ROSENBLUM

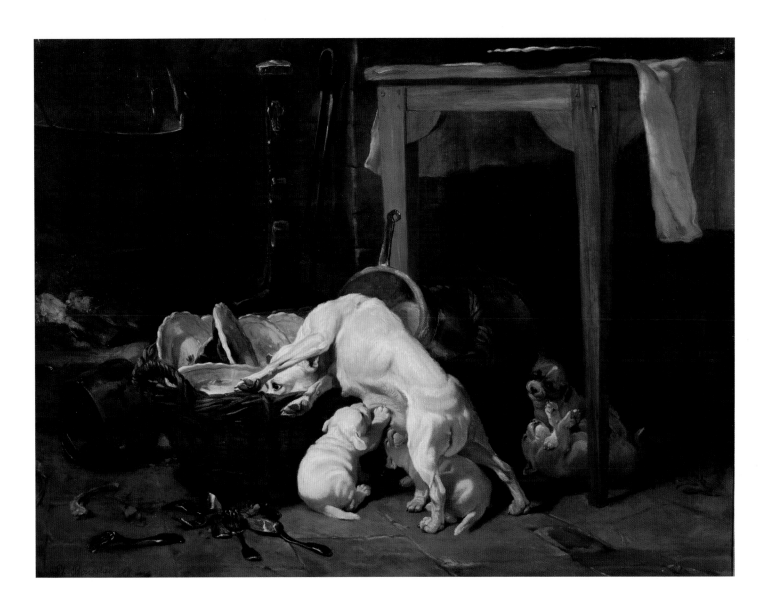

communicate with the individual lives of her sitters, capturing their changing moods. In *Barbaro*, a painting whose imposing dimensions put us on equal terms with this Grand Griffon Vendéen, a breed that specialized in rabbit hunting, Bonheur captures the dog's restlessness after his return from the hunt. His name coarsely inscribed on the kennel wall to mark his place, Barbaro is now chained to a nail, from which his unbuckled collar also hangs. His searching eyes apprehensive, he looks ill at ease. At his left are a bucket and brush, suggesting that it is the ritual dog wash that may be responsible for his anxiety. But the larger point is that the artist obliges us to share our emotions with those of an individual dog, just as we would with a human sitter, prompting us to invent a scenario that might explain this psychological unrest.

Nineteenth-century painters often revived those scenes of domestic havoc familiar to the many seventeenth-century Dutch and Flemish glimpses of unguarded kitchens, where stealthy dogs devour the family's next meal. But at times the bounty can be more meager, permitting us to shed a tear or two over the plight of a dog whose fight for survival matched that of the working class of humans. So it is in *Everyone for Himself* by Philippe Rousseau, a vignette of dog life (fig. 56) that was shown at the

ROBERT ROSENBLUM

Salon of 1865 in the very different company of Manet's *Olympia*. Oudry's contented, well-fed mother dog, who, in a painting a century before, had pleased so many Salon audiences, had now become a creature desperate for survival in a humble kitchen. As she ransacks the remains of dinner, looking for scraps of food in a basket full of dirty dishes, two of her innocent, cuddly pups are being suckled while two others frolic under a table, all four of them still unaware of the facts of life. It was a twinge of social conscience that was far more fully explored by a Belgian painter, Joseph Edouard Stevens, whose more famous brother, Alfred, specialized in fashion-plate paintings of upper-class women enjoying their domestic comforts. Although at times he did paint cherished pets, Joseph, in a fraternal about-face, shared the spirit of his generation, that of Karl Marx and Gustave Courbet, confronting again and again the grim realities of working-class poverty as mirrored in the urban world of dogs, whether employed or vagrant. He could record, for example, the miseries of being a cart dog, a mongrel that, in groups, was harnessed to wagons carrying passengers or cargo, the equivalent of equally abused dray horses. Elsewhere, he documented the pathetic street spectacle of a dog market, where impoverished humans display an assortment of canine wares to the highest bidder (see fig. 100). In *Dog with a Bone (Misère)* of 1854 (fig. 57), we watch a homeless survivor of the city looking for his next meal in the garbage left from a sumptuous shellfish dinner and finding only a bone to chew. Stevens could not have offered a more heartrending commentary on the difference between rich and poor, high life and low life (the titles, in fact, of other nineteenth-century dog paintings). Only a decade before, in 1845, another Belgian painter, Eugène-Joseph Verboeckhoven had recorded the opposite extreme, a group portrait of

FIG. 57. Joseph Edouard Stevens (Belgian, 1816–1892). *Dog with a Bone (Misère)*. 1854. Oil on canvas, 35⅞ x 47¼ in. (91.2 x 120 cm). Musée des Beaux-Arts de Tournai, Collection Van Cutsem.

the happy, well-groomed thoroughbreds (a Newfoundland, an Italian greyhound, and a King Charles spaniel), not to mention a parrot and a monkey, belonging to none other than King Leopold I (see fig. 95). Like his niece, Queen Victoria, the Belgian king had a passion for dogs and for those artists who, like Landseer, could best portray them in luxurious, yet informal, at-home situations.

As for Stevens's far more famous contemporary, Gustave Courbet, with his embrace of the common people and his loyalties to socialist politics, he was as much of a canine Marxist as the Belgian painter. Courbet painted in the rugged territory of the Franche-Comté, where he was born, and his images of coarse, regional folk shocked Parisian audiences. In his works, dogs suited the subject matter quite well, and ordinary rural mongrels even appear in his painting of a solemn burial. But for all his populist roots, Courbet had no problem experimenting with upward mobility, both human and canine, when, in September 1866, the wealthy comte de Choiseul invited him to a spend a month at his luxurious villa in Deauville, a posh resort on the Normandy coast. Following Agasse's aristocratic footsteps in the portrait of two of Lord Rivers's highly bred greyhounds, Courbet, appropriate to his blue-blooded

host, painted another pair of greyhounds reflecting the count's own elite breeding
(fig. 58). This casual duet follows closely the format provided in another painting
of a greyhound couple by a French artist of equal nobility, Henri d'Ainecy, comte
de Montpezat, who specialized in recording the most elegant dogs and horses of the
Second Empire's titled aristocrats (fig. 59). Courbet must have had such an upscale
image in mind when he painted the comte de Choiseul's greyhounds, echoing
the nonchalant informality of their poses that, as was also the case with Agasse's
greyhounds, adds to their natural hauteur. But Courbet being Courbet, he could not
help peering through this artificial rhetoric, disclosing an unexpected scruffiness and
awkwardness in this haughty pair. High above the horizon, they loom over us like
royals, one facing the Channel waters, the other turning his attention to the spectator
with a surprising expression of curiosity that undercuts the aloofness of the breed.
Similarly, Courbet challenges the formal conventions of depicting greyhounds as
streamlined abstractions. By emphasizing the brushy, irregular textures of their fur, he
undermines the presumed perfection of their silhouettes and tight-skinned bodies. In
Courbet's hands, the idealized greyhound begins to look downwardly mobile, given

a strong touch of the mutt who might be at home in the artist's native town, Ornans, just as in the posh villa of a count.

As our closest animal companions, dogs provide blank slates for almost any artist's goals, whether to sharpen our awareness of social injustice; to offer exemplary models of loyalty, love, and courage; to quicken our sense of the primordial ties that bind us to the animal world; or, in many cases, to play comic roles that prevent us from being too serious about humorless things. As for the latter, nineteenth-century artists, in particular, had a field day translating high-minded human activities into canine theater. Landseer, for example, offered the story of Alexander and Diogenes played by dogs and also envisioned a trial with a bewigged British judge played by a frizzy-haired poodle. Such jokes are common, expanding at times to a cast of hundreds, as in *The Dog Congress (Candidates for Bench Show)* of c. 1876, by William H. Beard (fig. 60), an American specialist in animal painting who also depicted, quite literally, the bulls and bears of Wall Street. Here the democratic chaos and order of a congressional election become a nineteenth-century version of a dog show at the Westminster Kennel Club. Painted in grisaille, which gives it the reportorial quality of a photograph or of the engraving that was, in fact, made from the painting for popular distribution, Beard's crammed little canvas captures both the elite and the rabble of the dog community of voters. In front of the triumvirate of dignified candidates,

FIG. 60. William H. Beard (American, 1824–1900). *The Dog Congress (Candidates for Bench Show)*. c. 1876. Oil on canvas, 19¹⁄₂ x 29³⁄₈ in. (48.9 x 74.6 cm). Wadsworth Atheneum Museum of Art, Hartford, Conn.; The Ella Gallup Sumner and Mary Catlin Sumner Collection Fund.

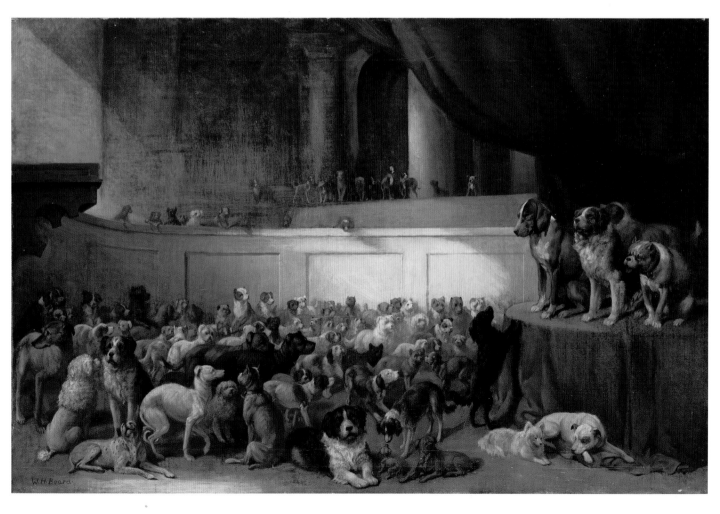

ROBERT ROSENBLUM

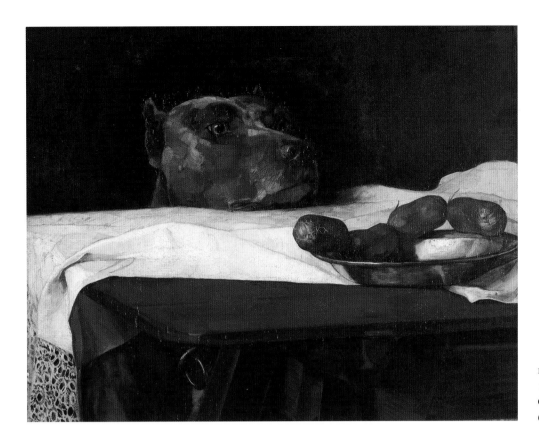

FIG. 61. Wilhelm Trübner (German, 1851–1917). *Crossing the Rubicon*. 1878/79. Oil on canvas, 19⅛ x 24 in. (48.6 x 60.9 cm). Staatliche Kunsthalle, Karlsruhe.

raised high on a table, is a cropped cross section of "the people," represented by a daunting assortment of thoroughbreds and mutts and a confusion of responses that range from eager spectatorship, with dogs straining for a glimpse of the chosen few, to downright indifference to the proceedings. Amazingly, every member of this canine constituency has an individual face, mirroring, as it were, the endless diversity of American voters at the polls.

Even more high-minded, at least in terms of historical references, is another painting of the 1870s, *Crossing the Rubicon*, by Wilhelm Trübner (fig. 61), a German artist who, even when he painted Christ's dead body, worked in a brushy, Realist vein. Dogs had often been given classical names (Diana, Jupiter, Pompey), so there was nothing unusual about their assuming, on occasion, the dictatorial authority of Julius Caesar himself, a joke enjoyed not only by Trübner but by contemporary illustrators. One of Trübner's paintings, depicting a dog wearing a mock laurel wreath of sausages, is subtitled *Ave Caesar, morituri et salutant* ("Hail Caesar, those who are about to die salute you"), a reference to the ritual gladiatorial tribute to the emperor; and in *Crossing the Rubicon*, a humorous modern close-up of all those aristocratic hounds guarding and sniffing their master's trophies, the dog's stealthy approach to the almost inaccessible sausage in a bowl on a tablecloth is likened to that great moment in 49 B.C., remembered from every nineteenth-century schoolchild's lessons in ancient history, when Caesar, then governor of Gaul, took the decisive but treasonous step of crossing the river boundary to Rome, a rebellious act that resulted in civil war and his overthrowing Pompey. For Trübner, this courageous defiance of military rule can

even be reenacted at home with a dog who looks very much like the artist's own pet, which appears in photographs of his master.

If a dog could play the role of Caesar, he could also play the role of an elegant French gentleman who stands up on two legs and sports a lorgnette, a point made unforgettably clear in an offbeat yet prophetic painting by Jean-Léon Gérôme. An artist whose name was synonymous with right-wing academicians, Gérôme had actually warned the president of France, Émile Loubet, to shield his eyes from the exhibition of mainly modern Impressionist paintings displayed at the 1900 Paris World's Fair, the equivalent, he thought, of a national disgrace. But just two years later, at the age of seventy-eight, he concocted a dog painting so deliriously irrational that we might date it from the heyday of Dadaism and Surrealism. It was then, in 1902, that the city of Paris sponsored an exhibition of advertising signs made by artists (an old tradition, in fact, with museum-worthy examples by Jean-Antoine Watteau and Géricault). Of all people, Gérôme was a participant, stepping out of his academic ivory tower into a public world of commerce, where he apparently felt free to let loose his verbal and visual wit in a sign for an optician's shop (fig. 62). On an opaque blue ground that undoes the illusionistic depths familiar to his official work, Gérôme, in a preview of the fragmented Cubist works of Pablo Picasso and Georges Braque, has inscribed O PTI CIEN, which, when pronounced in French, becomes a pun on "Au Petit Chien," that is, "at the sign of the little dog." A perky terrier, painted with the artist's hyperrealist precision, perches on a two-dimensional red line, which leaves it floating, like a mirage, amid the optical wares for sale. Two pairs of miniature binoculars, a round convex mirror, and one pair of glasses (whose lenses are tinted the same blue as the background) are attached, like *objets trouvés*, to the ornate frame. Above, the mirror reflects a huge cyclopean eye, and just below, a pince-nez frames a pair of eyes that, disembodied, hover over the dog; the disquieting sign stares back at us with an eerie, hypnotic intensity. It should come as no surprise that one of the painting's later admirers was Salvador Dalí.

Even by the most avant-garde twentieth-century standards, Gérôme's painting of 1902 was wildly eccentric, a capricious swan song from an artist firmly rooted in the nineteenth-century academy. But within a decade, before the outbreak of the First World War, dogs, like people, would be subjected to strange transformations that, through art, could turn them into machines or mysterious spirits. As for the former, the classic

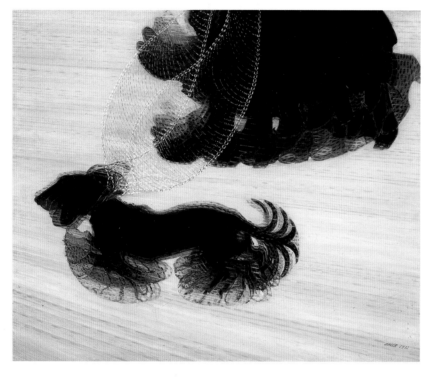

FIG. 63. Giacomo Balla (Italian, 1871–1958). *Dynamism of a Dog on a Leash.* 1912. Oil on canvas, 35⅜ x 43½ in. (89.8 x 110.5 cm). Albright-Knox Art Gallery, Buffalo, bequest of A. Conger Goodyear and gift of George F. Goodyear, 1964.

OPPOSITE
FIG. 62. Jean-Léon Gérôme (French, 1824–1904). *Optician's Sign.* 1902. Oil on canvas, 34¼ x 26 in. (87 x 66 cm). Private collection.

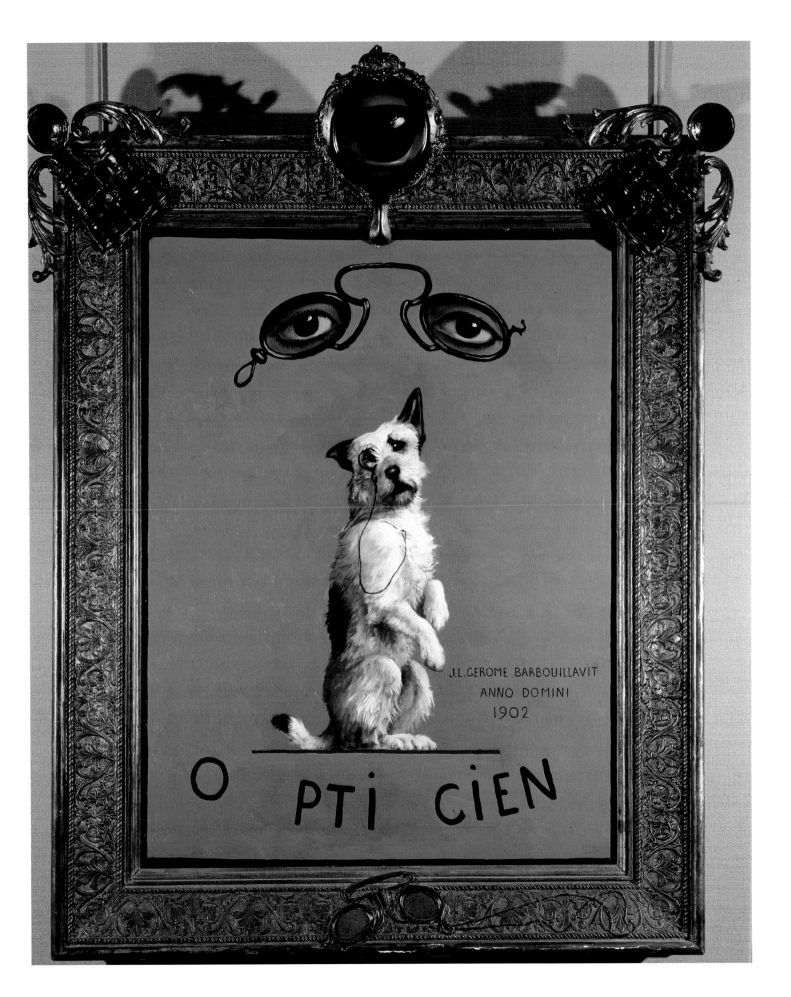

Modernist dog image is by the Italian Futurist Giacomo Balla, whose *Dynamism of a Dog on a Leash* of 1912 (fig. 63) looks like a hybrid fantasy of newfangled inventions, from motion photography and film to X-rays and diagrams of calibrated velocities. Balla further enforces his scientifically up-to-date vocabulary by adding a regimented pattern of broken lines on the frame. Ironically, this ultramechanized image was prompted by the artist's observation of a pupil of his, who happened to be a contessa, taking her dog out for a stroll in the Tuscan countryside. But like his fellow Futurists, Balla was obsessed with new diagrammatic ways of depicting motion, whether of machines, people, or animals, fusing in one image the constantly changing positions of something caught on the run. Here, as in a physics textbook about the interaction of space, time, and velocity, Balla compares the movement of the low-lying, short-legged dachshund (who has to walk faster than most dogs to keep up with his mistress's step), the circling rhythm of the metal leash, and the cropped fragment of the lady's shoes and skirt as they obey the relentlessly mechanized beat. In this triple forward-march against an immaterial background of swiftly streaking lines, even the dachshund's rapidly wagging tail, seen eight times as it rises and falls behind the blur of its moving legs, joins the Futurist parade that unexpectedly mixes a charming vignette from old-fashioned high society with a learned embrace of the latest news from a world of science and technology.

Such extremes produce their opposites, a point easily made in the work of the short-lived German painter Franz Marc, a victim of the First World War. Although at times he depicted people, usually naked, his overwhelming obsession was with animals, which, in his febrile imagination, could provide vehicles for reaching harmony with nature, so threatened by the modern industrial world. In a way, he

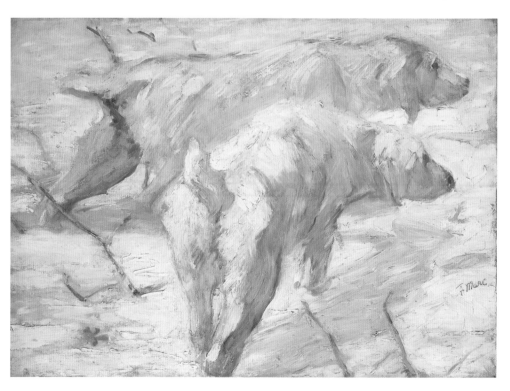

FIG. 64. Franz Marc (German, 1880–1916). *Siberian Dogs in the Snow.* 1909/10. Oil on canvas, 31⅝ x 44⅞ in. (80.5 x 114 cm). National Gallery of Art, Washington, D.C.; gift of Mr. and Mrs. Stephen M. Kellen.

ROBERT ROSENBLUM

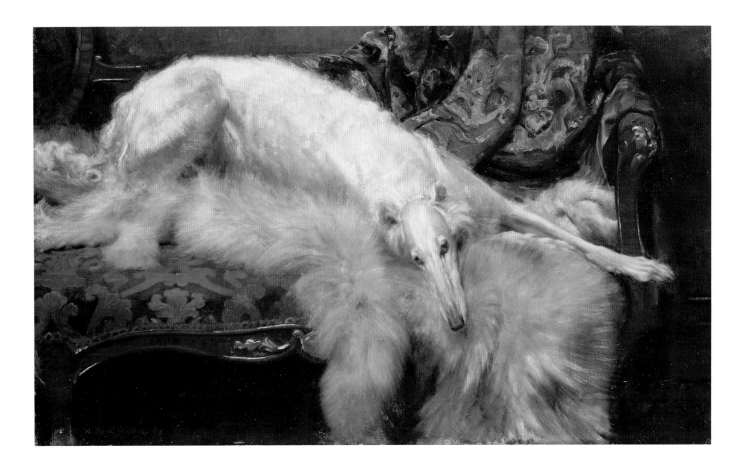

pursued the same goals as those of such earlier animal painters as Stubbs and Géricault, who could also find in animals a mirror of deeper truths that cut through human artifice, but Marc's words and his art pushed these intuitions to the brink of a spiritual mission. As he put it in a letter of December 1908, "I am trying to intensify my feeling for the organic rhythm of all things, to achieve a pantheistic communion with the throb and flow of nature's bloodstream in trees, in animals, in the air." In Marc's repertory of animals, which included horses and deer as well as lions and tigers, dogs loomed large, including his own pet Siberian wolfhound, Russi (an affectionate abbreviation of *russischer Hund*), whose inner being the artist hoped somehow to share. This snow-white breed prompted several paintings in which the dog seems to revert to its natural origins, in this case the remote, snow-covered plains of North Asia. In one painting of 1909–10 (fig. 64), Marc depicts two of these dogs, who, like phantoms, almost disappear within the equally white background of snow. A student of zoology might be interested in the way that nature camouflages these once wild animals, whose shapes dissolve in a white blur, but Marc, the seeker of spiritual truths, must have experienced this fusion of white fur on white snow as a regression to a primordial harmony of dog and nature, much as he would equate the whiteness of an animal with its inherent purity of soul. Less than a decade later, in 1918, the Russian pioneer of abstraction, Kasimir Malevich, pushed these mystical premises even further, envisioning an unpolluted, disembodied cosmos where a hovering white square could almost vanish against a white ground that seems to expand forever.

FIG. 65. William Frank Calderon (English, 1865–1943). *A Lady of Quality.* 1913. Oil on canvas, 30¾ x 48 in. (78.1 x 129.1 cm). Private collection, Florida.

FIG. 66. Photographer unknown. *Alexandra, Consort of King Edward VII, with Her Borzoi Russian Wolfhound Champion, Alex.* 1901.

It is amusing to imagine how repelled Marc, not to mention Malevich, might have been at the sight of a dog painting, also of a Russian wolfhound, by one of his conservative, older contemporaries, William Frank Calderon, the son of another successful Victorian painter. Reviving the Rococo tradition of depicting dogs totally at home with exquisite human artifice rather than with the elemental nature Marc hoped to penetrate, *A Lady of Quality*, exhibited at the Royal Academy in 1913, offers the portrait of a borzoi whose lap of luxury reaches extremes surpassing even those provided by the likes of Marie-Antoinette (fig. 65). In England, Russian wolfhounds (not called borzois until 1936) were an elite rarity, introduced as imperial gifts from the czars. A pair of them (a brace, in dog parlance) had been given to Queen Victoria, but the breed became better known through her successor, Queen Alexandra, who had also received them as a gift from her brother-in-law, Czar Alexander III, and who would enter her own favorite, Alex, in many dog shows, where he won prize after prize. So close was their bond that she would even be photographed with him on January 31, 1901, while still dressed in mourning for her mother-in-law, Queen Victoria (fig. 66). The borzoi reeked of noble refinement and sensibility, sure to equal or perhaps even to confirm the status of its owner, as in the case of a famous portrait, by Jules Clairin, of the renowned actress Sarah Bernhardt languorously reclining on a sofa as her pet borzoi assumes a similar pose at her feet. Calderon's "lady of quality"–the title says it all–reaches the heights of canine elegance and comfort. Her snout, torso, and legs more attenuated than those of the most thoroughbred human aristocrats, she stretches out for yet another siesta on a feathery white animal pelt that rivals her own silken fur, a pelt that in turn covers a chaise longue further embellished by its gilded Rococo frame and an embroidered swag of drapery. A perfect match for Giovanni Boldini's and John Singer Sargent's most extravagant society portraits of the "belle époque," *A Lady of Quality* might well be subtitled "The Last Romanov."

From the orthodox view of what happened in twentieth-century art, Calderon's painting would be considered an endangered species, although it is a species that continues to flourish today in the international world of commercial dog portraits. But the classic masters of modern art, being as human as the rest of us, could also turn to dogs for inspiration, even in their most imaginary excursions to a fairy-tale world, visible only to the inner eye. Such was the case in *Howling Dog*, a typically childlike invention by the Swiss-born Paul Klee in 1928 (fig. 67). Like Franz Marc, his junior by one year, Klee lived and exhibited in Munich before 1914 and must have been aware of his colleague's passionate efforts to reach the mysterious souls of animals, both wild and domestic. If anything, he pushed this direction further, but with a more whimsical touch, evident in this image of archetypal canine behavior, a dog barking at the moon. Within a foggy, fluid atmosphere that suggests a spooky night in a Germanic forest, a wraith of a dog bays at the remote glow of the moon, an eerie sound that, through a meandering line, seems to penetrate the entire canvas. But

ROBERT ROSENBLUM

FIG. 67. Paul Klee (Swiss, 1879–1940). *Howling Dog.* 1928. Oil on canvas, 17 1/2 x 22 3/8 in. (44.5 x 56.8 cm). The Minneapolis Institute of Arts; gift of F. C. Schang.

Klee, like Marc before him, would try to share the dog's imaginative life, which here transforms the night forest's ghostly forms into a mirage that looks like both a tree with leafless branches and a stag with antlers. In the 1920s, the heyday of Freud and Surrealism, this might almost be the material of canine dream analysis.

Klee's theme was a universal one, the stuff of proverbs about folly or of excursions into nocturnal mysteries, and is even better known through another Surrealist exploration of the more mysterious side of a dog's life. *Dog Barking at the Moon* of 1926, by the Catalan master Joan Miró (fig. 68), also rushes us to the dead of night, replacing Klee's Nordic fog with a Mediterranean clarity, which silhouettes precisely every strange shape that, with lunar whiteness, floats about this pitch-black sky. As in Klee's painting, there is a comic, childlike ring (further enforced by the artist's inspiration in cartoon art), but there is also the opening of darker vistas that suggest longing and helpless folly. The dog barks at the inaccessible image of a man-in-the-moon profile, just as the ladder, at left, rushes upward to an equally inaccessible cloud-bird that, far, far away, floats by. We seem to have regressed, as in Klee's painting, to a more instinctual world of canine fantasies, alert to the primal facts of nature

FIG. 68. Joan Miró (Spanish, 1893–1983). *Dog Barking at the Moon.* 1926. Oil on canvas, 28¾ x 36¼ in. (73 x 92.1 cm). Philadelphia Museum of Art, A.E. Gallatin Collection.

that overturn reason. It was, in fact, the kind of fantasy that could be re-created in many forms, including the world of science fiction, in which extraterrestrial friends and enemies contact planet Earth through spaceships as beyond reason as the moon and the sun. In the 1980s, when *Star Trek* and *Star Wars* ruled imaginations young and old, the short-lived Keith Haring, a victim of AIDS, invented the equivalent of cartoonlike hieroglyphs from a remote civilization, archetypal images of humans and animals in mythic adventures that, like an inspired gremlin, he spread far beyond the confines of art museums, all the way to T-shirts and subway stations. In his vast repertory of ideograms, as easily intelligible to children as those by Klee and Miró, dogs figure large. In one of these images, made with a marker, indicative of his role as a graffiti artist, an Earth dog barks not at the moon but at a UFO that may be planning an abduction to outer space (fig. 69).

Dogs, like their masters, mirrored the preoccupations of their moments in history. If Klee's and Miró's howling dogs of the interwar period speak of Freud and Carl Jung, dogs who survived the Second World War and Hiroshima often bear the

ROBERT ROSENBLUM

FIG. 69. Keith Haring (American, 1958–1990). *Untitled.* 1982. Marker and acrylic on board, 6¾ x 8½ in. (17.1 x 21.6 cm). Courtesy The Stephanie and Peter Brant Foundation, Greenwich, Conn.

scars of their human companions. That bleak, postapocalyptic mood is cast on the unforgettable bronze *Dog* of 1951, by Alberto Giacometti (fig. 70), the exact canine counterpart to the sculptor's haunting population of isolated human beings whose attenuated flesh has turned into an impalpable mixture of spirit and feeling. Only eighteen inches high, the size of an elegant bibelot for a nineteenth-century drawing room, this anonymous dog, its loping gait paralyzed by the long, thin base, offers disturbing variations on earlier traditions. Like Joseph Edouard Stevens's homeless and starving urban dogs, this one conveys an acute sense of melancholy and despair, a point made by Giacometti when he recalled how, walking through postwar Paris in the rain, he was reminded of a sad, head-down dog he had once seen and was moved to project his own emotions into this canine form, imagining that he was looking at the world and sniffing the ground as if he were a dog himself. Arriving home, he began working on a sculpture of this canine pariah, destined to be alive but forever alone on city streets. No less than Giacometti's human wraiths, this dog might be used as a logo for Existentialism, an image that evokes the Paris of Jean-Paul Sartre. And,

FIG. 70. Alberto Giacometti (Swiss, 1901–1966). *Dog.* 1951. Bronze, height 18 in. (45.7 cm). The Hirshhorn Museum and Sculpture Garden, Washington, D.C.

OPPOSITE
FIG. 71. Francis Bacon (Irish, 1909–1992, active in Britain). *Man with Dog.* 1953. Albright-Knox Art Gallery, Buffalo.

looked at from another angle, this pitiful dog makes a sour mockery of the elongated grace familiar to the rendering of upper-crust dogs like greyhounds and borzois. Distilled to an almost skeletal armature, its leanness has more to do with hunger and loneliness than with aristocratic breeding and artificial grace.

Across the Channel, in postwar London, comparably alienated but far more menacing dogs emerged on dark and rainy city streets in the nightmare inventions of Francis Bacon. Like Giacometti, his senior by eight years, Bacon seemed to work in an emotional range that mixed private melancholy with a public awareness of a new world born in the shadows of concentration camps and atom bombs. In 1952–53 Bacon did a series of dogs seen alone on city streets, spooky apparitions that instantly evoked a potentially savage presence in the midst of man-made order. The images of these dogs, in fact, were taken from Eadweard Muybridge's innovative studies of human and animal locomotion, published in 1887, which, in sequential photographs, documented one split second after another of the ordinary movements of man and beast. Bacon was particularly attracted to a series of twenty-four photographs that recorded the steps of a large mastiff, whose name, Dread, is lived up to in his paintings. In the last and most ominous of the series, *Man with Dog* of 1953 (fig. 71),

ROBERT ROSENBLUM

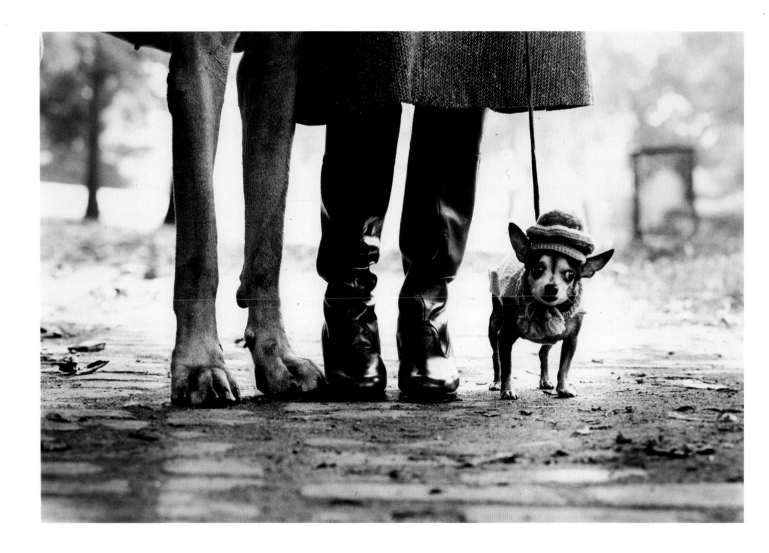

FIG. 72. Elliott Erwitt (American, born 1928). *New York City.* 1974. Gelatin silver photograph, 20 x 23⅞ in. (50.8 x 60.6 cm). The Museum of Fine Arts, Houston; gift of Anne H. Bushman.

he excerpts a frame from Muybridge's documentary sequence (#9) and reincarnates it in a painting of an empty, pitch-black city, so that the white blur of the dog standing on a pavement in front of a sewer grate becomes even more ghostly in contrast to the signs of man-made order. And to add another haunting dimension to the image, the dog is not alone, like the other dogs in the series, but wears a glistening, almost immaterial leash, like a sinister path of Futurist motion, that is attached to its invisible master—invisible, that is, except for the inexplicable shadow of his lower legs and shoes across the gray pavement. Two decades later, in 1974, the American photographer Elliott Erwitt, who made hundreds of irresistibly entertaining photos of urban dogs, offered a welcome comic relief to Bacon's vision of a still from a horror film about a city where a satanic dog and owner roam by night. His *New York City* of 1974 (fig. 72) offers a startlingly fragmented glimpse of a commonplace sight, as seen from the lowest possible dog's-eye level. Here city dogs become part of the human comedy as, in the midst of winter pedestrian traffic, we first come face to face with a Chihuahua, bundled up in a wool hat and scarf, and then move our eyes way, way up to discover that high above its and our horizon are two elongated pairs of cropped legs, one pair belonging to what appears to be a Great Dane, the other to the dogs' fashionably booted mistress.

ROBERT ROSENBLUM

As for Bacon's supernatural world of canine ectoplasm, it turns out that there was at least one contemporary branch off his tree, as documented in a horrific little painting of the 1950s by an obscure British artist, Denis Wirth-Miller (fig. 73). A close friend of Bacon's in the 1940s and 1950s, Wirth-Miller at one point even shared a flat or studio with him. Although he apparently painted mainly landscapes, there are several grisly exceptions to this, one being a painting of a dog from the same vintage, c. 1951, as Bacon's spooky canines. Its connection to Bacon could not be clearer, although its lashes of white brushwork and more literal rendering are obviously by a very different hand. For one, the image is taken from the same series in Muybridge's *Animal Locomotion* that Bacon had used for his trotting mastiff (but from a different frame, #12). For another, this is, if possible, a far more hellish dog than Bacon's, an understudy, were it given two more heads, for the mythical canine role dog lovers prefer not to think about, that of Cerberus. To find in recent centuries an ancestor of this supernatural demon, one might look back to Johann Gottlieb Kirchner's porcelain Bolognese.

Of course, for artists remote from Europe, the trauma of the war years seemed to take place on another planet, and no more so than in the work of Andrew Wyeth, the artist whose name has been so firmly synonymous with the preservation of rural American values that one could never guess from his work that he had ever been to New York City. As an endangered species, his art clings steadfastly to the depiction of venerable traditions of rugged country life inspired by his residence in backwater

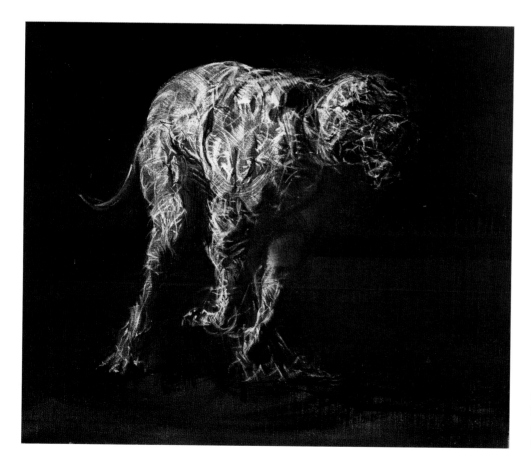

FIG. 73. Denis Wirth-Miller (English, born 1915). *Running Dog.* c. 1951. Oil on canvas, 29½ x 36 in. (74.9 x 91.4 cm). Courtesy James Birch.

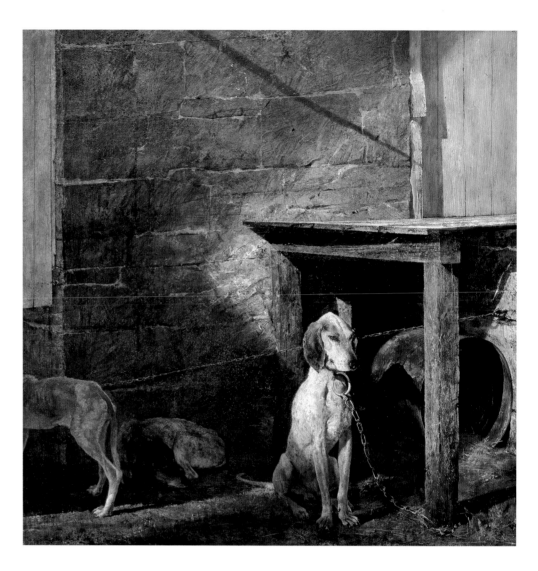

areas of Maine and Pennsylvania. In *Raccoon* of 1958 (fig. 74), he evokes a seamless continuity between those nineteenth-century images of hunting dogs, chained in their barns like Bonheur's *Barbaro*, and regional American life of the 1950s. Painted in tempera on panel, a technique as archaic as the theme, *Raccoon* offers a bleak glimpse of three hounds imprisoned for untold hours in a barn of chilling austerity, where only cracks of sunlight appear. Wyeth's signature palette of browns, beiges, and grays underlines, with this puritan monochrome, the simple stuff of country life—wood, stone, earth—in which any color would be a seductive intruder. The solemn mood is encapsulated in the local dog, Raccoon, which, according to Wyeth, was a "fabulous model" and one he rendered with such sharp-focus reality that a woman working in the New York gallery where the painting was shown quipped that she had gotten fleas from it. Remote as this may seem from the worlds of Giacometti and Bacon, there is, if only by coincidence, a similar mood of painful isolation, forcing us to focus on a sentient animal as alone in a void as the human players in Wyeth's silent dramas.

Old-fashioned dogs could also make an appearance in very different ways, as is clear from the ones that turn up in the work of the German painter Georg Baselitz, who as a teenager crossed Berlin's East/West barrier and who later would live with

ROBERT ROSENBLUM

his favorite breed, the bull mastiff. Like his broadly brushed, willfully crude way of painting—a conscious revival of Germany's Expressionist heritage—his subjects often have an earthy coarseness, depicting simple country types and animals in settings as remote from the modern world as Wyeth's, but animated by a ferocious energy that could tear their world to shreds. Dogs make many appearances in this repertory firmly rooted in German peasant soil. In *Two Upward Dogs (Zwei Hunde aufwärts)* of 1968 (fig. 75), the year before Baselitz began painting his images upside down, we are confronted with a frightening canine archetype, almost more wolf than dog, whose impact is so violent and sudden that it is hard to correlate the title with the number of dog fragments that we see in the three fractured horizontal tiers. One head, two bodies, and three tails lunge across this pallid green landscape, leaving behind a blur of movement, a savage replay of Balla's harmless little Futurist dachshund. Knowing the artist's biography and the tormented history of his country, one finds it hard to

FIG. 75. Georg Baselitz (German, born 1938). *Two Upward Dogs (Zwei Hunde aufwärts)*. 1968. Oil on canvas, 63¾ x 51¾ in. (162 x 130 cm). Courtesy Michael Werner Gallery, New York and Cologne.

look at these wild creatures without recalling the police dogs that were taught to work for their Nazi masters.

Like people, dogs can learn to be vicious, but in art, as in life, they are far more often seen as comforts who can offer a kind of solace, a point made in works by two British artists, Lucian Freud and David Hockney, who update and bring a new edge to the countless images of dogs sharing, in the most informal ways, the domestic lives of their owners. As for Freud, a self-proclaimed dog lover, he focused on a situation instantly recognizable to all of us who have lived with dogs, namely, the way they

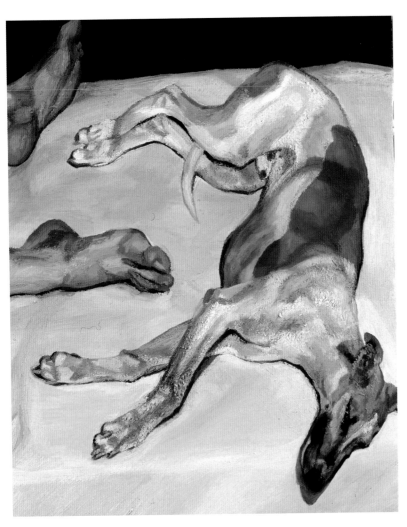

usurp human presences in our beds. Working in his signature style of ruthless, gritty realism, in which everything seems far uglier and harsher than unedited truth, Freud, for decades, painted variations on the theme of a human and a dog sharing the total physical abandon of flopping down on a bed and embracing in awkward but heartbreakingly tender ways. He could depict everybody from his own daughter to his studio assistant in this posture of intimate bonding, so familiar in real life but so rarely, if ever, depicted in art. Perhaps the most surprising of these bedroom couples, whose arms and legs are usually intertwined, is an overhead view dating from 2002 (fig. 76), in which we see the full reclining body—paws crossed, tail between legs—of the whippet Eli (a descendant of Freud's beloved Pluto, who was actually a female and whose grave Freud would later paint). But at the left, drastically cropped by the frame, a graceless pair of human feet that happen to belong to the artist's studio assistant, David Dawson, suddenly intrude,

FIG. 76. Lucien Freud (English, born 1922). *Eli.* 2002. Oil on canvas, 28 x 24 in. (71.1 x 61 cm). Private collection.

making it clear that the dog is stretched out at the feet of his human bed partner. And with amazing subtlety for an artist known never to cringe at the coarseness of ordinary facts, these two feet seem to be forever locked into place in an alternating pattern with the dog's own legs.

We may experience a similar shock of domestic candor in one of the forty-five painted variations Hockney made in 1995 on another theme of canine comfort, the warming sight of his two beloved dachshunds, Stanley and Boodgie, at home and at ease on a blue and yellow pillow in postures of total relaxation that only dogs, we feel, can assume (fig. 77). A highly informal mutation of those eighteenth-century portraits of dogs who posed with frontal charm or dignity while propped up on velvet

ROBERT ROSENBLUM

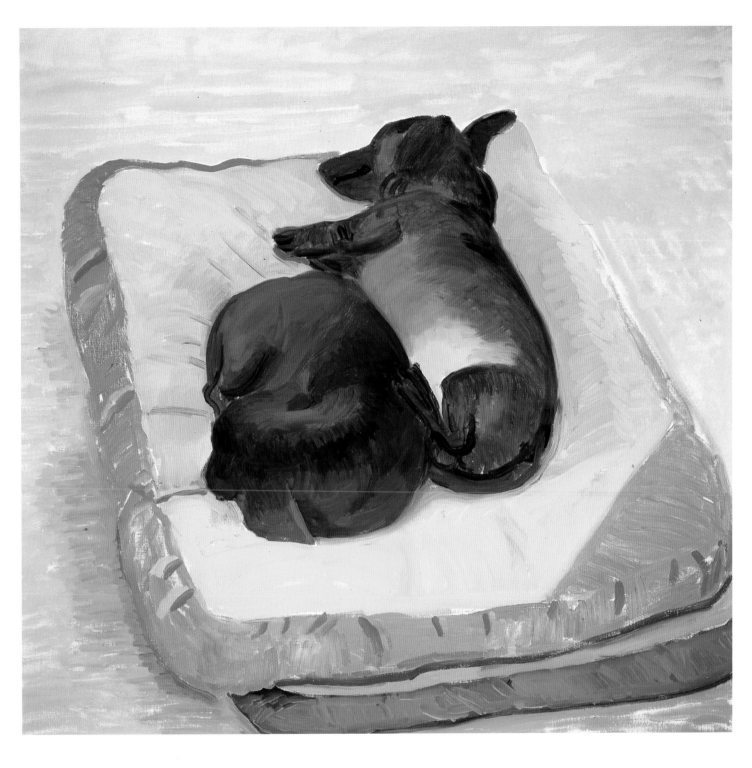

FIG. 77. David Hockney (English, born 1937). *Dog Painting 22*. 1995. Oil on canvas, 18¼ x 25¾ in. (46.4 x 65.4 cm). Private collection.

cushions, these cosseted dogs reveal an intimacy and warmth that Hockney once put into words: "The dogs were my little friends and I started painting them after Henry died" (that is, Henry Geldzahler, a prominent art-world figure and one of the artist's closest friends). "It was probably my wanting a tender, loving subject." Tender and loving as these vignettes are, they were also used by Hockney as a series of formal variations on the delicate contrast of the messy shapes of the dachshunds' warm brown bodies with the orderly disposition of floor, cushion, and wall rendered in the palest colors, a rigorous sequence that offers a canine version of Josef Albers's *Homage to the Square*.

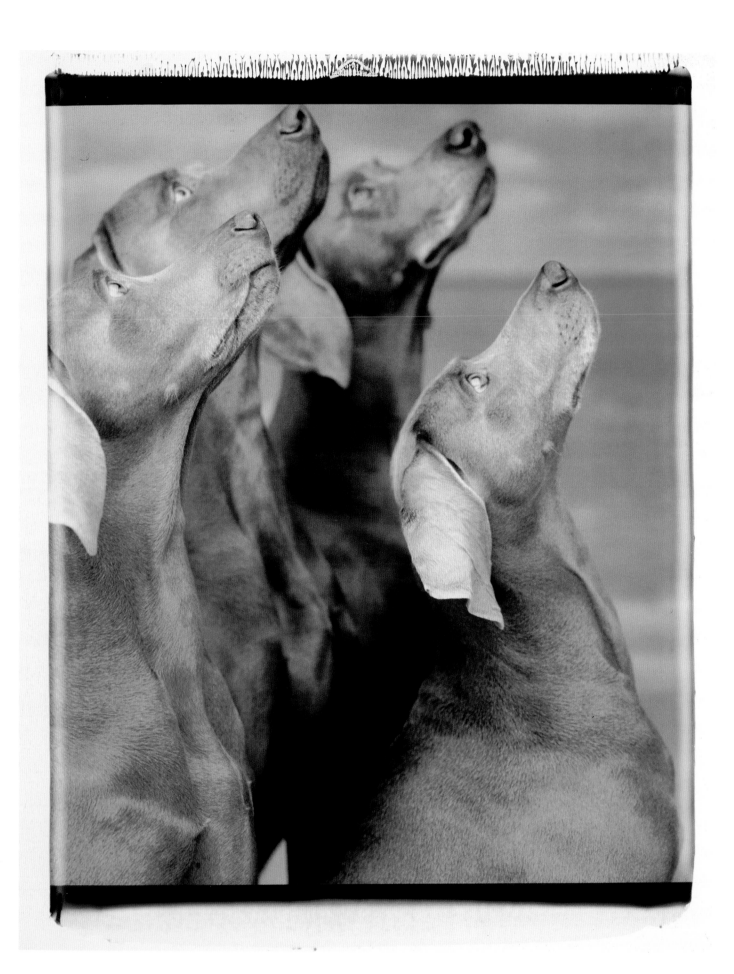

It was a fascination with sequential images that kindled many artists' imaginations, including that of William Wegman, by now a household name, known as the photographer who totally revamped what are called "anthropomorphic" dog images, using his own obedient weimaraners to pose as everything from fashion models and a Picasso guitarist to Little Red Riding Hood and a grade-school student of arithmetic. In *Flöck* of 1998 (fig. 78), the artist's compliant and usually costumed purebred dogs seem to revert to more atavistic roots, grouped as an uncollared and unleashed pack of four hounds out in the wilds who, with upturned eyes, are suddenly alerted to what must be a flock of birds passing above them. As such, they may be allied to familiar outdoor traditions of depicting dogs on the trail, such as Balleroy's disciplined quartet of French hunting dogs or Baselitz's more savage German pack. But characteristically for Wegman, artifice triumphs over nature, because this quartet of weimaraners turns out to be an elegant spoof on themes and formats familiar to more high-minded modern art. Constructed as a four-part polyptych, each photograph is slightly different from its neighbor. What may start off as an image of rural dogs doing what comes naturally ends up as a mock-serious variation on everything from Muybridge's sequential motion photographs and Monet's series paintings to the repetitive, elemental geometry that defines the abstract look of Minimalism.

OPPOSITE

FIG. 78. William Wegman (American, born 1943). *Flöck* (one of four panels). 1998. Iris color digital ink-jet photograph, 43½ x 34½ in. (110.5 x 87.6 cm). The Museum of Fine Arts, Houston; The Manfred Heiting Collection.

BELOW

FIG. 79. Andy Warhol (American, 1928–1987). *Ginger*. 1976. Synthetic polymer and silkscreen on canvas, 50 x 40 in. (127 x 101.5 cm). Private collection; courtesy Sperone Westwater, New York.

A comparable mix of old-fashioned traditions and up-to-date wit animates *Ginger* (fig. 79), a 1976 dog portrait by Andy Warhol, whose many dog paintings can range from the studied formality of this perfectly sedate and immaculately groomed cocker spaniel to the Polaroid-type intimacy familiar to the portraits of his two beloved miniature dachshunds, Amos and Archie, which, in his art, as in his life, offered a preview of Hockney's relationship with Stanley and Boodgie as both models and the closest of friends. But in *Ginger*, such domestic coziness is replaced by an unexpected grandeur in which a beloved house pet, belonging to the art collector Peter Brant, almost usurps the commanding authority of Warhol's celebrity images, whether of Elvis or Chairman Mao. The stiffness of the pose against a blank, pale-blue ground evokes the studio setup of nineteenth-century portrait photography, but

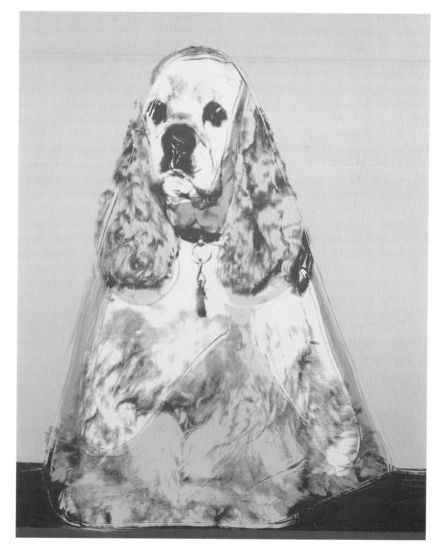

Warhol turns this dog's snapshot into something startlingly unfamiliar. Looming much larger than life (the canvas is four feet tall), assuming a posture of pyramidal monumentality, and looking far beyond and above a lowly spectator, Ginger reigns with an aloof majesty unexpected in the category of pampered pets. In a nod to the traditions of aristocratic society portraiture, Warhol renders Ginger's luxuriant coat of caramel-colored fur with dashing, bravura brushstrokes, just as the artist's human sitters seem to have their pedigrees enhanced by memories of Sargent's and Boldini's virtuoso animation of pigment. Ginger still belongs to the blue-blooded world of Calderon's borzoi, the "lady of quality," except that she has now left her siesta in order to pose for an official state portrait.

No less imperious and, if possible, even more coddled is a life-size wooden *Poodle* by Jeff Koons (fig. 80), who, in a triumph of metamorphic kitsch, has somehow married this breed, famous for its elaborately artificial coiffure, to the image of a teenage rock star, who might also spend most of her life fashioning curls and tresses. Her glass eyes glistening as if gazing into a mirror or at an admiring spectator, this

painted poodle is a tour de force of a groomer's and a sculptor's skill in rendering everything from the puffy tufts that crown each paw to the cascades of silken hair that, like a sumptuous fur collar, frame her head and shoulders and that, tied in a discreet knot sweeping upward from her forehead, become a further adornment to the profusion of ringlets that crown her narcissistic face. In the often-repeated competition for the title of "pampered pooch," Koons's poodle is a clear winner and would have been equally at home in Mme de Pompadour's chambers at Versailles.

From these grand heights, nothing could be more downwardly mobile than the 1981 *Beagle in a Basket* by Duane Hanson (fig. 81), a dog portrait that lands solidly on the floor of that vast world of "ugly Americans" cloned forever in the artist's eerily lifelike population ranging from cleaning women and office clerks to exhausted shoppers and homeless derelicts. A twentieth-century Mme Tussaud, Hanson became world-famous through these meticulous facsimiles, including eyeglasses and stubble, of the anonymous humans so conspicuous in the seamier side of American society, three-dimensional illusions so real that, by accident, museum spectators have often spoken to them or, by intention, have prodded them to make sure they are not real. As for the slumbering beagle, it is, in fact, a posthumous portrait of the artist's dog, Petra, a memento mori that offers a strange mutation of those sculpted dogs, symbols of fidelity, who lie for eternity at the feet of their medieval masters' tomb effigies. The

FIG. 81. Duane Hanson (American, 1925–1996). *Beagle in a Basket.* 1981. Polyvinyl, polychromed in oil, with accessories, life-size. Mrs. Duane Hanson.

FIG. 82. Ron Mueck (Australian, born 1958). *Mongrel.* 1996. Mixed media, 15¾ x 24 x 8 in. (40 x 61 x 20.3 cm). Lord Glenconner.

velvet cushions and expensive pelts that comforted so many upper-class dogs in their painted and sculpted portraits are replaced here by a crude swatch of shag rug tucked into an equally low-budget synthetic wicker basket, typical of Hanson's insistence on the seedier props of American lower-class domesticity.

To many, Hanson's art of body snatching seemed both so mindlessly realistic and so quick to attract the prolonged attention of people who had never looked at a work of art before that it was often written off as a populist gimmick, more waxworks and taxidermy than anything to do with mainline contemporary art. But with the irony of history, Hanson soon emerged as a major ancestral figure to many younger artists who, like him, were fascinated by body doubles and their variants. Of these, the most showstopping is Ron Mueck, whose replications of the human species perhaps go even farther than Hanson's in their microscopic details of every last hair and pore. But to these obsessively realist premises Mueck adds a fantastic new dimension, constantly enlarging or diminishing the actual size of the human creatures—infants, teenagers, old women—whom he seems to have embalmed as giants or pygmies. And this is equally true of his one dog sculpture, *Mongrel* (fig. 82), of an unlovable, potentially

vicious mutt with a snarling mouth, stunted legs, scruffy fur, and a graceless tail. This might be a commonplace sight in a dog pound, were it not for the fact that it is only the size of a small puppy, some two feet long, a change of normal dimensions that turns fact into something like science fiction.

Comic but no less grotesque is another variation on a taxidermic theme, *Dog Skeleton with Le Monde*, by Maurizio Cattelan (fig. 83), except that now the canine subject—a whippet?—is not stuffed but literally stripped to its bones, so that it at first looks as though it should be displayed in a museum of natural history or a veterinary school rather than in an art collection. Cattelan loved to create animal sculptures that broke all the rules—a stuffed Asian elephant might be totally veiled, face and body, except for the piercing eyes that evoke a Muslim woman's mixture of complete secrecy and a potentially seductive gaze. And he also liked to remove clothing and skin, as in his dizzying acrobatic pileup of animal skeletons: a horse carrying on its back a dog, who carries a monkey, who in turn carries a bird, the whole a macabre tour de force from a nightmare circus. His dog skeleton is equally disciplined by human forces, and, in this case, despite the fact that he is no skin and all bones, Fido performs the lovably familiar domestic service of bringing, between locked jaws, the daily newspaper. With even greater specificity for a commonplace but now startlingly grotesque canine antic, this surreal event seems to have taken place in France, since the newspaper is *Le Monde* (December 19, 1997).

Eerie in a more subliminal way is the work of Emily Mayer, a British sculptor as well as a professional taxidermist who actually offers to pet owners the unusual service of preserving for eternity the body and perhaps even the soul of a dog who

FIG. 83. Maurizio Cattelan (Italian, born 1960). *Dog Skeleton with Le Monde*. 1997. Bone and paper, 28 x 15 x 14¾ in. (71.1 x 38.1 x 37.5 cm). Stefan T. Edlis Collection.

was loved as much as a person, a feat already prophesied in Hanson's *Beagle in a Basket*. However, in her floor piece of 1996, *Lounging Lurcher* (fig. 84), Mayer moves from taxidermy to an imaginative paleontology, creating a canine fossil that, unlike the real, clean-boned skeletons of Cattelan's active dogs, is composed of found fragments of wood and steel. Mayer has transformed this modern detritus into what looks like the time-worn relic, pathetically incomplete and painfully twisted, of a dog accidentally preserved in an archaeological site, like an invented relative of the Pompeian dogs destroyed by the eruption of Vesuvius in A.D. 79, whose incinerated remains can still be seen today. Mayer's inanimate materials morph into a wizened, contorted corpse, a knobby tangle of head, neck, and limbs, creating a new kind of memento mori that makes us grieve a dog that, unlike the creations of her taxidermy practice, never existed.

The death of a dog, like the death of a person, can be evoked in infinite ways; all of us today and throughout the ages who have lost a dog have felt the painful void of what was a constantly loving presence, a void that, at times to our discomfort and embarrassment, can often feel more desperate and passionate than the loss of a human friend. We are grateful to the young British artist Tracey Emin for capturing

FIG. 84. Emily Mayer (English, born 1960). *Lounging Lurcher*. 1996. Wood and steel, 14 x 49½ x 22 in. (35.6 x 125.8 x 55.8 cm). Courtesy Emily Mayer.

ROBERT ROSENBLUM

FIG. 85. Tracey Emin (English, born 1963). *Reincarnation.* 2005. Single screen projection animation, transferred to DVD. Edition of 10. Courtesy the artist; White Cube, London; and Lehmann Maupin Gallery, New York.

with startling candor this poignant memory of a beloved dog. In her three-minute film *Reincarnation* (fig. 85), she replays the amateur movies she had made of her late German shepherd on the street or at the seashore. On these faded, casual clips, which almost have the ghostly quality of spirit photography, she keeps inscribing in a raw handwriting the simple and intense emotions triggered by the inevitable trauma of losing a close friend and lover whose life span is so much shorter than ours. She writes brief but heartbreaking phrases: "to know your smile," "the touch of your skin," "I love you, I love your soul," "to feel your breath," "I kiss you deep inside you," "I never stopped loving you"; and at one point in the film she switches to her own animated drawings of the dog whose tomb she is creating through her own art of mixed media. She is hardly alone in believing that dogs, like us, must have an afterlife.

To Winnie and to the late Archie, the suns in our family solar system

The Purebred Dog in Art

Eighteenth and Nineteenth Centuries

WILLIAM SECORD

Although dog fanciers may trace the ancestry of their purebred dogs back hundreds of years, the vast majority of the breeds as we know them today were developed in the nineteenth century. The concept of genetically pure dog breeds was once very rare, and, with the exception of mastiffs, greyhounds, and foxhounds, few breeds had an organized breed registry. Dogs were used for work, for sport, and, by the upper classes, as household pets.

This being said, there are depictions of dogs on pottery and in mosaics dating back at least to the fourth century B.C., in medieval manuscripts, and in Renaissance and Baroque paintings. In most works the dog appears as part of a larger composition, whether in portraits or in hunting, religious, or mythological scenes. With few exceptions, it was only in the eighteenth century that the dog came into its own as the primary subject of a painting. The origins of this evolution lay in Belgium and the Lowlands, where such artists as Jan Fyt, Frans Snyders, and Paul de Vos created turbulent canvases depicting dogs fighting or taking down wild deer or boar. Breed types are recognizable in their paintings, as they are in the work of the Dutch artist Abraham Hondius, whose masterpiece, *Amsterdam Dog Market* (see fig. 29), was to indirectly influence eighteenth- and nineteenth-century British animal artists.

Eighteenth-century England saw the evolution of three distinct types of dog paintings, usually of purebred types, which became fully developed in the nineteenth century: portraits of sporting dogs, of pets, and of purebred dogs. In the convention of sporting-dog portraits, it is not necessarily the appearance of the dog that is important but rather how it performs in the field. Although foxhounds are not sporting dogs, the many fox-hunting scenes created in the eighteenth and nineteenth centuries fall into

DETAIL FROM FIG. 96

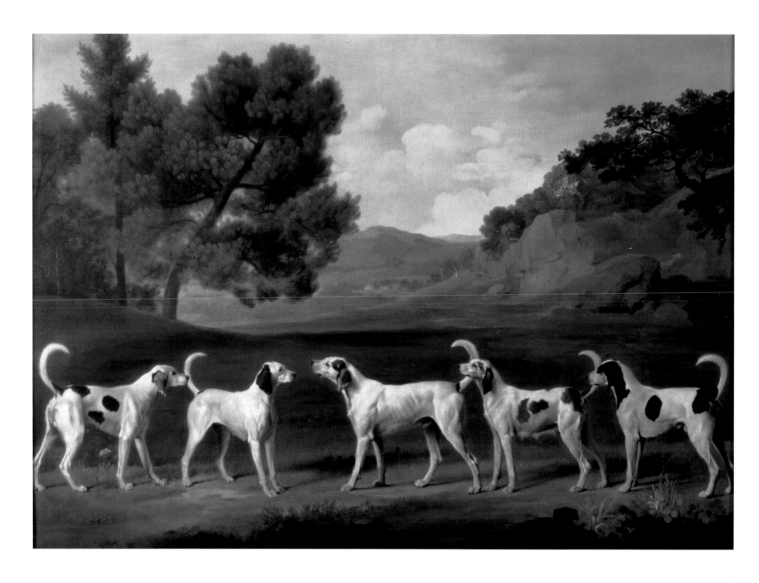

FIG. 86. George Stubbs (English, 1724–1806). *Five Staghounds in a Landscape.* c. 1760. Oil on canvas, 40 x 50 in. (101.6 x 127 cm). The Trustees of the Rt. Hon. Olive, Countess Fitzwilliam's Chattels Settlement, by permission of Lady Juliet Tadgell.

this category. The purebred-dog portrait depicts the animal in a very specific pose, standing in profile, often with its head slightly turned toward the viewer. The pet portrait—a more general category—often positions the dog in a domestic interior, its only purpose being to please its master.

Many eighteenth-century artists in England depicted the dog in sporting activities, including John Wooton, Henry Thomas Alken, and John Boultbee, but George Stubbs stands head and shoulders above the others. The son of a Liverpool tanner, Stubbs received little academic training but showed an interest in anatomy from an early age, producing his monumental work, *The Anatomy of the Horse*, in 1758. This understanding of an animal's structural makeup is evident throughout his work. England was the first European country to develop scientific attitudes toward animal husbandry, and the selective breeding of animals to improve livestock was widespread among the English gentry. Portraits of racehorses, prize bulls, and both sporting and pet dogs attest to the pride with which the owners kept their animals.

Five Staghounds in a Landscape (fig. 86) is one of five paintings commissioned by the Marquis of Rockingham, a prominent sportsman.[1] Stubbs depicts the dogs, including two bitches, in a friezelike progression across the foreground of the canvas.

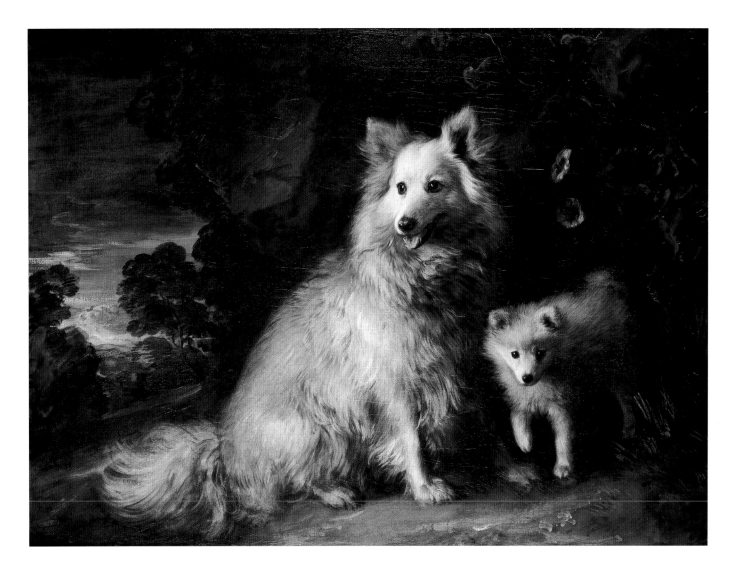

FIG. 87. Thomas Gainsborough (English, 1727–1788). *Pomeranian Bitch and Puppy*. c. 1777. Oil on canvas, 32½ x 43½ in. (82.6 x 110.5 cm). Tate, London.

Painted before the full evolution of the purebred-dog portrait, they are very much individual portraits of the hounds, each depicted in profile. As Robert Fountain and Alfred Gates have pointed out, the staghound may well have descended from large French hounds that were crossed with various breeds to enhance their hunting abilities.[2] As the natural habitat of the stag was depleted, and new fortunes were made by men who wanted to enjoy country pursuits, fox hunting became the preferred sport. Although the staghound continued to exist as a breed, it would also be bred, along with the beagle and the southern hound, to create the eighteenth-century foxhound.

Many eighteenth-century artists continued to include dogs in their compositions, and several of them painted portraits of individual dogs. Thomas Gainsborough, for example, often included an owner's dog in a portrait and also did many portraits of individual dogs. *Pomeranian Bitch and Puppy* (fig. 87) depicts a breed that today would be considered a spitz, but there is little doubt that it was a Pomeranian of the type illustrated by Sydenham Edwards in his *Cynographia Britannica*.[3] The Pomeranian, whose name is derived from that of a former province of northern Germany on the Baltic Sea, is a member of the spitz family of dogs, which originated in the Arctic

Circle and have certain characteristics in common: prick ears, a mane of hair around the neck, and a high-set, plumed tail carried over the back.

Pomeranians were much larger in the eighteenth and early nineteenth centuries than they are today, weighing up to thirty pounds. In the late nineteenth century they were selectively bred to decrease their size. Queen Victoria, who showed four Pomeranians at the Crufts dog show of 1892,[4] preferred the smaller type, in the twelve- to sixteen-pound range, and by the turn of the century the dog-show world had appropriated the Pomeranian as its own. The American Kennel Club's written standard for the breed today calls for a dog in the four- to six-pound range.

The eighteenth century in France saw a somewhat parallel development in the painting of the purebred dog, with the emergence of Alexandre-François Desportes as an animal painter, along with the younger artist Jean-Baptiste Oudry. Desportes was first a portrait painter in the Polish court and later moved to France, where he executed hunting scenes. In 1700 he received the first of many commissions from King Louis XIV, painting five canvases depicting various scenes of the hunt for the Ménagerie at the château at Versailles. He created many action-filled canvases, as well as individual portraits of dogs, for both Louis XIV and Louis XV.

Hunting in France reached its greatest popularity during the seventeenth and eighteenth centuries. A highly formalized affair, it required extensive preparations. During the reign of Louis XV, for instance, the head huntsman had a staff consisting of two equerries, fourteen lieutenants, twenty-four captains, five valets for bloodhounds, and seventy grooms. The kennels contained as many as four hundred hounds. The larger hounds were used to hunt deer, wild boar, and wolves, and the smaller breeds were used to hunt hare and rabbits.

By the 1720s, some fifty years before Stubbs first exhibited his work at the Royal Academy in London, Desportes was well known for his detailed and anatomically correct depictions of dogs. *Pompée and Florissant, Hounds of Louis XV* (fig. 88), painted for the king, portrays what are probably two French pointers, known as *braques*, at rest, formally posed in a landscape. The French created a number of sporting breeds by crossing the Spanish pointer with different hounds to create dogs distinguished by their coats: the braque (short-haired), the *épagneul* or setting spaniel (long-coated), and the griffon (rough-haired).[5] The braque was a pointing dog used to hunt game birds such as pheasants and partridges. Louis XV hunted at least three times a week, and almost every day when he was in residence at Fontainebleau. He preferred what was considered the noblest of quarries—the stag—but he also hunted wild boar, wolf, rabbit, pheasant, and other game birds.[6]

The two dogs in *Pompée and Florissant* are painted with great attention to anatomical detail, in the tradition of seventeenth-century Flemish artists, and are artificially posed in profile. The birds, studies of which Desportes painted from life some twenty years earlier, are equally well painted, although somewhat artificially

FIG. 88. Alexandre-François Desportes (French, 1661–1740). *Pompée and Florissant, Hounds of Louis XV.* 1739. Oil on canvas, 66⅛ x 55⅛ in. (168 x 140 cm). Musée National du Château de Compiègne.

WILLIAM SECORD

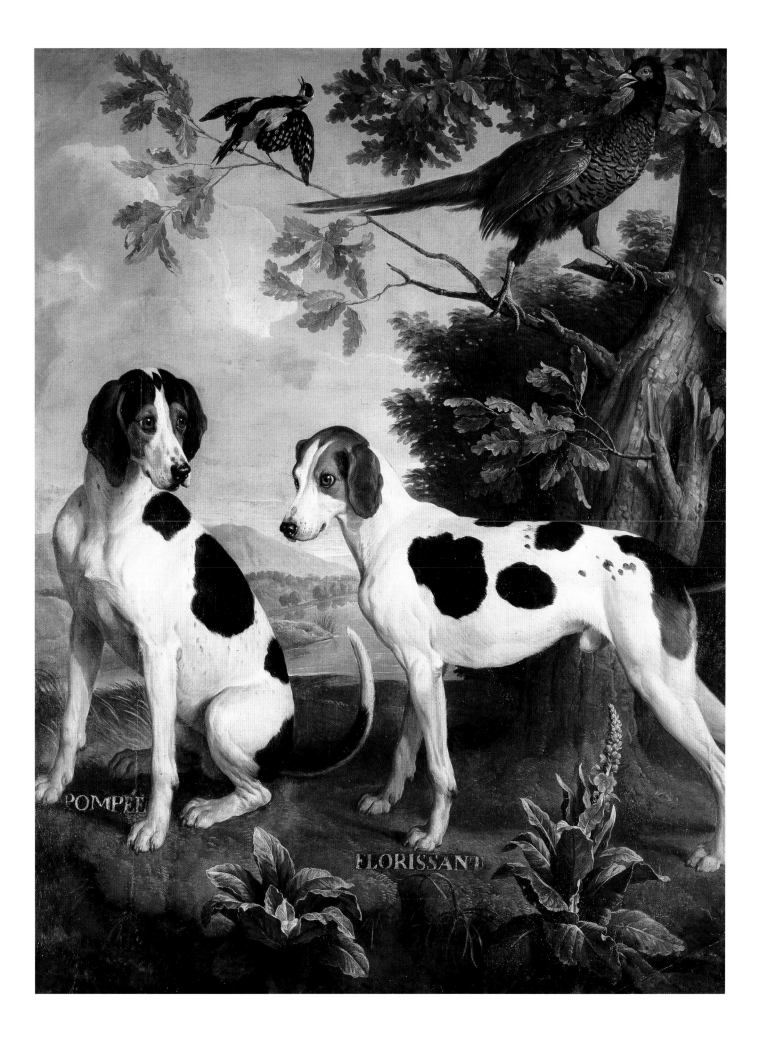

posed in the trees, seemingly unaware of their natural enemies a few feet away. Unlike his many other canvases in the sporting tradition, in which the dogs are shown on point in the field or posed with dead game after the hunt, these dogs are individual portraits, painted from life, of two of the king's favorite dogs.

Desportes's role as court animal painter was eventually turned over to Jean-Baptiste Oudry, who was invited to the court at Versailles in 1726 and named painter for the royal tapestry manufactory at Beauvais. Oudry painted a variety of subjects early in his career but was unsurpassed as an animal painter. Like Desportes, he depicted the king's hounds and sporting dogs working in the field, but he also completed what we would now regard as pet portraits, such as *Bitch Nursing Her Puppies* (fig. 89). The scene depicts a French pointer, or braque, probably an ancestor of the present-day Braque Saint Germain, a breed distinguished by large yellow-orange spots. Oudry's painting, executed three years before his death in 1755, departs from his more conventional portraits in that it depicts an intimate moment in the dog's life: the bitch lifts her front leg to allow her puppies access to nurse. Although rare in Oudry's work, this subject matter, in which the dog takes on almost human emotions, set an important precedent for later nineteenth-century pet portraits. As Robert Rosenblum has pointed out, the rationalist, Descartian notion that dogs have no souls, but are "mere mechanistic creatures," became more and more difficult to maintain when confronted with such maternal devotion.[7]

Identifying the intelligence and "human" emotions of dogs was a pursuit that was most fully developed in the nineteenth century, and paintings of dogs came to reflect these new insights. In England, pet and sporting dogs found a patron in Queen Victoria, an avid animal lover, who ascended the British throne in 1837. During her reign she kept as many as seventy purebred dogs at her kennels at Windsor Castle and commissioned several portraits of her pets. Under the queen's influence, the British middle and upper classes became fascinated with dogs, causing this once-scorned subject matter to reach unprecedented heights of popularity. England witnessed an increasing interest in purebred dogs in particular in the mid- to late nineteenth century.

The concept of keeping a breed pure by not mating it to another breed had been relatively loose in previous decades, but by the early nineteenth century writers had published not only descriptions of the functions of different kinds of dogs but also detailed breed standards, specifying how an ideal specimen of a particular breed should look. The subject was a matter of heated debate. One of the early champions of breed standards was J. R. Walsh, who, in 1867, wrote that "at present, exhibitors do not know what points will ensure a prize, and all is confusion; while, if they could depend on any recognized scale, they would know what course to pursue."[8]

Dog shows and field trials, in which sporting dogs competed against one another in the field, did become more organized, and this fascination with breeding eventually

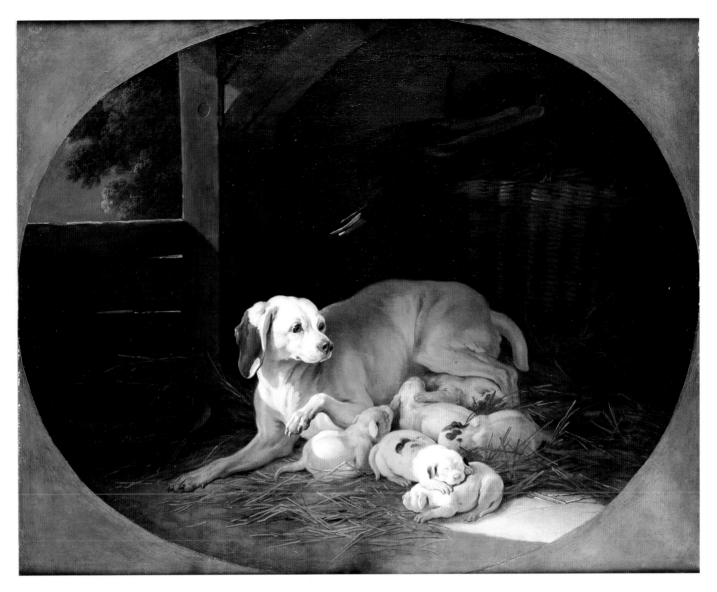

FIG. 89. Jean-Baptiste Oudry (French, 1686–1755). *Bitch Nursing Her Puppies.* 1752. Oil on canvas, 40¾ x 52 in. (103.5 x 132.1 cm). Musée de la Chasse et de la Nature, Paris.

led to the establishment, in 1873, of the Kennel Club, which regulated dog shows and published changes in the written standards for the breeds. With the patronage of the Prince of Wales and eventually other members of the royal family, the Kennel Club gave social prestige as well as structure to the sport and to showing dogs.

As a child, Queen Victoria had been given a portrait of her beloved spaniel, Dash, painted by Edwin Landseer (1836; Collection Her Majesty the Queen), by her mother, the Duchess of Kent, and the future queen became enamored of the artist's work. Landseer created a small circular head study of her favorite pet. Loosely painted in his signature style, the portrait exactly captures the pleasing nature of the little dog. This breed is an ancestor of what we know today as the English toy spaniel, as well as the Cavalier King Charles spaniel. Although its exact origins are rather obscure, as early as 1570 Dr. Johannes Caius refers to a "delicate, neate, and pretty kind of dogges called the Spaniel gentle."[9] The breed was eventually named after King Charles II, and with his ascension to the throne in 1660, the toy spaniel's place in the royal household was assured. Indeed, when one of the king's dogs was lost or stolen, he was inconsolable and advertised for its return. These toy spaniels were said

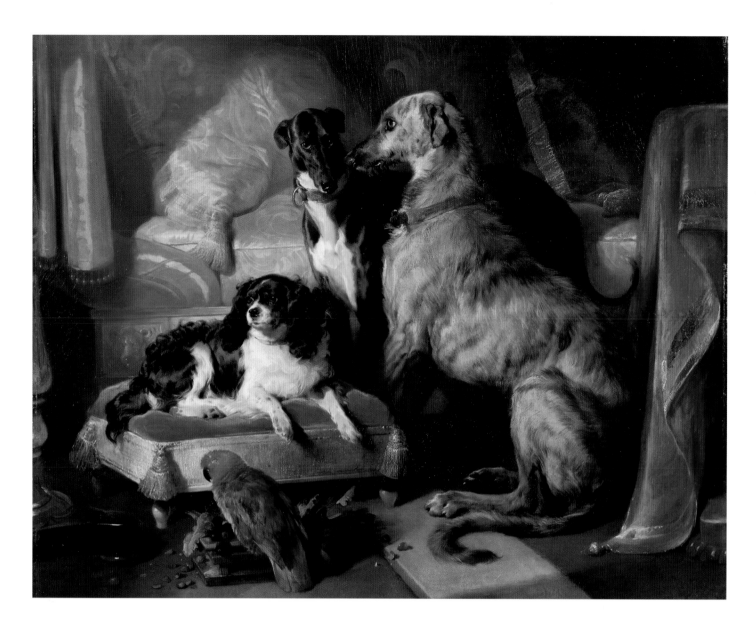

FIG. 90. Sir Edwin Landseer (English, 1802–1873). *Hector, Nero and Dash with the Parrot, Lory* (also titled *Portraits of Her Majesty's Favourite Dogs and Parrot*). 1837– 38. Oil on canvas, 47½ x 59½ in. (120.7 x 151.1 cm). Collection Her Majesty the Queen.

to have been allowed free access at all times to Whitehall, Hampton Court, and other royal palaces.

Landseer, who worked in the colorist tradition of Anthony van Dyck and Peter Paul Rubens, was an ideal choice to portray Queen Victoria's pets. He had a fondness for animals since his early years and had been a child prodigy, first exhibiting his work at the Royal Academy when he was only twelve. Although he was not from an aristocratic family–his father, John, was a well-known engraver–his alliance with the young queen would be instrumental in forging his career. The queen was captivated by Landseer's work, and a series of royal commissions ensued, culminating in his being knighted in 1850. These commissions are among the artist's best paintings of dogs. *Eos* (1841; Collection Her Majesty The Queen) depicts Prince Albert's greyhound in a simple, direct pose, in profile and waiting beside her master's gloves, top hat, and walking stick. It is one of Landseer's most successful compositions, for in its simplicity, he demonstrates the fidelity and latent power of a favorite hound. One of the oldest breeds, the greyhound traces its origins to as early as 4000 B.C. In England

the breed is recorded as early as 1598, when John Manwod, in his *Laws of the Forest*, explained how freemen may own greyhounds, but only if they are kept ten miles from the king's forest, where hunting was traditionally the perquisite of the king. These "forest laws," designed to protect game, were drawn up over a period of years, starting in 1016, and imposed strict rules on those who lived in or around the royal forest; punishments for breaking them could be very severe.

Greyhounds hunt by sight rather than scent. They were kept in packs, although when hunting, they were released in pairs, or braces. In the late sixteenth century the Duke of Norfolk, an early greyhound enthusiast, drew up a set of regulations for the sport of hunting hare, known as coursing. Coursing clubs and societies developed, such as the Swaffham Coursing Society, established by the Earl of Orford in 1776, and they began to compete against each other.

The royal greyhound, Nero, and Dash appear in one of Landseer's commissioned portraits of the queen's pets, along with Hector, a Scottish deerhound, and Lory, a parrot (fig. 90). As Lory scatters nutshells on the floor in the foreground, Dash rests regally on a footstool, and Hector and Nero pose in the background. Surrounded by rich fabrics and the trappings of wealth and privilege, the dogs are posed in a triangular composition, with Dash, the queen's favorite, in the middle ground.

The Scottish deerhound, like the greyhound and the Cavalier King Charles spaniel, was a breed closely associated with the aristocracy. Sometimes confused in the canine literature with the Irish wolfhound, Scottish deerhounds are identifiable as early as the seventeenth century and were highly prized for their hunting skills. Indeed, ownership of a Scottish deerhound was originally restricted to the Highland chieftains, its exclusivity eventually leading to an alarming decrease in its numbers. The restoration of the breed was undertaken by Archibald and Duncan McNeill, who, about 1825, established an extensive breeding program. The Scottish deerhound began to be shown in conformation dog shows in the 1870s, but its true home remained in the Scottish Highlands, where it was highly prized for its speed and keen nose. The royal family first visited Scotland in 1842, some eighteen years after Landseer's first visit. Following the advice of the queen's physician, Sir James Clark, who recommended Scotland for its bracing fresh air, the family first stayed at Taymouth Castle, eventually purchasing Balmoral, with its seventeen hundred acres, from the Earl of Fife in 1852.

Landseer's paintings were greatly valued during his lifetime, and he was supported by a wide range of aristocratic patrons. His portrait of a Scottish deerhound and an early bloodhound, *Deerhound and Recumbent Hound* (fig. 91), may have been commissioned by the fifth Earl of Tankerville, who is known to have owned both breeds.[10] It is especially difficult to identify certain breeds in nineteenth-century paintings, for they have changed in appearance over the years. At first glance, the recumbent dog appears to be a foxhound, but its long ears, heavy bone structure, and

overall brown color would imply that it is a relative of the bloodhound. Although the standard for the breed today permits a small amount of white coloration, early-nineteenth-century bloodhounds often had blazes of white on the chest and white markings on the muzzle. Ancestors of the breed, known in much of Europe as the St. Hubert hound, are believed to have been in England since before the twelfth century. Esteemed for their scenting abilities, bloodhounds were often used to track animals or persons, as they are today.

What might have been a simple portrait in the hands of another artist is transformed by Landseer into a touching tribute to the two dogs. Using a pyramidal composition in which the dogs virtually fill the canvas, the painting has an almost monumental quality. Moreover, the deerhound appears to be consoling the other

FIG. 91. Sir Edwin Landseer (English, 1802–1873). *Deerhound and Recumbent Hound.* 1839. Oil on canvas, 45¼ x 48¼ in. (114.9 x 122.6 cm). The American Kennel Club Museum of the Dog, Saint Louis.

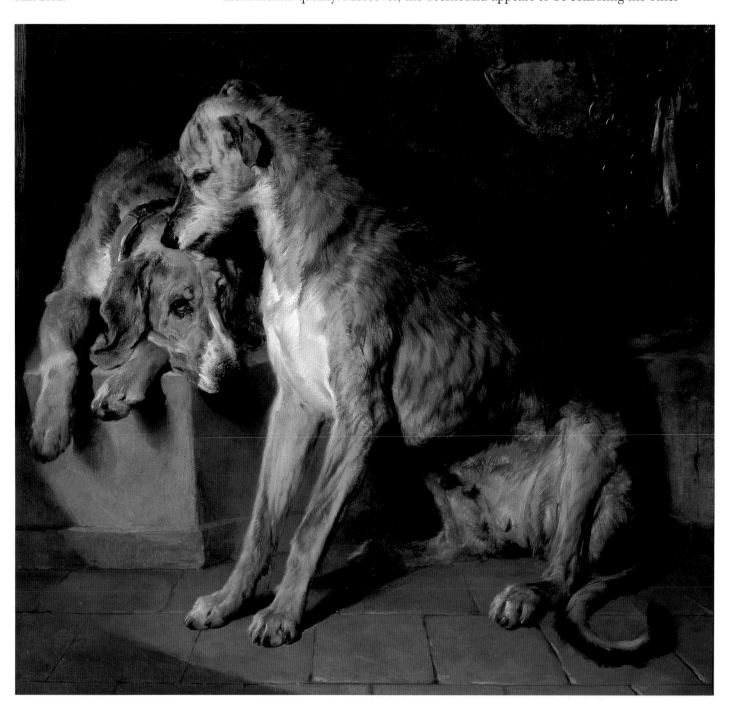

WILLIAM SECORD

FIG. 92. Sydenham T. Edwards (English, 1768–1819). *The Bulldog.* 1800–1805. Hand-colored engraving, 10½ x 8⅞ in. (26.7 x 22.3 cm). The American Kennel Club Museum of the Dog, Saint Louis, gift of Marie A. Moore.

dog, leaning over and licking its head, as the bloodhound looks directly at the viewer, as if to elicit sympathy. Undoubtedly a commissioned portrait, it has lost its specific meaning, but the message is timeless—a visualization of the bond between two dogs.

Before the advent of Impressionism and the concept of art for art's sake, realistic and finely detailed depictions of dogs were highly appreciated by mid-nineteenth-century sensibilities. Indeed, the highest praise that Queen Victoria could lavish on a painting of one of her pets was that it was "like"—in effect, lifelike. Dog paintings created during this period were generally more or less lifelike, but they were also informed by each artist's unique sensibilities. Also, as was true of the human subjects in the paintings, a dog's appearance was often subtly changed to suit its owner. Landseer typically idealized his canine subjects, choosing the most flattering angles and showing them at their best, frequently in sumptuous surroundings that reflected the social status of the owner.

In the nineteenth century the pictorial conventions of the purebred-dog portrait, first seen in the image of the great parti-colored mastiff of Abraham Hondius's *Amsterdam Dog Market* and, later, in the work of George Stubbs, became the norm: the dog is posed in profile, its head slightly turned toward the viewer. Each aspect of the breed's written standard is made visible: ear set, size of eyes, expression, top line, lay-back of legs, and so forth. Part of the fascination with the breeding of dogs is that the animal is genetically malleable, so that its appearance can be transformed in a few generations. The bulldog, for instance, one of England's oldest and most beloved breeds, was originally bred as a guard dog, as well as to bait bulls and other animals. Indeed, its name derives from the now-outlawed practice of baiting bulls, a "sport" in which these dogs were let loose upon a bull. The goal was to attack the bull's nose and hold it, while the bull roared in agony. The bulldog was selectively bred to be fearless, strong, and tenacious when confronted with a bull. The shape of its mouth and nose was especially important, as it allowed the dog to breathe while locking its bite.

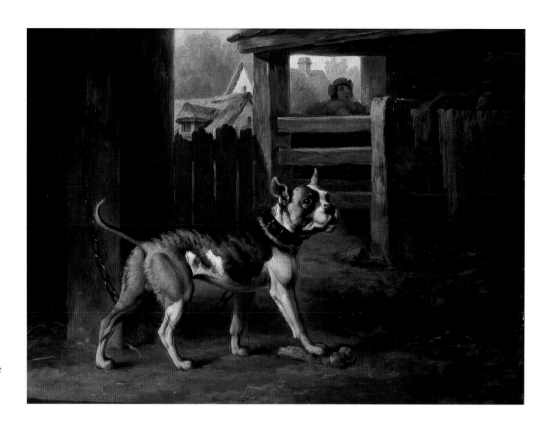

The early bulldog type may be seen in Sydenham Edwards's illustration for his landmark book *Cynographia Britannica* (fig. 92), published between 1800 and 1805. The illustration shows a rather long-legged dog with a well-developed musculature, the lower jaw giving the appearance of sweeping upward. By this time bull baiting had begun to lose favor with the public, and bulldogs were increasingly used as fighting dogs. One dog would be pitted against another, and physical prowess was critical to the animal's survival. Bets were taken, and, as with cockfighting, the stakes could be very high. One can easily imagine the bulldog depicted in Philip Reinagle's painting of about 1790 to be just such a contender, for he virtually bristles with strength (fig. 93). Compared with the dog in Edwards's engraving, the Reinagle dog is leaner, higher on leg, and appears to have a smaller head. Arthur Wardle's portrait of Press Gang (fig. 94) shows the bulldog breed very much changed—one that would not have been recognized one hundred fifty years earlier. Most obviously, the legs are shorter, the body stockier, the muzzle short, and the head very much increased in size.

Between 1805 and 1900, the bulldog was put to many uses, but by the time the standard for the breed was written by the British Bulldog Club in 1875, it had changed dramatically. Bulldogs differed greatly in appearance, and as the breed gained acceptance in the show-dog world, they became better adapted to their new role. As the noted author Edgar Farman pointed out in 1899, the "appearance of an up to date specimen became a caricature of the active and plucky animal that baited the bull, and which was a dangerous customer at any time. For the show bench as an object lesson of what can be done by scientific breeding for 'points,' the bulldog is an excellent example of the triumph of man over nature, but as an example of what

the dog was originally, can hardly be a success."[11] What was once a game, physically fit, and incredibly tenacious fighting dog around the turn of the eighteenth century became, in the late nineteenth century, a show dog that was often unable to breed or give birth without veterinary assistance.

This physical transformation was less obvious in other breeds, but as dogs were no longer used for their original purpose—terriers for ratting, dachshunds for going after badgers, Old English sheepdogs for herding, and so on—many of the breeds underwent significant physical changes in a relatively short period of time. In an era before color photography, paintings of these dogs, as well as engravings and prints, provide the only visual record of the history of individual breeds.

The popularity of purebred dogs extended beyond Britain's shores. They also appeared in the paintings of France, Belgium, and Holland. The Dutch-born artist Eugène-Joseph Verboeckhoven created many academic and highly finished dog portraits. Like Landseer, he became successful at a young age and benefited from royal patronage. Verboeckhoven traveled extensively and visited England in 1824.

FIG. 94. Arthur Wardle (English, 1864–1949). *Press Gang*. 1902. Oil on canvas, 24 x 30 in. (61 x 76.2 cm). The E. M. Hershey II Collection.

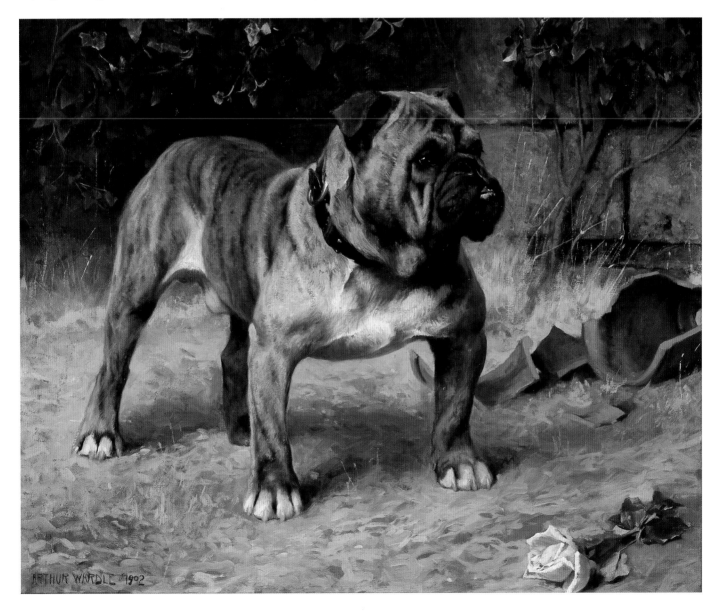

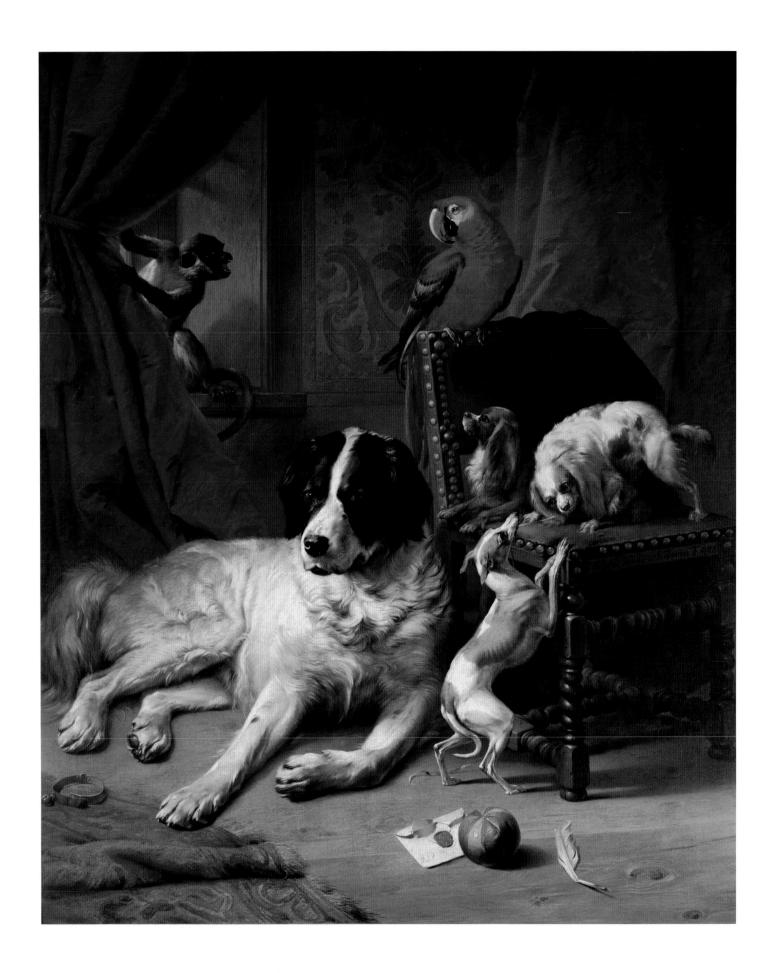

He undoubtedly would have been aware of Landseer, who had exhibited paintings at the Royal Academy since 1814. Verboeckhoven moved to Brussels in 1827, where he enjoyed further success. King Leopold I, the uncle of England's Queen Victoria, commissioned several portraits. Verboeckhoven's 1845 portrait of the royal family's favorite pets is of particular interest, for it is an archetypal pet portrait in which the dogs are relaxed in a domestic interior amid luxurious surroundings (fig. 95). This image precedes countless other paintings of dogs reclining on cushions or footstools, but it, too, harks back to an earlier composition—Landseer's portrait *Hector, Nero and Dash with the Parrot, Lory.*

Verboeckhoven's composition is almost a mirror image of Landseer's, with the chair positioned on the right and the focus of attention on the large black-and-white Newfoundland dog. The Landseer Newfoundland was named after the artist because of his particular fondness for the black-and-white variety. The Newfoundland breed is thought to have been developed in Newfoundland by selectively breeding European dogs with native Newfoundland breeds. Since at least the eighteenth century, the breed was known in England for its ability to save the lives of those in danger of drowning. Like the animals in Landseer's painting, those in Verboeckhoven's work appear in the best possible light, cleaned up for their portrait, no doubt to please their royal patrons. Such portraits were very much admired and in the mainstream of art at the time.

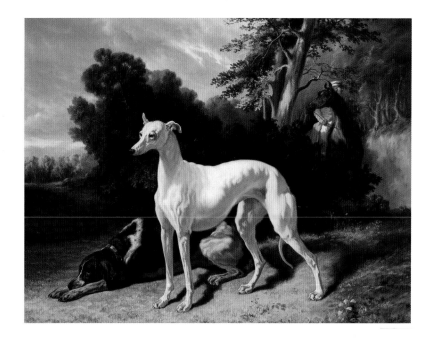

FIG. 96. Alfred Dedreux (French, 1810–1860). *Hounds in a Wooded Landscape.* c. 1850–55. Oil on canvas, 28¾ x 36¼ in. (73 x 92.1 cm). Collection Mr. and Mrs. R. M. Franzblau.

The three types of dog painting that flourished in nineteenth-century England were also evident in France during this period, and these types continue to the present day: the purebred-dog portrait, with its roots in seventeenth-century Holland; the pet portrait; and the sporting-dog portrait. The French artist Alfred Dedreux was aware of the work of Landseer and other British animal artists, and after the Revolution of 1848, he moved to England, where he studied the English masters. Of aristocratic birth, he eventually counted Napoleon III and Queen Victoria among his patrons. Richly colored and painted with a slightly looser brushstroke than that of his predecessors, his *Hounds in a Wooded Landscape* includes a portrait of a white greyhound that is a classic of its type (fig. 96). The elegant canine is posed according to the standard convention of purebred-dog portraits, standing parallel to the picture plane. The composition is enlivened by the contrast between the recumbent houndlike dog and the arrival of a horse and rider in the background to the right. The identity of the greyhound is unknown, but the subject matter is symbolic of the life of the

OPPOSITE
FIG. 95. Eugène-Joseph Verboeckhoven (Belgian, 1798–1881). *The Favorite Animals of King Leopold I.* 1845. Oil on canvas. 71¼ x 59 in. (181 x 149.9 cm). BELvue Museum, Brussels.

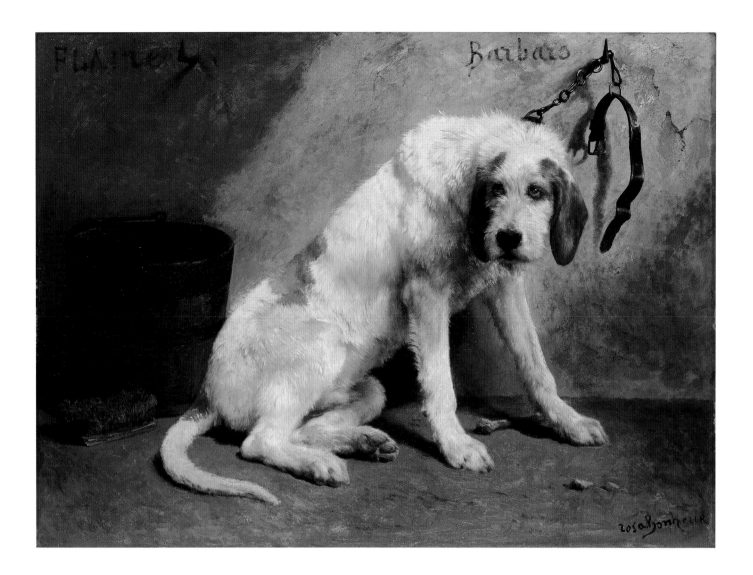

FIG. 97. Rosa Bonheur (French, 1822–1899). *"Barbaro" after the Hunt*. Late 19th century. Oil on canvas, 38 x 51¼ in. (196.5 x 130.2 cm). Philadelphia Museum of Art, The W. P. Wilstach Collection, gift of John G. Johnson.

French aristocracy. Greyhounds had long been associated with the aristocracy in both England and France, and Dedreux often painted them in refined, elegant surroundings. One such etching and aquatint depicts a white greyhound adorned with an elegant collar and a richly embroidered velvet cape with a royal crest, confronted by a large shaggy dog of indifferent breeding that holds a tin begging cup.[12]

Rosa Bonheur, another artist of the time, painted many animal subjects, and although her paintings of dogs are a relatively small part of her work, they stand out as some of her best. From a young age, Bonheur chose animals as her subject matter and later stated, "I was only happy in the company of animals. I really got into studying their ways, especially the expression in their eyes. Isn't the eye the mirror of the soul for each and every living creature? Nature didn't give them any other way to express their thoughts, so that's where their feelings and desires get reflected."[13] After initially studying with her father, Raymond Bonheur, she established herself in Paris, gaining acceptance at the Salon at the age of eighteen. Bonheur continued to exhibit there as well as in the provinces virtually every year thereafter, quickly winning great popularity. *"Barbaro" after the Hunt* (fig. 97), one of her finest paintings of dogs, depicts what is widely thought to be a Grand Griffon Vendéen, the ancestor of four types of

FIG. 98. Albert de Balleroy (French, 1828–1872). *French Hounds.* c. 1860. Oil on canvas, 29 x 32 in. (73.7 x 81.3 cm). Collection Mr. and Mrs. R. M. Franzblau.

the Griffon Vendéen. The rough-coated Vendéen hound was bred in four sizes: grand, briquette, grand basset, and petit basset. The two versions of the Basset Griffon Vendéen–the petit (small) and the grand (large)–continue to be popular in France today. They are used to hunt hare and rabbit in *chasse-à-tir,* in which hounds are used to drive game to hunters waiting with guns, and in *chasse-à-courre,* in which the hounds hunt by scent, pursuing their prey to its death. The first written standard for the Basset Griffon was adopted in 1898, and the breed club was founded in 1907. A new standard was written in 1909, but it was not until the 1950s that the Société de Vénerie (a society devoted to *chasse-à-courre*) recognized the small and the large Griffon Vendéen as separate breeds.

In contrast to the idealized works of Bonheur and Dedreux, the paintings of Gustave Courbet, as well as of other artists such as Alexandre-Gabriel Decamps, Constant Troyon, and Count Albert de Balleroy, followed the Realist stylistic approach in the late nineteenth century. The Realist school chose its subject matter based on the view that art should have as its starting point the real world rather than exotic religious or literary subjects. Many of these artists depicted the hounds of the French countryside rather than the pampered pets of Paris. Balleroy, who exhibited at the Paris

Salon almost every year between 1853 and 1870, painted in a direct and unaffected manner. His canine subjects were often painted life-size, as seen in his portrait of four French hounds, the central one looking boldly out at the viewer (fig. 98).

Courbet was inspired to do a series of hunting paintings after attending a hunt held in his honor near Munich in the 1850s. One need only compare his painting of two French hounds (fig. 99) with Bonheur's brightly colored portrait of a very clean, rather idealized dog to see the difference in their attitudes toward Realism. Bonheur's scene is brightly lit, evidently from a kennel window, and the dog is immaculately groomed, especially considering that it has just returned from a hunt. Courbet's scene, by contrast, is more loosely painted, and the hounds are rather scruffy in appearance. Posed in the middle ground of the landscape, they have caught the light coming through the foliage in the upper left corner.

Although academic, highly finished paintings remained popular, the realistic portrayal of everyday life became more accepted about 1860, and it was used by different artists for different reasons. Geraldine Norman has pointed out that "it was approached from many different directions: as a means of highlighting social injustice . . . in a moralizing vein . . . as a vehicle for entertaining characters and situations, or simply as an objective study of the human situation."[14]

This was certainly the case with the Belgian artist Joseph Edouard Stevens, who was a Realist in both style and subject matter. In contrast to the portraits of purebreds

that remained popular, Stevens preferred to represent the most brutal aspects of the canine world in a direct and sympathetic manner. His subjects included heavy cart dogs hauling loads of salt, stray dogs emaciated from lack of nourishment, and weary circus dogs—the unwanted and ill-cared-for dogs of the street. His painting *At the Dog Walk, Paris* depicts dogs with a naturalistic sympathy that was unprecedented (fig. 100). The painting shows a Parisian street vendor offering dogs for sale, then a common practice in large European cities. This work begs comparison with Hondius's *Amsterdam Dog Market*, in which the focus of the composition—a mastiff—is carefully posed and lit to best advantage. One cannot imagine a more dissimilar image than that depicted by Stevens.

The principal subject, also a large dog, is a shorthaired St. Bernard that stares out at the viewer, almost challenging us with his gaze. A pointer bitch with her puppies lies in the lower right, while the hunting hounds in the background, tied to a fence, appear to howl with boredom. A greyhound appears just beyond the fence on the left, and a young man with a hat carries off one of the lucky ones—a small black-and-tan toy spaniel, evidently just purchased from the vendor. Whereas the woman is carefully bundled up against the cold, the dogs are left to shiver in the bitterly cold weather. These dogs were painted not to please a royal patron but at least partly to draw attention to their plight.

The English counterpart to this painting, *Buy a Dog, Ma'am?* by Richard Ansdell (fig. 101), depicts a similar scene. The small black-and-tan toy spaniel has not yet been

FIG. 100. Joseph Edouard Stevens (Belgian, 1816–1892). *At the Dog Walk, Paris*. Oil on canvas, 94¹/₂ x 114 in. (240 x 289.6 cm). Musées Royaux des Beaux-Arts de Belgique.

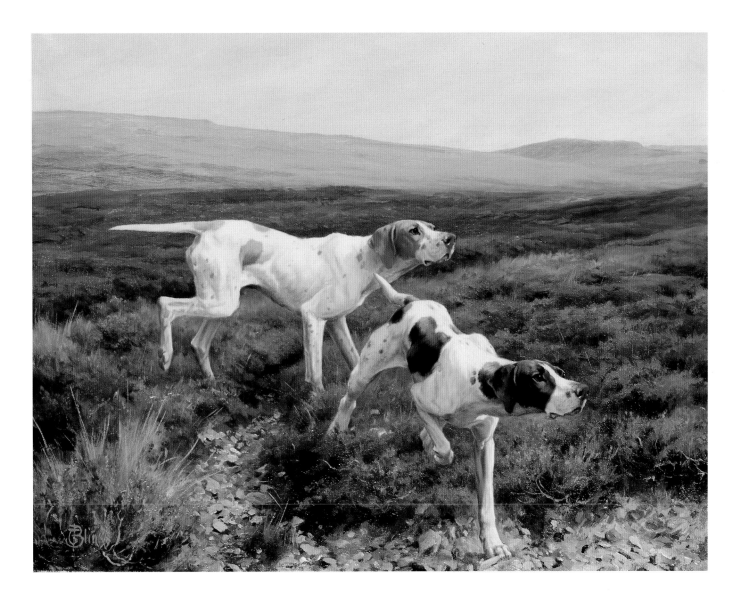

FIG. 102. Thomas Blinks (English, 1853–1910). *Pointers in the Field*. Oil on canvas. 14 x 18 in. (35.6 x 45.7 cm). Collection William Secord Gallery, Inc., New York.

sold, and a large pointer rests his head upon the back of a shorthaired St. Bernard. The dog seller in Ansdell's work, however, appears rather stoic, offering the animals to potential clients. Except for the rather forlorn-looking St. Bernard, the dogs seem comfortable and well tended.

In the late nineteenth and early twentieth centuries, several British artists carried on the tradition of painting dogs, as pets, as show dogs, and in the sporting field. Artists such as Thomas Blinks continued to work in a highly finished style, and although he depicted a number of breeds, he is best known for his images of sporting dogs in the field. His *Pointers in the Field* (fig. 102), of two dogs on the Scottish moors, is typical of his best work. Blinks's understanding of anatomy and his ability to capture an archetypal pose served him well, giving his works an almost photographic quality. Blinks has captured the dogs at the very moment when they have pointed their quarry, every muscle quivering in anticipation. Most authorities agree that the pointer originated in Spain. It was the first breed in England to stand game as we know it today, and by 1711, when shooting game on the wing became popular, this dog was used almost exclusively for pointing game birds. The pointer continued to be used as

OPPOSITE

FIG. 101. Richard Ansdell (English, 1815–1885). *Buy a Dog, Ma'am?* 1860. Oil on canvas, 36 x 29 in. (91.4 x 73.7 cm). Collection of The Kennel Club, London.

FIG. 103. George Earl (English, active 1856–1883). *Champion Dogs of England.* c. 1870. Oil on canvas, 35½ x 53½ in. (90.2 x 135.9 cm). Collection of The Kennel Club, London.

a sporting dog, and in the late nineteenth century it also appeared in dog shows and in field trails.

George Earl's work is also very much in the English academic tradition of the late nineteenth century. A sportsman himself, he produced detailed paintings with scenes of dogs and the sporting life. Earl was the patriarch of a family of artists. His brother, Thomas, was a fine academic painter of dogs; his daughter, Maud, became world-renowned for her paintings of dogs; and his son, Percy, was a painter of horses and dogs. Earl's work was exhibited frequently; some nineteen of his paintings were displayed at the Royal Academy between 1857 and 1883. Among his most significant works are two versions of the *Field Trail Meet* (c. 1880; both in private collections): *Going North* (1883; Collection National Railway Museum, York) and *Going South* (1883; Collection National Railway Museum, York). In this pair of paintings, dog owners, handlers, and sporting dogs prepare to leave for and return from the shooting season.

Champion Dogs of England, a well-known series of paintings that Earl completed in the 1870s, is of particular importance. He produced eight large canvases, each depicting five dogs, for a total of forty breeds. The series was very popular, and many of the large canvases were subsequently cut into five separate portraits. The Kennel Club in London has the only known canvas, of the eight, in its original state (fig. 103).

FIG. 104. George Earl (English, active
1856–1883). *Italian Greyhound* (detail).
c. 1870. Oil on canvas, 15¼ x 17½ in.
(38.7 x 44.5 cm). Collection of The
Kennel Club, London.

FIG. 105. George Earl (English, active
1856–1883). *Charlie* (detail). c. 1870.
Oil on canvas, 15¼ x 17½ in. (38.7
x 44.5 cm). Collection of The Kennel
Club, London.

FIG. 106. Maud Earl (English, 1864–1943). *Luska, a Siberian Sledge Dog in a Snowy Landscape*. c. 1908. Oil on canvas, 30½ x 40¼ in. (77.5 x 102.2 cm). Collection Mrs. Damon Raike.

This work includes five circular portraits on one canvas of four different breeds: the King Charles spaniel, known today as the Cavalier King Charles spaniel, the Italian greyhound, the Yorkshire terrier, and the spitz.

The Italian greyhound Molley (fig. 104), owned by a Mr. Macdonald, a breed dating back to Roman times, is depicted seated, no doubt to highlight the elegant profile of this, the most attenuated of toy breeds. A favored pet of many royal families, it had become a show dog by 1870, and in this portrait is bedecked with prize medallions indicating its elevated status.

The red-and-white toy spaniel, Charlie (fig. 105), in contrast, is the image of a pampered pet. Like Landseer before him, Earl places the dog on a pillow, and while he was undoubtedly a show dog, his primary role seems to have been as a pet. The black-and-tan toy spaniel, Hylas, is portrayed in a more conventional head-and-shoulders pose, similar to Landseer's early portrait of Dash, as is the Yorkshire terrier, Huddersfield Ben.

By this time a companion animal, the Yorkshire terrier was originally bred in Scotland, a mixture of several types of terrier brought to Yorkshire by Scottish

weavers around the middle of the nineteenth century. The dog was quickly adopted by the industrial classes of England, who used it as a ratter. Around 1900, the Yorkshire terrier established itself as a show dog. The other dog portrayed in Earl's painting is a Pomeranian named Tiger, although to modern eyes it looks more like a white spitz.

George Earl's daughter, Maud, would ultimately surpass him as the quintessential painter of purebred dogs, a subject she pursued from 1880–the date of her first known dog painting–to 1940. When asked during an interview in 1898 if she had painted almost every breed in existence, she replied: "Very nearly. I have never painted a Mexican hairless dog, or an African dog. Last year in my exhibition at Graves Galleries, I was represented by seventy portraits, in which were forty-eight varieties of dogs."[15]

Maud Earl developed different styles of painting throughout her career, but she always captured the individual type and character of the dogs she depicted. Her skill attracted the attention of the royal family and prominent dog fanciers alike; she completed commissions for Queen Victoria and the Prince of Wales. Her large-scale portrait *Luska, a Siberian Sledge Dog in a Snowy Landscape* (fig. 106), depicting a dog given to Prince Albert, is typical of her work at the turn of the century. This particular dog would have been a very exotic animal in England at that time; while its name may imply that it was a Siberian husky, it is identified by Count Henri de Bylandt[16] as a laika-type dog, a kind of large spitz that was originally used as a draft and hunting dog. What we know today as the Russo-European laika, the East Siberian laika, the West Siberian laika, and the Karelian bear dog are all relatives of

FIG. 107. John Emms (English, 1843–1912). *Foxhounds and Terrier in a Kennel.* Oil on canvas, 16 x 20 in. (40.6 x 50.8 cm). Private collection.

FIG. 108. John Sargent Noble (English, 1848–1896). *Bloodhounds at Rest.* c. 1880–85. Oil on canvas, 40 x 60 in. (101.6 x 152.4 cm). Collection Frances G. Scaife.

OPPOSITE

FIG. 109. John Sargent Noble (English, 1848–1896). *Pug and Terrier.* 1875. Oil on canvas, 36 x 26 in. (91.4 x 71.1 cm). Collection The American Kennel Club, New York.

this bold and fearless animal. The Karelian bear dog is now more numerous in Finland, where it is used to hunt elk.

Luska, who was eventually exhibited in dog shows by Edward VII, is depicted by Maud Earl in the conventional pose for purebred dogs, but his head is turned rather than being shown in profile, and he stares boldly at the viewer in an almost defiant stance. Luska is situated in a snowy landscape, evidently to indicate his northern origins.

John Emms was a prolific artist known for his portraits of purebred dogs, as well as for fox-hunting scenes and paintings of horses and hounds. Born in Norfolk, he was a studio assistant to the prominent artist Lord Frederick Leighton. Emms's early work was in the highly finished academic tradition, but he soon developed a distinctive painterly style, creating expressive animal portraits with bold, almost calligraphic brushstrokes. The subject of *Foxhounds and Terrier in a Kennel* (fig. 107) is characteristic of Emms's work, as he painted many versions of the same theme. Although these are working hounds, bred to hunt fox in packs since at least the sixteenth century in England, they are posed indoors in the pet-portrait convention. As in many of his hound portraits, the larger, slower dogs are contrasted with the small, excitable hunt terrier, thought by some to be a predecessor of the Jack Russell terrier. The hunt

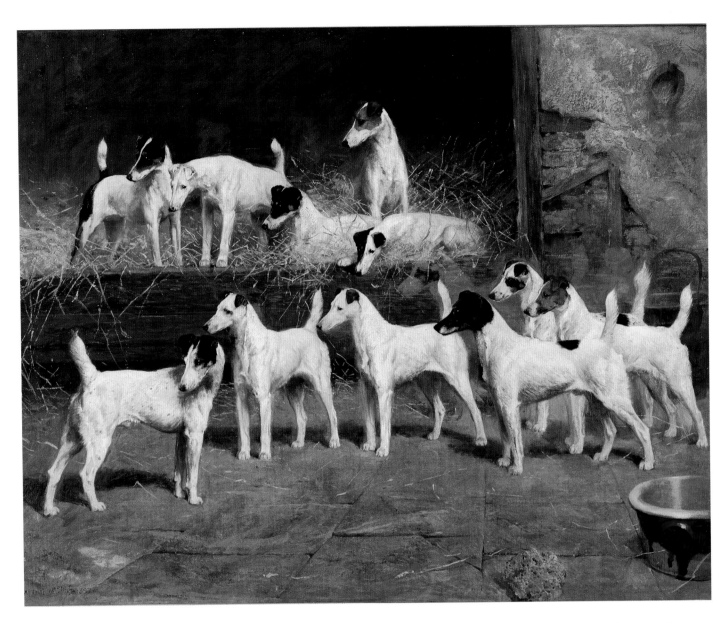

FIG. 110. Arthur Wardle (English, 1864–1949). *The Totteridge Eleven*. 1897. Oil on canvas, 27½ x 35½ in. (69.9 x 90.2 cm). Collection of The Kennel Club, London.

terrier, a strain of the fox terrier, was used to go to ground after the fox and also to dispatch small vermin such as rats.

Working in a similar painterly style, John Sargent Noble studied at the Royal Academy schools and exhibited extensively during his short life. His portrait *Bloodhounds at Rest* is a masterpiece of its type (fig. 108). The recumbent hounds are depicted in an interior setting, posed like the hound in one of Landseer's portraits. Although extremely active when working, these bloodhounds appear almost sluggish at rest, and Noble has succeeded in capturing their soft expressions, as well as their underlying anatomical structure. Noble's painting *Pug and Terrier* (fig. 109) is more anecdotal in nature, depicting a scruffy terrier looking up at a rather haughty pug.

Pugs were long associated with the House of Orange, because these dogs accompanied William the Silent of Holland and his wife, Mary, when they crossed the English Channel in 1688 to ascend to the throne of England. The breed was well established in England by the eighteenth century and continued to be

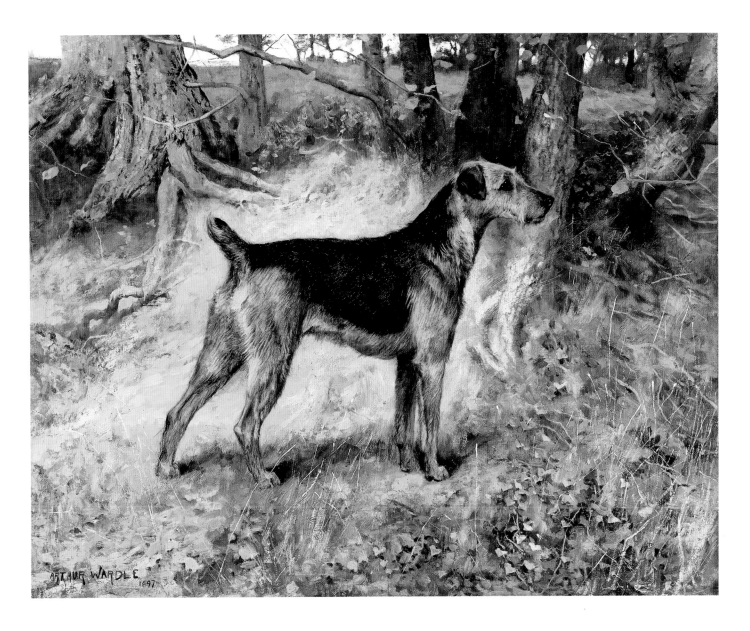

FIG. 111. Arthur Wardle (English, 1864–1949). *Ch. Dumbarton Lass.* 1897. Oil on canvas, 16 x 20 in. (40.6 x 50.8 cm). Collection Tom and Melinda Peters.

associated with royalty in the nineteenth century. Queen Victoria was a great lover of the breed and had both fawn and black pugs at her kennels at Windsor. By 1875 the pug was a recognized show dog, but it was still associated with the upper classes; in Noble's depiction, the dog peers down at the terrier mix, perhaps alluding to its elevated status.

Another successful and prolific artist, Arthur Wardle, exhibited 113 paintings at the Royal Academy between 1880 and 1938. Also known as a painter of wildlife and big game, Wardle was one of the preeminent dog painters of the day. Most of these paintings were commissioned by prominent dog breeders. His well-known painting *The Totteridge Eleven* (fig. 110) depicts eleven smooth fox terriers from Francis Redmond's famous kennel: (clockwise from back left): Dryad, Ch. Daddy, Dame Dalby (sitting), Divorcee, Diamond Court, Ch. Donnington, Ch. D'Orsay, Ch. Dame Fortune, Ch. Donna Fortuna, and Ch. Dominie.

The composition is carefully constructed so that each dog appears in a show pose, displaying how each conforms to the standard for the breed. Redmond, elected

FIG. 112. Photographer unknown. *Ch. Dumbarton Lass.* From Mary Swash and Donald Millar, *Airedale Terriers,* 1990.

to Kennel Club membership in 1893, had bred and exhibited smooth fox terriers since the 1870s. His highly successful Totteridge Kennel was instrumental in developing the breed. As Desmond O'Connell stated in *The New Book of the Dog,*[17] "To no one do we owe so much; no one has made such a study of the breed, reducing it to almost a science, with the result that even outside his kennels no dog has any chance of permanently holding his own unless he has an ample supply of the blood." Smooth fox terriers had been bred to kill vermin, but by this time they were very much show dogs.

It is tempting to think that these nineteenth- and early-twentieth-century artists depicted the dog in a naturalistic way. However, this is not a safe assumption, for, as seen in the idealized work of Landseer or that of the Realist Courbet, each artist worked in a specific style that inevitably transformed the subject. This is no less true for depictions of purebred dogs, the vast majority of which were commissioned and thus influenced by the patron's wishes. Who could imagine, for instance, that the sleek, trim, and immaculately groomed Airedale bitch in Arthur Wardle's painting *Ch. Dumbarton Lass* (fig. 111) is the same dog that appears in a photograph from the period (fig. 112)? One would expect to see the dog properly groomed for its portrait, but Wardle has gone much further, actually changing the shape of its head, no doubt to please the owner.

Wardle continued to paint dogs on commission until at least the 1930s, although many of his works are not dated. Other artists carried on this tradition well into the twentieth century, but as new styles of painting emerged and were embraced by the public, academic and realistic styles eventually lost favor with the art-buying public.

Only recently, since the late twentieth century, has Realism been reevaluated and gained renewed appreciation. The purebred dog has yet to lose its popularity and has managed to prevail in ever-new styles of art.

Notes
1. Fountain and Gates 1984, p. 33.
2. Ibid.
3. Edwards 1800–1805.
4. Ash 1927, p. 155.
5. Schneider-Leyer 1970, p. 207.
6. Véron-Denise 2003, p. 15.
7. Rosenblum 1988, p. 17.
8. Walsh 1867.
9. Caius 1576, p. 20.
10. Ormond 1982, p. 126.
11. Farman 1899, p. 24.
12. Secord 2000, p. 312.
13. Klumpke 1908/2000, p. 122.
14. Norman 1977, p. 176.
15. Earl 1898, p. 11.
16. Bylandt 1904, p. 576.
17. Leighton 1911, p. 341.

Notes on the Nature of Dogs

CAROLYN ROSE REBBERT

Early Studies

People have been trying to understand dogs ever since the beginning of
time. One never knows what they'll do.

— Wilson Rawls, *Where the Red Fern Grows*

Dogs have the longest and most intimate association with the human race of any
domesticated mammal. How and when the relationship started, and who was the
first to experiment in understanding, training, and breeding dogs, are subjects for
speculation, the answers known only to those who left no records behind them. Yet
these trials resulted in a lasting partnership, with dogs well established as part of the
human cultures of the classical world. The Greek and Roman philosophers wrote
entire chapters on dogs as they recorded their observations, producing the earliest
treatises on nature. These classical works carried the weight of authority for over
a millennium, so that even the Renaissance scholar of the early sixteenth century
turned to these texts first in his quest to understand dogs.

In 350 B.C., Aristotle wrote *The History of Animals* and included such detailed
observations on anatomical features as could only have been gained by careful
dissections. He created a classification scheme in which dogs were first grouped
broadly with other animals containing red blood, and then more specifically with
four-footed animals that bear live young, that is, the "viviparous quadrupeds."
However, to create a compendium of such breadth, Aristotle also depended on
observations described by others and so included hearsay, fables, and fantastic stories.

DETAIL FROM FIG. 115

Though at times scornful of Greeks, Pliny the Elder relied heavily on Aristotle and other Greek and Roman writers in addition to his own observations while writing his encyclopedic *Natural History*, published in part in A.D. 77. Pliny described this treatise as a compendium of twenty thousand facts about "the nature of things" for the benefit of his friend the Roman emperor Vespasian, as well as anyone else who wished to read it. His chapter on dogs describes behavioral characteristics, with specific stories to exemplify traits such as unwavering faithfulness and intelligence. Although Pliny judiciously avoided anecdotes too fantastic to believe, he did include fables such as one also told by Aristotle about the breeding of dogs with tigers in India.

The scholars of the Middle Ages held the works of these classical philosophers in such esteem that they limited their curiosity and observation of the natural world to areas with immediate practical applications. Botany progressed because of the medicinal value of plants, but zoology languished, apart from a treatise on fowling written by the exceptionally keen observer Emperor Friedrich II. The study of dogs was doubtless further hampered by early Christian symbolism that equated these animals with evil. In the Old Testament, for instance, Job moans, "But now they hold me in derision who are younger in years than I; Whose fathers I should have disdained to rank with the dogs of my flock." Also, according to legend, Saint Christopher was a cynocephalus, a monstrous, dog-headed creature, and became truly human only when he accepted Christianity. But by the high to late Middle Ages, dogs also represented virtues such as truth, justice, and mercy and were included in bestiaries, popular works that used ancient stories about both real and mythical animals to provide a moral lesson. Thus, for example, the author of a fifteenth-century English bestiary used the observation that dogs lick their wounds as an allegory for the salve of confession healing the damage of sin. However, bestiaries generally fell short as zoological treatises, aside from some manuscripts with illustrations that distinguish animals at the species level.

Interest in animal life revived in the sixteenth century, and the publication of Konrad Gesner's *History of Animals* marks the start of modern zoology. Inspired by the classical compendia on animals, this Swiss physician and botanist created his own encyclopedic work, culling information not just from ancient sources but also from contemporary ones and from his own observations. He carefully cited each piece of information and eschewed some of the more fantastic creatures found in bestiaries. Affirming the value of illustrations to the study of living things, Gesner included numerous woodcuts of the animals he described (fig. 113).

He addressed dogs and other four-footed mammals in the first volume, printed in 1551. In the English translation of this book, Gesner noted that dogs inherit traits such as strength or intelligence from the sire, and that hunters crossbreed dogs in order to change or enhance certain characteristics. He considered that some of the more massive types of dogs might have resulted from wolf-dog mixes. The

CAROLYN ROSE REBBERT

Of the *GRAY-HOUND*, with a narration of all ſtrong and great hunting *DOGS*.

descriptions of the different breeds of dogs came from information sent to him by the English physician Johannes Caius, who in turn republished the information in his 1570 work, *Of Englishe Dogges*, the first book written solely about dogs.

Caius received his medical training at the University of Padua at the same time as Andreas Vesalius, a Flemish student destined to revolutionize anatomy. Dissections of human cadavers were part of university lectures, not as participatory events but simply as demonstrations to illustrate the authority of a classical scholar, Galen of Pergamum (c. A.D. 130–200). Galen had learned anatomy and the functions of various organs, arteries, and nerves solely by dissecting nonhuman mammals such

FIG. 113. *Among the divers kinds of hunting Dogs, the Gray-hound . . . deserveth the first place.* Woodcut, from Edward Topsell, *The History of Four-footed Beasts and Serpents, Collected out of the Writings of Conradus Gesner and Other Authors,* 1658. Courtesy American Museum of Natural History Library.

FIG. 114. Genealogical Table of the Different Races of Dogs. From Georges Louis Leclerc, comte de Buffon, *Natural History, General and Particular*, 1812 (translated edition of Buffon's *Histoire Naturelle*, 1749). Courtesy American Museum of Natural History Library.

as Barbary apes, dogs, and pigs. Naturally this led to certain errors in extrapolating the results to humans. Unlike Galen, Vesalius had access to human cadavers, with the gallows as his main source, supplemented by bodies from a Medici-controlled hospital in Florence, and at times even stolen from graves. He performed his own dissections of humans and dogs and, by juxtaposing the results, illustrated the errors in Galen's work.

Throughout the Renaissance, physicians continued to dissect both dead and live dogs to further their understanding of physiology. At Oxford in 1664, natural philosophers Robert Boyle and Robert Hooke investigated the process of respiration. As the experimentalist, Hooke performed the vivisection of a dog to show the function of the lungs by filling them with air from a bellows, but afterward he reported to Boyle that he would not do it again because of the suffering inflicted on the animal. Less traumatic was Christopher Wren's experiment, also performed for Boyle, to investigate whether blood circulates throughout the body. In this case, Wren

injected opium into a vein in a dog's hind leg, and the animal nodded off to sleep as nicely as if the injection had been given much closer to the brain.

With the Enlightenment, scientists returned to considering the dog as part of the larger natural world, the origins and history of which they sought to uncover. Georges Louis Leclerc, comte de Buffon, was one of the most ingenious natural historians of his day. In volume four of *Histoire naturelle*, published in 1753, Buffon noted that in spite of the incredible variety of "races" or breeds of dogs, they must all belong to one species, because they can interbreed and produce fertile offspring (fig. 114). However, Buffon questioned an earlier notion that species are fixed entities, unchanged from the day of creation. Rather, he postulated that through the influence of environmental conditions and inheritance, all dog types have developed from one ancestral form. By studying the wild dogs of various continents, Buffon thought this ancestral dog would have erect ears, coarse hair, and a slender muzzle. From this he concluded that "the shepherd's dog is the true dog of Nature . . . to be regarded as the origin and model of the whole species."[1]

Noting the similarities of wolves and foxes to dogs, Buffon attempted a few breeding experiments to determine if dog origins extended beyond the ancestral form. In one instance, he penned a she-wolf and an Irish greyhound together to see if they would mate. All his pairings failed to breed, leading him to write that "the dog derives not his origin from the wolf or the fox." Yet he was reluctant to dismiss the idea entirely, suggesting the possibility that in different places and times, or under different conditions, all three species might have intermixed, and he encouraged other naturalists to attempt the experiment.

The Evolution of Dogs

> And when, on the still cold nights, he pointed his nose at a star and howled long and wolf-like, it was his ancestors, dead and dust, pointing nose at star and howling down through the centuries and through him.
>
> —Jack London, *Call of the Wild*

The naturalists of the eighteenth and nineteenth centuries continued to debate the origin of the dog, as documented in Charles Darwin's *The Variation of Animals and Plants under Domestication*. Based on his review of the literature and his own observations and reasoning, Darwin thought that "it is highly probable that the domestic dogs of the world are descended from two well-defined species of wolf (viz. *C. lupus* and *C. latrans*), and from two or three other doubtful species (namely, the European, Indian, and North African wolves); from at least one or two South American canine species; from several races or species of jackal; and perhaps from one or more extinct species."[2]

Makenzie River Dog.　　　　　Esquimaux Dog.

Although Darwin believed that most species developed along a single lineage, he felt it was highly unlikely in the case of dogs for several reasons. Because members of the dog family are found throughout the world, he thought it probable that domestication occurred not once but rather numerous times and on different continents. Moreover, any canid species that can be tamed and is able to breed in captivity would have been a candidate for domestication. Finally, the great range of variation between breeds of dogs absolutely confounded Darwin, and so he considered that descent from several species could account for some of the differences (fig. 115).

The question of whether the dog evolved from wolves alone or from several canids addresses only the tip of his ancestral tree. Modern paleontological studies tell a story that begins about thirty-seven million years ago, when the first members of the dog family, or Canidae, appeared in North America. *Hesperocyon gregarius,* the "social western dog," was a slender, martenlike carnivore with a tail as long as its body and could follow its prey of small mammals and birds up into trees. Fossils of *Hesperocyon* (fig. 116) have been found only in North America, primarily in strata of the American Midwest and West, making this continent the birthplace of the Canidae.

For the next thirty million years, the dog family branched out into various forms while remaining within the confines of this continent. From *Hesperocyon*, three lineages or subfamilies emerged. Two of these eventually became extinct, whereas the third, the Caninae, began diversifying about nine million years ago to eventually produce all thirteen genera of modern living canids. Approximately seven million years ago, some of the canids developing in North America migrated to Asia and Europe, apparently through the Bering Strait, and took over the roles of now-extinct carnivores. These migrating members of the dog family diversified into species such as the gray wolf, red fox, and golden jackal, infiltrated Africa, where the fennec fox and African hunting dog are now found, and extended into Southeast Asia to develop into animals like the raccoon dog and dhole. Canids also migrated to South America, where the maned wolf, bush dog, and crab-eating fox now live.

Not all the canid groups left the North American continent, and some that had migrated returned to the continent after diversifying abroad. During the Ice Age, which extended from two million to ten thousand years ago, sea level rose and fell, repeatedly exposing the Bering land bridge. Starting approximately eight hundred thousand years ago, wolves and foxes used the land bridge to migrate to North America from Eurasia. Thus native groups as well as immigrant wolves and foxes developed into the North American assemblage of canids that includes both the highly successful coyote and the extinct dire wolf.

Given this diversity of canids and their distribution on every continent except Antarctica, it is no wonder Darwin concluded that dogs originated from more than one species. Moreover, biologists today have a less restrictive definition of species than was held in Darwin's time, recognizing, for example, that all species in the *Canis* genus (wolves, coyotes, and jackals) are able to interbreed.

What can modern genetics reveal about the direct ancestor of our faithful friend? In a landmark study Robert Wayne and his associates compared the mitochondrial

FIG. 116. *Hesperocyon gregarius*, Oligocene epoch (c. 32 million years before the present time), Logan County, Colorado. Courtesy American Museum of Natural History, no. 8774.

DNA of 140 dogs from 67 breeds with that of 162 wolves from 27 different localities in Europe, Asia, and North America.[3] They also studied the DNA of five coyotes and twelve jackals. Based on their analysis, most scientists agree that *Canis lupus*, the gray wolf (fig. 117), is the sole ancestor of the domestic dog.

Becoming Best Friends

> The Woman said, "Wild Thing out of the Wild Woods, help my Man to
> hunt through the day and guard this Cave at night, and I will give you as
> many roast bones as you need." . . . Wild Dog crawled into the Cave and
> laid his head on the Woman's lap. . . . And the Woman said, "His name is
> not Wild Dog any more, but the First Friend."
>
> —Rudyard Kipling, *Just So Stories*

The dog, *Canis lupus familiaris*, is our oldest nonhuman companion, and no matter whether he guards the house or wags his tail at every stranger, he captivates us. Archaeologists and biologists have sought to understand how, when, and where this connection was first made, whereupon our partner ceased being a wolf and became a dog. Skeletal remains, such as the wolf skulls methodically placed at the entrance to Paleolithic caves in the south of France, indicate that wolves and humans have at least shared territory for more than one hundred thousand years. The oldest bone of an animal whose dentition is distinctly doglike is a fourteen-thousand-year-old mandible

CAROLYN ROSE REBBERT

FIG. 118. Petroglyph from the Eastern or Arabian desert showing a human hunting an ostrich with a dog. Neolithic rock carving, c. 4000–2000 B.C. Courtesy of the Egypt Exploration Society.

from Germany. Slightly younger remains, twelve thousand years old, have been found in Israel and Iraq. Burial sites of the same age in Israel contain humans cradling doglike pups, implying that humans had by then incorporated tamed animals into their society. And by the Neolithic period, between 5,000 and 2,500 years ago, the first pictorial representations of dogs participating in human culture appear in the rock art of the Arabian and Western deserts of northeastern Africa (fig. 118).

Based on this evidence, scholars concluded that humans had domesticated wolves by fifteen thousand years ago and that domestication very likely took place several times by different human populations. Before 11,500 years ago, *Homo sapiens sapiens* (Cro-Magnon man) was still a nomadic hunter, so one theory proposes that early humans took in and tamed wolf pups to become hunting partners. Similarities in social structure, hunting methods, and means of communication within wolf and human societies forged a bond between the two species. Tamed wolves that stayed within their human pack also bred in captivity and, over time, became reproductively and thus genetically separate from their wild family.

In an attempt to further refine the time of domestication, Robert Wayne and his colleagues used the genetic data from their study as the basis for a molecular clock.[4] This method calculates the age when two related species diverged by assuming that the degree of genetic difference between the two results from a constant rate of mutation. With a one percent degree of difference between wolves and dogs, Wayne calculated that the two became distinct one hundred thirty-five thousand years ago. Wayne's study further challenged conventional wisdom, because the inheritance patterns suggested there were only two domestication events plus two occurrences of

wolf-dog interbreeding. From this he concluded that domesticating a wolf to create a new species or subspecies is a relatively rare event that requires skill.

The scientific community continues to study the issue. On the one hand, skeletal evidence makes no distinction between wolves and dogs prior to fourteen thousand years ago. But Wayne and his colleagues argue that genetic differences can exist without necessarily being expressed in the morphology of bones and teeth. Additionally, given that Neanderthal man might not have had the skill to tame and isolate wolves, behavioral biologist Raymond Coppinger proposed in 2001 that wolves initiated the connection, attaching themselves as scavengers on human encampments. However, some biologists question whether such a group of wolves would become reproductively separate from their wild siblings. Finally, Peter Savolainen, a colleague of Robert Wayne, reinvestigated the genetic differences. In his analysis of mitochondrial DNA from 654 dogs and 38 wolves, he assumed that dogs came from several wolf populations. In this case, the data indicate that the dog originated about fifteen thousand years ago in East Asia. But in an interview Savolainen stated that it is not yet possible to choose one date over another as being correct.[5]

Most will agree, however, that humans were heavily involved in shaping the domestic dog starting roughly twelve thousand years ago. As humans settled into agricultural communities, dogs filled an expanding array of roles, including those of shepherd, guardian, and household companion. Early peoples would have selected dogs with appropriate characteristics to fill these roles and probably killed those that were deemed unfit. Images of dogs with distinctive features indicate that people quickly learned to breed dogs to maintain desirable traits. For example, Egyptian hunting scenes from 2000–1000 B.C. depict saluki-type sight hounds, and an Assyrian relief from c. 645 B.C. shows mastifflike dogs in lion hunts and battle scenes.

Although these dogs resemble some modern breeds, external morphology is insufficient to trace the ancestry of the hound drooling beside us back to the court of the pharaohs. For more than eleven thousand years, breeding was a mixed-up affair involving multiple crossings of different types of dogs. On this subject, Konrad Gesner wrote in the sixteenth century that "nature rejoyceth more in variety."[6] In spite of the recommendations of naturalists from Gesner to Darwin, nineteenth-century European society valued pure bloodlines and developed the breed barrier rule. This rule required that both parents of a dog must be registered as breed members in order for it to be registered as well. Thus, from the handful of dog types listed by Buffon in the eighteenth century, there are now over 400 breeds, with 158 of these acknowledged by the American Kennel Club.

Given the stringent breeding requirements of the past two hundred years, biologists wondered if dog breeds could be differentiated on the basis of their genetic makeup. If breeds do have distinctive genetic markers, this knowledge could be

applied in a number of ways, from determining the parentage of a mutt to assessing its risk for any of three hundred fifty inherited disorders associated with purebred dogs. Elaine Ostrander, Leonid Kruglyak, and their research team carried out such an investigation and found that the particular breed of a dog accounts for 27 percent of its genetic variation from other dogs.[7] Based on their data, they devised a test to determine breed membership and applied it to samples from 414 dogs representing 85 breeds. The scientists were able to correctly assign the dog to its breed in 410 cases.

Examining the data further, they found that dog breeds cluster into four groups. The majority of dog breeds are of recent origin and group according to their function–guardian, herder, or hunter–but the fourth cluster contains dogs that are genetically closer to their wolf ancestors. Among this group of ancient breeds are dogs traditionally considered to be old, such as the Middle Eastern saluki (see fig. 11), the Chinese Pekingese, and the African basenji. It also includes breeds that resemble the wolf, such as the Siberian husky. However, other dogs that were thought to be old do not occur in this group. For example, although the pharaoh hound looks similar to dogs portrayed in Egyptian tombs, it is in fact the product of more recent breeding combinations.

Since Johannes Caius published the first book on dogs in 1570, the number of books and articles dealing with everything from dog origins to canine cognition has increased phenomenally. Research dollars, lab space, and the efforts of scientists worldwide are devoted to unraveling the mysteries of our favorite friend. Dogs came into being as a result of human association, and they soon got under our skin and into our hearts. Wherever we go, we will make sure that the dog is there to accompany us.

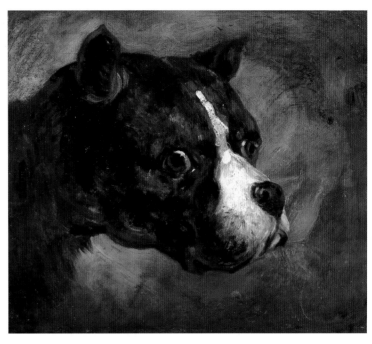

FIG. 119. Théodore Géricault (French, 1791–1824). *Head of a Bulldog*, c. 1817–18. Oil on board laid on panel, 9 1/8 x 10 7/8 in. (23.2 x 27.6 cm). Private collection, courtesy Wildenstein & Co., New York. It is difficult to discern the breed of this dog because breeds were not strictly established along pure bloodlines in the early nineteenth century. Whether it is called a bulldog, mastiff, or boxer, this dog is one of several genetically related breeds of recent origin.

Notes

Wilson Rawls, *Where the Red Fern Grows* (Garden City, N.Y.: Doubleday, 1961).

1. Buffon 1812.
2. Darwin 1875.
3. Vilà et al. 1997.
4. Ibid.
5. Savolainen et al. 2002.
6. Topsell 1658.
7. Parker et al. 2004.

Checklist of the Exhibition

Jacques-Laurent Agasse (Swiss, 1767–1849)
Rolla and Portia, 1805
Oil on canvas, 60⅝ x 48⅜ in. (154 x 123 cm)
Musée d'Art et d'Histoire, Geneva (1929-77)

Giacomo Balla (Italian, 1871–1958)
Dynamism of a Dog on a Leash, 1912
Oil on canvas, 35⅜ x 43½ in. (89.8 x 110.5 cm)
Albright-Knox Art Gallery, Buffalo; bequest of A. Conger
Goodyear and gift of George F. Goodyear, 1964 (1964.16)

Albert de Balleroy (French, 1828–1872)
French Hounds, c. 1860
Oil on canvas, 29 x 32 in. (73.7 x 81.3 cm)
Mr. and Mrs. R. M. Franzblau

Antoine-Louis Barye (French, 1795–1875)
Tom, Algerian Greyhound, modeled 1868, cast c. 1889
Bronze, 17⅞ x 34½ in. (45.4 x 87 cm)
The Walters Art Museum, Baltimore (27.476)

Georg Baselitz (German, born 1938)
Two Upward Dogs (Zwei Hunde aufwärts), 1968
Oil on canvas, 63¾ x 51¾ in. (162 x 130 cm)
Courtesy Michael Werner Gallery, New York and Cologne

Jacopo Bassano (Italian, c. 1510–1592)
Two Hunting Dogs, c. 1548–50
Oil on canvas, 24 x 31½ in. (61 x 80 cm)
Musée du Louvre, Département des Peintures, Paris (R.F. 1994–23)

William H. Beard (American, 1824–1900)
The Dog Congress (Candidates for Bench Show), c. 1876
Oil on canvas, 19½ x 29⅜ in. (48.9 x 74.6 cm)
Wadsworth Atheneum Museum of Art, Hartford, Conn.; The
Ella Gallup Sumner and Mary Catlin Sumner Collection Fund
(1942.443)

FIG. 120. Sir Edwin Landseer (English,
1802–1873). *Dignity and Impudence*.
c. 1839. Oil on canvas, 35½ x 25½ in.
(90.2 x 70 cm). Tate, London.

Rosa Bonheur (French, 1822–1899)
"Barbaro" after the Hunt, c. 1865
Oil on canvas, 38 x 51¼ in. (96.5 x 130.2 cm)
Philadelphia Museum of Art; gift of John G. Johnson for the
W. P. Wilstach Collection (W 1900-1-2)

Brassaï (French, 1899–1984)
Police Station, Paris, 1944
Gelatin silver photograph, 10½ x 8¾ in. (27 x 22 cm)
The Museum of Fine Arts, Houston; gift of Joan Morgenstern in
honor of Mark and Joan Silberman (98.1)

William Frank Calderon (English, 1865–1943)
A Lady of Quality, 1913
Oil on canvas, 30¾ x 48 in. (78.1 x 129.1 cm)
Private collection, Florida

Maurizio Cattelan (Italian, born 1960)
Dog Skeleton with Le Monde, 1997
Bone and paper, 28 x 15 x 14¾ in. (71.1 x 38.1 x 37.5 cm)
Stefan T. Edlis Collection

Benvenuto Cellini (Italian, 1500–1571)
Saluki, 1544–45
Bronze, 7 x 10¼ in. (17.8 x 26 cm)
Museo Nazionale del Bargello, Florence

Clodion (French, 1738–1814)
Model for a Mausoleum for Ninette, c. 1780–85
Terra-cotta, 14¹⁵⁄₁₆ x 7¹⁄₁₆ x 6¼ in. (38 x 18 x 16 cm)
Musée Lorrain, Nancy (71.2.7)

Gustave Courbet (French, 1819–1877)
The Greyhounds of the Comte de Choiseul, 1866
Oil on canvas, 35 x 45¾ in. (88.9 x 116.2 cm)
Saint Louis Art Museum; gift of Mrs. Mark C. Steinberg
(168:1953)

Alexandre-Gabriel Decamps (French, 1803–1860)
Hospital for the Mangy ("The Convalescent Dogs"), 1830
Oil on canvas, 15 x 18⅛ in. (38 x 46 cm)
Charles Janoray, New York

Alfred Dedreux (French, 1810–1860)
Hounds in a Wooded Landscape, c. 1850–55
Oil on canvas, 28¾ x 36¼ in. (73 x 92.1 cm)
Mr. and Mrs. R. M. Franzblau

Alexandre-François Desportes (French, 1661–1740)
Tane, A Hunting Dog of Louis XIV, 1702
Oil on canvas, 64⅜ x 53⅜ in. (163.5 x 135.5 cm)
Musée de la Chasse et de la Nature, Paris (Dépôt du Musée du Louvre, 1967)

Alexandre-François Desportes (French, 1661–1740)
Still Life with Dog and Game, 1710
Oil on canvas, 32¼ x 40⅜ in. (81.9 x 102.5 cm)
The Sarah Campbell Blaffer Foundation, Houston (1991.6)

Alexandre-François Desportes (French, 1661–1740)
Pompée and Florissant, Hounds of Louis XV, 1739
Oil on canvas, 66⅛ x 55⅛ in. (168 x 140 cm)
Musée National du Château de Compiègne (inv. 3917)

Gerrit Dou (Dutch, 1613–1675)
A Sleeping Dog Beside a Terracotta Jug, a Basket, and a Pile of Kindling Wood, 1650
Oil on wood, 6½ x 8½ in. (16.5 x 21.6 cm)
Private collection

Jan le Ducq (Dutch, 1629/30–1676)
A Dog and a Hare, c. 1665
Oil on canvas, 9¼ x 11 in. (23.5 x 28 cm)
Private collection

Tracey Emin (English, born 1963)
Reincarnation, 2005
Single screen projection animation, transferred to DVD
Edition of 10
Courtesy the artist; White Cube, London; and Lehmann Maupin Gallery, New York

Elliott Erwitt (American, born 1928)
New York City, 1974
Gelatin silver photograph, 20 x 23⅞ in. (50.8 x 60.6 cm)
The Museum of Fine Arts, Houston; gift of Anne H. Bushman (94.61)

François-Xavier Fabre (French, 1766–1837)
Portrait of "Bel Pirro," 1823
Oil on canvas, 25⅝ x 38⅝ in. (65 x 98 cm)
Musée Fabre, Montpellier

Thomas Gainsborough (English, 1727–1788)
Portrait of a Pug Belonging to Jonathan Spilsbury, in a Landscape, c. 1780–85
Oil on canvas, 11½ x 13½ in. (29.2 x 34.3 cm)
Richard L. Feigen & Co., New York

Théodore Géricault (French, 1791–1824)
Head of a Bulldog, c. 1817–18
Oil on board laid on panel, 9⅛ x 10⅞ in. (23.2 x 27.7 cm)
Private collection, courtesy Wildenstein & Co., New York

Jean-Léon Gérôme (French, 1824–1904)
Optician's Sign, 1902
Oil on canvas, 34¼ x 26 in. (87 x 66 cm)
Private collection

Grégoire Giraud (French, 1783–1836)
Hound, 1827
Marble, 20⅞ x 32¼ x 19⅝ in. (53 x 82 x 50 cm)
Musée du Louvre, Département des Sculptures, Paris (Inv. N 15568)

Juan van der Hamen y León (Spanish, 1596–1631)
Still Life with Vase of Flowers and a Dog, c. 1625
Oil on canvas, 89¾ x 37⅜ in. (228 x 95 cm)
Museo Nacional del Prado, Madrid (6413)

Juan van der Hamen y León (Spanish, 1596–1631)
Still Life with Vase of Flowers and a Puppy, c. 1625
Oil on canvas, 89¾ x 37⅜ in. (228 x 95 cm)
Museo Nacional del Prado, Madrid (4158)

Duane Hanson (American, 1925–1996)
Beagle in a Basket, 1981
Polyvinyl, polychromed in oil, with accessories, life-size
Mrs. Duane Hanson

Keith Haring (American, 1958–1990)
Untitled, 1982
Marker and acrylic on board, 6¾ x 8½ in. (17.1 x 21.6 cm)
Courtesy The Stephanie and Peter Brant Foundation, Greenwich, Conn.

David Hockney (English, born 1937)
Dog Painting 22, 1995
Oil on canvas, 28 x 29 in. (71.1 x 73.7 cm)
Private collection

Abraham Hondius (Dutch, c. 1631–1691)
Amsterdam Dog Market, c. 1671–72
Oil on canvas, 38½ x 48½ in. (97.8 x 123.2 cm)
Walter F. Goodman and Robert A. Flanders

Jean-Baptiste Huet (French, 1745–1811)
A King Charles Spaniel, 1778
Oil on canvas, 18 x 22 in. (45.8 x 55.8 cm)
Private collection, courtesy Wildenstein & Co., New York

Johann Gottlieb Kirchner (German, 1706–after 1738)
Bolognese, c. 1733
Meissen, hard-paste porcelain, 16¹³⁄₁₆ x 14½ in. (42.7 x 36.8 cm)
The Metropolitan Museum of Art, New York; gift of R. Thornton Wilson, in memory of Florence Ellsworth Wilson, 1954 (54.147.69)

Paul Klee (Swiss, 1879–1940)
Howling Dog, 1928
Oil on canvas, 17½ x 22⅜ in. (44.5 x 56.8 cm)
The Minneapolis Institute of Arts; gift of F. C. Schang (56.42)

Jeff Koons (American, born 1955)
Poodle, 1991
Polychromed wood, 23 x 40 x 20 in. (58.4 x 100.3 x 50.8 cm)
Private collection

Sir Edwin Landseer (English, 1802–1873)
*Portrait of a Terrier, The Property of Owen Williams, Esq., M.P.
(Jocko with a Hedgehog)*, 1828
Oil on canvas, 40 x 50 in. (102 x 127 cm)
Milwaukee Art Museum; gift of Erwin C. Uihlein (M1067.79)

Sir Edwin Landseer (English, 1802–1873)
Attachment, 1829
Oil on canvas, 39 x 31¼ in. (99.1 x 79.5 cm)
Saint Louis Art Museum; gift of Mrs. Eugene A. Perry in memory
of her mother, Mrs. Claude Kirkpatrick, by exchange (123:1987)

Sir Edwin Landseer (English, 1802–1873)
Dignity and Impudence, c. 1839
Oil on canvas, 35½ x 25½ in. (90.2 x 70 cm)
Tate, London

Sir Edwin Landseer (English, 1802–1873)
Deerhound and Recumbent Hound, 1839
Oil on canvas, 45¼ x 48¼ in. (114.9 x 122.6 cm)
The American Kennel Club Museum of the Dog, Saint Louis

Sir Edwin Landseer (English, 1802–1873)
Dog and Dead Deer (also called *Chevy*), c. 1868
Oil on canvas, 54 x 82 in. (137.2 x 208.3 cm)
The Detroit Institute of Arts; Founders Society Purchase, Alvan
Macauley, Jr., Fund (76.4)

Herbert List (German, 1903–1975)
Herr und Hund, 1936
Gelatin silver photograph, printed 1999, 15⅞ x 12 in.
(40.3 x 30.5 cm)
The Museum of Fine Arts, Houston; gift of an anonymous donor
in honor of James Edward Maloney and Beverly Ann Young
(2001.178)

Franz Marc (German, 1880–1916)
Siberian Dogs in the Snow, 1909/10
Oil on canvas, 31⅝ x 44⅞ in. (80.5 x 114 cm)
National Gallery of Art, Washington, D.C.; gift of Mr. and Mrs.
Stephen M. Kellen (1983.97.1)

Emily Mayer (English, born 1960)
Lounging Lurcher, 1996
Wood and steel, 14 x 49½ x 22 in. (35.6 x 125.8 x 55.8 cm)
Courtesy Emily Mayer

Ron Mueck (Australian, born 1958)
Mongrel, 1996
Mixed media, 15¾ x 24 x 8 in. (40 x 61 x 20.3 cm)
Lord Glenconner

John Sargent Noble (English, 1848–1896)
Pug and Terrier, 1875
Oil on canvas, 36 x 26 in. (91.4 x 71.1 cm)
Collection The American Kennel Club, New York

John Sargent Noble (English, 1848–1896)
Bloodhounds at Rest, c. 1880–85
Oil on canvas, 40 x 60 in. (101.6 x 152.4 cm)
Collection Frances G. Scaife

Jean-Baptiste Oudry (French, 1686–1755)
Dog with Bowl, c. 1751
Oil on canvas, 45¼ x 51⅝ in. (115 x 131 cm)
Musée de la Vénerie, Senlis (Inv. 7036)

Jean-Baptiste Oudry (French, 1686–1755)
Bitch Nursing Her Puppies, 1752
Oil on canvas, 40¾ x 52 in. (103.5 x 132.1 cm)
Musée de la Chasse et de la Nature, Paris (71.2.1)

Paulus Potter (Dutch, 1625–1654)
Dogs in an Interior, 1649
Oil on canvas, 45¼ x 57⅞ in. (115 x 147 cm)
Noortman Master Paintings

Philip Reinagle (English, 1749–1833)
Portrait of an Extraordinary Musical Dog, 1805
Oil on canvas, 28¼ x 36½ in. (71.7 x 92.7 cm)
Virginia Museum of Fine Arts, Richmond; Paul Mellon Collection
(85.465)

Philippe Rousseau (French, 1816–1887)
Everyone for Himself, 1864
Oil on canvas, 38⅛ x 51⅛ in. (97 x 130.5 cm)
Lawrence Steigrad Fine Arts, New York

Frans Snyders (Flemish, 1579–1657)
Two Dogs and a Cat in a Kitchen, c. 1630–35
Oil on canvas, 39 x 57 in. (99 x 145 cm)
Museo Nacional del Prado, Madrid (1750)

Joseph Edouard Stevens (Belgian, 1816–1892)
Dog with a Bone (Misère), 1854
Oil on canvas, 35⅞ x 47¼ in. (91.2 x 120 cm)
Musée des Beaux-Arts de Tournai; Collection Van Cutsem
(inv. 578)

George Stubbs (English, 1724–1806)
Five Staghounds in a Landscape, c. 1760
Oil on canvas, 40 x 50 in. (101.6 x 127 cm)
The Trustees of the Rt. Hon. Olive, Countess Fitzwilliam's Chattels
Settlement; by permission of Lady Juliet Tadgell

George Stubbs (English, 1724–1806)
King Charles Spaniel, 1776
Oil on wood, 23 x 27 in. (58.5 x 68.6 cm)
Private collection, United Kingdom

George Stubbs (English, 1724–1806)
Brown and White Norfolk or Water Spaniel, 1778
Oil on canvas, 31¾ x 38¼ in. (80.7 x 97.2 cm)
Yale Center for British Art; Paul Mellon Collection (B2001.2.10)

George Stubbs (English, 1724–1806)
Norfolk Water Dog in a Punt, c. 1780
Oil on canvas, 50 x 40 in. (127 x 101.5 cm)
National Gallery of Art, Washington, D.C.; Paul Mellon Collection
(1999.80.22)

Giovanni Battista Tiepolo (Italian, 1696–1770)
Portrait of the Spaniel of the Infanta Maria Josefa de Bourbón, c. 1763
Oil on canvas, 17⅞ x 12⅛ in. (45.5 x 31 cm)
Private collection; courtesy Galería Caylus, Madrid

Simone del Tintore (Italian, 1630–1708)
Two Pairs of Greyhounds, c. 1688
Oil on canvas, 38 x 36 in. (96.5 x 91.4 cm)
Private collection, Los Angeles

Titian (Italian, c. 1488/90–1576)
Boy with Dogs, c. 1570–76
Oil on canvas, 37¾ x 45¼ in. (96 x 115 cm)
Museum Boijmans Van Beuningen, Rotterdam

Constant Troyon (French, 1810–1865)
Hound Pointing, 1860
Oil on canvas, 64½ x 51⅜ in. (163.8 x 130.5 cm)
Museum of Fine Arts, Boston; gift of Mrs. Louise A. Frothingham
(24.345)

Wilhelm Trübner (German, 1851–1917)
Crossing the Rubicon, 1878/79
Oil on canvas, 19⅛ x 24 in. (48.6 x 60.9 cm)
Staatliche Kunsthalle, Karlsruhe (inv. 899)

Anne Vallayer-Coster (French, 1744–1818)
Les Petits Favoris, c. 1775–80
Oil on canvas, 16¹¹⁄₁₆ x 20⁹⁄₁₆ in. (42.4 x 52.2 cm)
Private collection, New York; courtesy Richard L. Feigen & Co.,
New York

Eugène-Joseph Verboeckhoven (Belgian, 1798–1881)
The Favorite Animals of King Leopold I, 1845
Oil on canvas, 71¼ x 59 in. (181 x 149.9 cm)
BELvue Museum, managed by the Bellevue Fund created within
the King Baudouin Foundation, Brussels

James Ward (English, 1769–1859)
Persian Greyhounds, 1807
Oil on canvas, 40 x 50 in. (101.5 x 127 cm)
The American Kennel Club Museum of the Dog, Saint Louis

Andy Warhol (American, 1928–1987)
Ginger, 1976
Synthetic polymer and silkscreen on canvas, 50 x 40 in.
(127 x 101.5 cm)
Private collection; courtesy Sperone Westwater, New York

Jan Baptist Weenix (Dutch, 1621–1659)
Hound with a Joint of Meat and a Cat, c. 1650–55
Oil on canvas, 45 x 51 in. (114.3 x 129.5 cm)
Jack Kilgore & Co., New York

William Wegman (American, born 1943)
Horst, 1979
Gelatin silver photograph, 13¾ x 10½ in. (34.9 x 26.7 cm)
The Museum of Fine Arts, Houston; The Allan Chasanoff
Photographic Collection (91.1226)

William Wegman (American, born 1943)
Elk's Club (from the portfolio *Five Still Lifes*), 1980
Internal dye diffusion photograph, 28⁹⁄₁₆ x 21¹⁵⁄₁₆ in.
(72.5 x 55.7 cm)
The Museum of Fine Arts, Houston; gift of Manfred Heiting, The
Manfred Heiting Collection (2002.4012.5)

William Wegman (American, born 1943)
"Grandmother," she said, "you look different" (from the suite *Little Red
Riding Hood*), 1993
Polaroid Polacolor ER photograph, 23½ x 19⁷⁄₁₆ in.
(59.2 x 49.4 cm)
Collection Friends of the Neuberger Museum of Art, Purchase
College, State University of New York; gift in 2003 from
Neuberger Berman in honor of Roy R. Neuberger's 100th birthday

William Wegman (American, born 1943)
Flöck (one of four panels), 1998
Iris color digital ink jet photograph, 43½ x 34½ in.
(110.5 x 87.6 cm)
The Museum of Fine Arts, Houston; The Manfred Heiting
Collection (2002.2627)

Denis Wirth-Miller (English, born 1915)
Running Dog, c. 1951
Oil on canvas, 29½ x 36 in. (74.9 x 91.4 cm)
Courtesy James Birch

Andrew Wyeth (American, born 1917)
Raccoon, 1958
Tempera on wood, 48 x 48 in. (121.9 x 121.9 cm)
Brandywine River Museum, Chadds Ford, Pa.; museum purchase
made possible by David Rockefeller, Laurance S. Rockefeller, Mimi
Haskell, and The Pew Memorial Trust, in memory of Nancy Hanks
(83.15)

Selected Bibliography

Ackley 2003
Ackley, Clifford S. *Rembrandt's Journey: Painter, Draftsman, Etcher.* Boston: MFA Publications, 2003. Published in conjunction with the exhibition "Rembrandt's Journey: Painter, Draftsman, Etcher," presented at the Museum of Fine Arts, Boston, and the Art Institute of Chicago.

Aikema 1996
Aikema, Bernard. *Jacopo Bassano and His Public: Moralizing Pictures in an Age of Reform, ca. 1535–1600.* Princeton: Princeton University Press, 1996.

Alte Pinakothek 1986
Alte Pinakothek Munich. Munich: Karl M. Lipp Verlag, 1986.

Ash 1927
Ash, Edward C. *Dogs: Their History and Development.* 2 vols. London, 1927.

Baglione 1642
Baglione, Giovanni. *Le vite de' pittori, scultori & architetti: Dal pontificato di Gregorio XIII del 1572 in fino a' tempi di Papa Urbano Ottavo nel 1642.* 1642. Facsimile edition, with marginal notes by Giovanni Bellori, edited by Valerio Mariani. Rome: Stab. arti grafiche E. Calzone, 1935.

Ballarin 1995
Ballarin, Alessandro. "Jacopo Bassano: Ritratto di Levriero." In *Jacopo Bassano: Scritti 1964–1995.* Vol. 1, 378–408. Cittadella, Italy: Bertoncello Artigrafiche, 1995.

Barnes, De Poorter, Millar, and Vey 2004
Barnes, Susan, Nora De Poorter, Oliver Millar, and Horst Vey. *Van Dyck: A Complete Catalogue of the Paintings.* New Haven and London: Yale University Press, 2004.

Bartsch 1805–70
Bartsch, Adam von. *Le peintre graveur.* 21 vols. Leipzig: J. A. Barth, 1805–70.

Bedaux 1990
Bedaux, Jan Baptist. *The Reality of Symbols: Studies in the Iconology of Netherlandish Art 1400–1800.* The Hague: Gary Schwartz/SDU Publishers, 1990.

Berger and Krahn 1994
Berger, Ursel, and Volker Krahn. *Herzog Anton Ulrich-Museum Braunschweig: Bronzen der Renaissance und des Barock; Katalog der Sammlung.* Braunschweig: Herzog Anton Ulrich-Museum, 1994.

Bialostocki 1990
Jan Bialostocki. "I cani di Paolo Veronese." In *Nuovi studi su Paolo Veronese,* edited by Massimo Gemin, 220–30. Venice: Arsenale Editrice, 1990.

Bocchi and Bocchi 1998
Bocchi, Gianluca, and Ulisse Bocchi, eds. *Naturaliter: Nuovi contributi alla natura morta in Italia settentrionale e Toscana tra XVII e XVIII secolo.* Casalmaggiore, Italy: Galleria d'Orlane, 1998.

Brewer, Clark, and Phillips 2001
Brewer, Douglas, Terence Clark, and Adrian Phillips. *Dogs in Antiquity: Anubis to Cerberus, the Origins of the Domestic Dog.* Warminster, United Kingdom: Aris & Phillips, 2001.

Brock 1998
Brock, Maurice. "Deux Chiens de Chasse par Jacopo Bassano." *Beaux Arts* 171 (1998): 76–77.

Broos 1990
Broos, Ben. *Great Dutch Paintings from America.* Zwolle, Netherlands: Waanders Publishers, 1990. Published in conjunction with the exhibition "Great Dutch Paintings from America," presented at the Mauritshuis, The Hague, and the Fine Arts Museums of San Francisco.

Brown 1981
Brown, David A. "A Print Source for Parmigianino at Fontanellato." In *Per A. E. Popham,* 43–53. Parma, Italy: Consigli Arte, 1981.

Budiansky 2000
Budiansky, Stephen. *The Truth About Dogs.* New York: Viking, 2000.

Buffon 1812
Buffon, Georges Louis Leclerc. *Natural History, General and Particular.* Translated by William Smellie. London, 1812.

Bylandt 1904
Bylandt, Comte Henri de. *Dogs of All Nations: Their Varieties, Characteristics, Points, Etc.* Vol. 1, *Sporting Dogs.* Deventer, Netherlands, 1904.

Caius 1576
Caius, Johannes. *Of English Dogges*. London, 1576.

Campbell 1990
Campbell, Lorne. *Renaissance Portraits: European Portrait-Painting in the 14th, 15th, and 16th Centuries*. New Haven and London: Yale University Press, 1990.

Carapelli 1986
Carapelli, Riccardo. "Cani bolognesi, principi medicei e alcuni disegni inediti seicenteschi." *Carrobbio* 12 (1986): 101–7.

Cellini 1995
Cellini, Benvenuto. *The Life of Benvenuto Cellini, Written by Himself*. 2d ed. Translated by J. Addington Symonds, introduction and notes by John Pope-Hennessy. London: Phaidon, 1995.

Clark 1977
Clark, Kenneth. *Animals and Men: Their Relationship as Reflected in Western Art from Prehistory to the Present Day*. New York: William Morrow and Company, 1977.

Clutton-Brock 1999
Clutton-Brock, Juliet. *A Natural History of Domesticated Mammals*. 2d ed. Cambridge: Cambridge University Press, 1999.

Cohen 1998
Cohen, Simona. "Animals in the Paintings of Titian: A Key to Hidden Meanings." *Gazette des Beaux-Arts* 132 (1998): 193–212.

Costamagna 2005
Costamagna, Philippe. "The Formation of Florentine Draftsmanship: Life Studies from Leonardo and Michelangelo to Pontormo and Salviati." *Master Drawings* 43, no. 3 (Fall 2005): 274–91.

Coutts 1980
Coutts, Howard. "A Veronese Drawing in Edinburgh." *Master Drawings* 18 (1980): 142–44.

Cuvier 1827–35
Cuvier, Georges. *Animal Kingdom*. Vol. 1. 1827–35. Reprint, New York: Arno Press, 1978.

Damian 2004
Damian, Véronique. *Pittura italiana tra Sei e Settecento: Un Portrait de lévrier par Baccio del Bianco*. Paris: Galerie Canesso, 2004.

D'Anthenaise, de Fougerolle, MacDonogh, and Prestate 2000
D'Anthenaise, Claude, Patricia de Fougerolle, Katherine MacDonogh, and Marie-Christine Prestate. *Vies de Chiens*. Paris: Alain de Gourcuff Éditeur, 2000.

Darwin 1859
Darwin, Charles. *The Origin of Species by Means of Natural Selection*. 1859. Reprint, New York: Modern Library, 1936.

Darwin 1875
Darwin, Charles. *The Variation of Animals and Plants under Domestication*. Vol. 1, 2d ed. London: John Murray, 1875. Also available online at http://www.gutenberg.org/etext/2871.

Dayton 2003
Dayton, Leigh. "On the Trail of the First Dingo." *Science* 302 (2003): 555.

DeGrazia Bohlin 1979
DeGrazia Bohlin, Diane. *Prints and Related Drawings by the Carracci Family*. Washington, D.C.: National Gallery of Art, 1979.

De Luca and Winspeare 2003
De Luca, Maddalena, and Maddalena Paola Winspeare. *Dogs in Galleries*. Livorno, Italy: Sillabe, 2003.

Derr 2003
Derr, Mark. "Darwin's Dogs." In *Dog Is My Co-pilot: Great Writers on the World's Oldest Friendship*, edited by The Bark, 148–52. New York: Crown Publishers, 2003.

Droguet, Salmon, and Véron-Denise, 2003
Droguet, Vincent, Xavier Salmon, and Danièle Véron-Denise, *Animaux d'Oudry, Collections des ducs de Mecklembourg-Schwerin*. Paris: Réunion des Musées Nationaux, 2003. Published in conjunction with the exhibition "Animaux d'Oudry, Collections des ducs de Mecklembourg-Schwerin," presented at the Musée National du Château de Fontainebleau.

Earl 1898
Earl, Maud. "Interview with Maud Earl." *The Young Woman* 2 (November 1898): 11.

Edwards 1800–1805
Edwards, Sydenham. *Cynographia Britannica: consisting of coloured engravings of the various breeds of dogs existing in Great Britain; drawn from the life, with observations on their Properties and Uses*. London, 1800–1805.

Eisler 1991
Eisler, Colin. *Dürer's Animals*. Washington and London: Smithsonian Institution Press, 1991.

Ertz and Nitze-Ertz 1997
Ertz, Klaus, and Christa Nitze-Ertz. *Pieter Breughel der Jüngere, Jan Brueghel der Ältere: Flämische Malerei um 1600; Tradition und Fortschritt*. Lingen: Luca Verlag; Essen: Kulturstiftung Ruhr, 1997. Published in conjunction with the exhibition "Pieter Breughel der Jüngere, Jan Brueghel der Ältere: Flämische Malerei um 1600; Tradition und Fortschritt," presented at Kulturstiftung Ruhr, Villa Hügel, Essen; Kunsthistorisches Museum, Vienna; and Koninklijk Museum voor Schone Kunsten, Antwerp.

Faldi 1966
Faldi, Italo. "I dipinti chigiani di Michele e Giovan Battista Pace." *Arte antica e moderna* 34–36 (1966): 144–50.

Farman 1899
Farman, Edgar. *The Bulldog*. London, 1899.

Florence 1983
Sustermans: Sessant' anni alla corte dei Medici. Florence: Centro Di, 1983. Published in conjunction with the exhibition "Sustermans: Sessant' anni alla corte dei Medici," organized by Marco Chiarini and Claudio Pizzorusso and presented at the Palazzo Pitti, Florence.

Fountain and Gates 1984
Fountain, Robert, and Alfred Gates. *Stubbs' Dogs*. London: Ackermann, 1984.

Franits 2004
Franits, Wayne E. *Dutch Seventeenth-Century Genre Painting: Its Stylistic and Thematic Evolution*. New Haven and London: Yale University Press, 2004.

Garrard 2004
Garrard, Mary D. "'Art More Powerful than Nature?' Titian's Motto Reconsidered." In *The Cambridge Companion to Titian*, edited by Patricia Meilman, 241–61. Cambridge: Cambridge University Press, 2004.

Genoways and Burgwin 1984
Genoways, Hugh H., and Marion A. Burgwin, eds. *Natural History of the Dog*. Pittsburgh: Carnegie Museum of Natural History, 1984.

Gerson 1951
Gerson, Horst. "Het Meesterwerk van Abraham Hondius." *Oud Holland* 66 (1951): 246–48.

Glen 1993
Glen, Thomas L. "Should Sleeping Dogs Lie? Once Again, Las Meninas and the Mise-en-Scène." *Source* 12 (1993): 30–36.

Habert 1991
Habert, Jean. "Jacopo dal Ponte, dit Jacopo Bassano: Deux Chiens de chasse liés à une souche." In *Nouvelles acquisitions du département des peintures (1987–1990), Musée du Louvre*, edited by Jacques Foucard, introduction by Pierre Rosenberg, 212–20. Paris: Editions de la Réunion de Musées Nationaux, 1991.

Habert and Legrand 1998
Habert, Jean, and Catherine Loisel Legrand. *Exposition-dossier du départment des Peintures: Bassano et ses fils dans musées français*. Paris: Editions de la Réunion des Musées Nationaux, 1998.

Hall 1994
Hall, Edwin. *The Arnolfini Betrothal: Medieval Marriage and the Engima of Van Eyck's Double Portrait*. Berkeley, Los Angeles, and London: University of California Press, 1994.

Höltgen 1998
Höltgen, Karl Josef. "Clever Dogs and Nimble Spaniels: On the Iconography of Logic, Invention, and Imagination." *Explorations in Renaissance Culture* 24 (1998): 1–36.

Jardine 1999
Jardine, Lisa. *Ingenious Pursuits: Building the Scientific Revolution*. New York: Nan A. Talese, 1999.

Jongh 2000
Jongh, Eddy de. *Questions of Meaning: Theme and Motif in Dutch Seventeenth-Century Painting*. Translated and edited by Michael Hoyle. Leiden: Primavera Pers, 2000.

Kete 1994
Kete, Kathleen. *The Beast in the Boudoir: Petkeeping in Nineteenth-Century Paris*. Berkeley: University of California Press, 1994.

Kloek 2005
Kloek, Wouter. *Jan Steen (1626–1679)*. Zwolle: Waanders Publishers; Amsterdam: Rijksmuseum, 2005.

Klumpke 1908/2000
Klumpke, Anna. *Rosa Bonheur*. 1908. Translated by Gretchen van Slyke. Reprint, Ann Arbor: University of Michigan Press, 2000.

Koslow 1995
Koslow, Susan. *Frans Snyders: The Noble Estate; Seventeenth-Century Still-life and Animal Painting in the Southern Netherlands*. Antwerp: Fonds Mercator Paribas, 1995.

Kultzen 1977
Kultzen, Rolf. "Justus Sustermans as an Animal Painter." *Burlington Magazine* 119 (1977): 39–40.

Kuretsky 1995
Kuretsky, Susan Donahue. "Rembrandt's *Good Samaritan* Etching: Reflections on a Disreputable Dog." In *Shop Talk: Studies in Honor of Seymour Slive; Presented on His Seventy-fifth Birthday*, edited by Cynthia P. Schneider, Alice I. Davies, and William W. Robinson, 150–53. Cambridge, Mass.: Harvard University Art Museums, 1995.

Lavin 2002
Lavin, Marilyn Aronberg. *Piero della Francesca*. London: Phaidon, 2002.

Leighton 1911
Leighton, Robert, ed. *The New Book of the Dog*. Vol. 2, special edition. London: Cassell and Co., Ltd., 1911.

Lightbown 1992
Lightbown, Ronald. *Piero della Francesca*. New York: Abbeville Press, 1992.

Lindberg 1992
Lindberg, David C. *The Beginnings of Western Science: The European Scientific Tradition in Philosophical, Religious, and Institutional Context, 600 B.C. to A.D. 1450*. Chicago: University of Chicago Press, 1992.

London 1999
London, Sotheby's. *Old Master Paintings* [sales catalogue]. December 16, 1999.

López-Rey 1996
López-Rey, José. *Velázquez: Catalogue Raisonné; Werkverzeichnis*. 2 vols. Cologne: Benedikt Taschen Verlag; Paris: Wildenstein Institute, 1996.

MacDonogh 1999
MacDonogh, Katharine. *Reigning Cats and Dogs*. New York: St. Martin's Press, 1999.

Malvasia 2000
Malvasia, Carlo Cesare. *Malvasia's Life of the Carracci*. Commentary and translation by Anne Summerscale. University Park: The Pennsylvania State University Press, 2000.

McConathy 1982
McConathy, Dale. *Best of Friends: The Dog and Art*. New York: The Dog Museum of America, 1982.

Meiss 1967
Meiss, Millard. *French Painting in the Time of Jean de Berry: The Late Fourteenth Century and the Patronage of the Duke*. 2 vols. London: Phaidon, 1967.

Meiss 1974
Meiss, Millard. *French Painting in the Time of Jean de Berry: The Limbourgs and Their Contemporaries*. 2 vols. With the assistance of Sharon Off Dunlap Smith and Elizabeth Home Beatson. New York: George Braziller, 1974.

Mezentseva 1978
Mezentseva, Charmian Aleksandrovna. "Four German Renaissance Bronzes." *Soobshcheniia Gosudarstvennogo Ermitazha* 43 (1978): 5–8.

Morell 1997
Morell, Virginia. "The Origin of Dogs: Running with the Wolves." *Science* 276 (1997): 1647.

Moro 2000
Moro, Franco. *I Piaceri della Vita nell'Arte dal XVI al XVIII secolo*. Milan: De Agostini Rizzoli, 2000. Published in conjunction with the exhibition "I Piaceri della Vita nell'Arte dal XVI al XVIII secolo" shown at the Castello di Belgioioso and Palazzo Chigi, Ariccia.

Naumann 1981
Naumann, Otto. *Frans van Mieris (1635–1681), the Elder*. Doornspijk, Netherlands: Davaco Publishers, 1981.

New York 2005
New York, Christie's. *Old Master Paintings* [sales catalogue]. May 25, 2005.

Norman 1977
Norman, Geraldine. *Nineteenth-Century Painters and Painting: A Dictionary*. London: Thames and Hudson, 1977.

Ormond 1982
Ormond, Richard. *Sir Edwin Landseer*. With contributions by Joseph Rishel and Robin Hamlyn. New York: Rizzoli, 1982.

Papy 1999
Papy, Jan. "Lipsius and His Dogs: Humanist Tradition, Iconography and Rubens's *Four Philosophers*." *Journal of the Warburg and Courtauld Institutes* 62 (1999): 167–98.

Paris and Venice 2004–5
Veronese: Gods, Heroes, and Allegories. Milan: Skira Editore, 2004. Published in conjunction with the exhibition "Veronese: Gods, Heroes, and Allegories," presented at the Musée du Luxembourg, Paris, and Museo Correr, Venice.

Parker et al. 2004
Parker, Heidi G., et al. "Genetic Structure of the Purebred Domestic Dog." *Science* 304 (2004): 1160.

Paulussen 1980
Paulussen, Isabelle M. J. "Tiberio Titi, ritrattista dei Medici." *Mededelingen van het Nederlands Historisch Instituut te Rome's-Gravenhage* 42 (1980): 101–27.

Pennisi 2002
Pennisi, Elizabeth. "A Shaggy Dog History: Biologists Chase Down Pooches' Genetic and Social Past." *Science* 298 (2002): 1540.

Pedrocco 2001
Pedrocco, Filippo. *Titian*. New York: Rizzoli, 2001.

Penny 1976
Penny, N. B. "Dead Dogs and Englishmen." *Connoisseur* 192 (1976): 298–303.

Peyser-Verhaar 1998
Peyser-Verhaar, Marijke. "Abraham Hondius: His Life and Background." *Oud Holland* 112 (1998): 151–56.

Phébus 1998
Phébus, Gaston. *The Hunting Book of Gaston Phébus*. Introduction by Marcel Thomas and François Avril. Commentary by Wilhelm Schlag. London: Harvey Miller Publishers, 1998.

Pliny c. A.D. 77
Pliny the Elder. *The Natural History*. c. A.D. 77.

Pope-Hennessy 1985
Pope-Hennessy, John. *Cellini*. New York: Abbeville Press, 1985.

Posner 1973
Posner, Donald. *Watteau: A Lady at Her Toilet*. New York: Viking Press, 1973.

Pulini 2001
Pulini, Massimo. *Guercino, racconti di paese: Il paesaggio e la scena popolare nei luoghi e nell'epoca di Giovanni Francesco Barbieri*. Milan: Federico Motta, 2001. Published in conjunction with the exhibition "Guercino, racconti di paese: Il paesaggio e la scena popolare nei luoghi e nell'epoca di Giovanni Francesco Barbieri," presented at the Pinacoteca Civica, Cento.

Rearick 1993
Rearick, W. R. "The Life and Works of Jacopo del Ponte, Called Bassano c. 1510–1592." In *Jacopo Bassano c. 1510–1592*, edited by Beverly Louise Brown and Paola Marini, 45–171. Fort Worth: Kimbell Art Museum; Bologna: Nuova Alfa Editoriale, 1993. Published in conjunction with the exhibition "Jacopo Bassano c. 1510–1592," presented at the Kimbell Art Museum, Fort Worth.

Reuterswärd 1991
Reuterswärd, Patrik. "The Dog in the Humanist's Study." In *The Visible and Invisible in Art: Essays in the History of Art*, 206–25. Vienna: IRSA Verlag, 1991.

Reynolds 1996
Reynolds, Sir Joshua. *A Journey to Flanders and Holland*. Edited by Harry Mount. Cambridge: Cambridge University Press, 1996.

Ritvo 1987
Ritvo, Harriet. *The Animal Estate: The English and Other Creatures in the Victorian Age*. Cambridge, Mass.: Harvard University Press, 1987.

Roethlisberger 1993
Roethlisberger, Marcel G. *Abraham Bloemaert and His Sons: Paintings and Prints; Biographies and Documents, Marten Jan Bok*. 2 vols. Doornspijk, Netherlands: Davaco, 1993.

Rosenblum 1988
Rosenblum, Robert. *The Dog in Art from Rococo to Post-Modernism*. New York: Harry N. Abrams, Inc., 1988.

Ruskin 1873
Ruskin, John. *Modern Painters*. 5 vols. London: Smith, Elder, 1873.

Savolainen et al. 2002
Savolainen, Peter, et al. "Genetic Evidence for an East Asian Origin of Domestic Dogs." *Science* 298 (2002): 1610.

Schneider-Leyer 1970
Schneider-Leyer, Erich. *Dogs of the World*. New York: Arco Publishing Company, 1970.

Secord 1992
Secord, William. *Dog Painting 1840–1940: A Social History of the Dog in Art*. Woodbridge, United Kingdom: Antique Collectors Club, 1992.

Secord 2000
Secord, William. *Dog Painting: The European Breeds*. Woodbridge, United Kingdom: Antique Collectors Club, 2000.

Secord 2001
Secord, William. *A Breed Apart: The Art Collections of the American Kennel Club and the American Kennel Club Museum of the Dog*. Woodbridge, United Kingdom: Antique Collectors Club, 2001.

Signorini 1978
Signorini, Rodolfo. "Two Notes from Mantua." *Journal of the Warburg and Courtauld Institutes* 41 (1978): 317–21.

Signorini 1988
Signorini, Rodolfo. "Le favole di Esopo nel 'giardino secreto' della villa del Te." *Quaderni di Palazzo Te* 4 (1988): 21–36.

Spallanzani 1983
Spallanzani, Marco. "Saluki alla corte dei Medici nei secoli XV–XVI." *Mitteilungen des Kunsthistorischen Institutes in Florenz* 27 (1983): 360–66.

Sutton 1984
Sutton, Peter C., ed. *Masters of Seventeenth-Century Dutch Genre Painting*. Philadelphia: Philadelphia Museum of Art, 1984. Published in conjunction with the exhibition "Masters of Seventeenth-Century Dutch Genre Painting," presented at the Philadelphia Museum of Art; Gemäldegalerie, Staatliche Museen, Berlin; and the Royal Academy of Arts, London.

Sutton 1994
Sutton, Peter C. *The Age of Rubens*. Boston and Ghent: Museum of Fine Arts, Boston, in association with Ludion Press, 1994. Published in conjunction with the exhibition "The Age of Rubens," presented at the Museum of Fine Arts, Boston, and the Toledo Museum of Art.

Sutton 1998
Sutton, Peter C. *Pieter de Hooch, 1629–1684*. New Haven and London: Yale University Press, 1998. Published in conjunction with the exhibition "Pieter de Hooch, 1629–1684," presented at the Dulwich Picture Gallery, London, and the Wadsworth Atheneum, Hartford.

Syson and Gordon 2001
Syson, Luke, and Dillian Gordon. *Pisanello: Painter to the Renaissance Court*. London: National Gallery Company, 2001.

Thomas 1984
Thomas, Keith. *Man and the Natural World: Changing Attitudes in England 1500–1800*. New York and Oxford: Oxford University Press, 1984.

Topsell 1658
Topsell, Edward. *The History of Four-footed Beasts and Serpents, Collected out of the Writings of Conradus Gesner and Other Authors*. London, 1658.

Vasari 1568
Vasari, Giorgio. *Lives of the Painters, Sculptors, and Architects*. 2 vols. 1568. Reprint, translated by Gaston du C. de Vere with an introduction and notes by David Ekserdjian. New York: Alfred A. Knopf, 1996.

Véron-Denise 2003
Véron-Denise, Danièle. "Louis XV, La Chasse et Oudry." In *Animaux d'Oudry, Collections des ducs de Mecklembourg-Schwerin*, with Vincent Droguet and Xavier Salmon. Paris: Réunion des Musées Nationaux, 2003. Published in conjunction with the exhibition "Animaux d'Oudry, Collections des ducs de Mecklembourg-Schwerin," presented at the Musée National du Château de Fontainebleau.

Vilà et al. 1997
Vilà, Carles, et al. "Multiple and Ancient Origins of the Domestic Dog." *Science* 276 (1997): 1687.

Walsh, Buijsen, and Broos 1994
Walsh, Amy, Edwin Buijsen, and Ben Broos. *Paulus Potter: Paintings, Drawings and Etchings.* The Hague: Mauritshuis; Zwolle: Waanders, 1994.

Walsh 1867
Walsh, John Henry, ed. *The Dogs of the British Islands.* London, 1867.

Waters and Waters 1984
Waters, Hope, and David Waters. *The Saluki in History, Art, and Sport.* 2d ed. Wheat Ridge, Colo.: Hoflin Publishing Ltd., 1984.

Weyerman 1729–69
Weyerman, Jacob Campo. *De levens-beschryvingen der Nederlandsche konst-schilders en konst-schilderessen: Met een uytbreyding over de schilder-konst der ouden.* 4 vols. The Hague: By de wed. E. Boucquet, 1729–69.

Wheelock 2004
Wheelock, Arthur K., Jr. *Gerard ter Borch.* Washington, D.C.: National Gallery of Art; New York: American Federation of Arts, 2004. Published in conjunction with the exhibition "Gerard ter Borch," presented at the National Gallery of Art, Washington, D.C., and the Detroit Institute of Arts.

Wheelock, Barnes, and Held 1990
Wheelock, Arthur, Susan J. Barnes, Julius S. Held, et al. *Anthony van Dyck.* Washington, D.C.: National Gallery of Art, 1990. Published in conjunction with the exhibition "Anthony van Dyck," presented at the National Gallery of Art, Washington, D.C.

Index

Page references in *italic* refer to illustrations.

Photography Credits

Figs. 2, 9, 10, 50, 88: Réunion des Musées Nationaux / Art Resource, NY

Figs. 5, 11: Scala / Art Resource, NY

Fig. 43: Photograph by Ron Jennings; © Virginia Museum of Fine Arts

Fig. 52: Photograph © The Detroit Institute of Arts

Fig. 63: © Artists Rights Society (ARS), New York / SIAE, Rome

Fig. 65: Courtesy Lawrence Steigrad Fine Arts

Fig. 67: © Artists Rights Society (ARS), New York / VG Bild-Kunst, Bonn

Fig. 68: © 2006 Successió Miró / Artists Rights Society (ARS), New York / ADAGP, Paris

Fig. 69: © Estate of Keith Haring

Fig. 70: © 2006 Artists Rights Society (ARS), New York / ADAGP, Paris

Fig. 71: © 2006 The Estate of Francis Bacon / ARS, New York / DACS, London

Fig. 72: © Magnum Photos New York

Fig. 73: © Denis Wirth-Miller

Fig. 74: © Andrew Wyeth

Fig. 75: © Georg Baselitz

Fig. 76: © Lucien Freud

Fig. 77: © David Hockney

Fig. 78: © William Wegman

Fig. 79: © 2006 Andy Warhol Foundation for the Visual Arts / ARS, New York

Fig. 80: © Jeff Koons

Fig. 81: © The Estate of Duane Hanson / Licensed by VAGA, New York, NY

Fig. 82: © Ron Mueck

Fig. 83: Photograph © Robert Millman

Fig. 84: © Emily Mayer

Fig. 85: © Tracey Emin

Figs. 94, 96, 98, 103, 104, 105, 107, 108, and 111: Photographs courtesy William Secord Gallery, Inc.

Fig. 106: Photograph Bill McLemore

Fig. 112: Photograph courtesy Mary Swash and Donald Millar

Fig. 120: © Tate, London 2005